Canon EOS 70D:
From
Snapshots to
Great Shots

Nicole S. Young

**Peachpit
Press**

Canon EOS 70D: From Snapshots to Great Shots
Nicole S. Young

Peachpit Press
www.peachpit.com

To report errors, please send a note to errata@peachpit.com
Peachpit Press is a division of Pearson Education.

Project Editor: Valerie Witte
Production Editor: Katerina Malone
Copyeditor: Emily K. Wolman
Proofreader: Patricia J. Pane
Composition: WolfsonDesign
Indexer: Valerie Haynes Perry
Cover Image: Nicole S. Young
Cover Design: Aren Straiger
Interior Design: Mimi Heft
Back Cover Author Photo: dav.d daniels

ISBN-13 978-0-133-57125-7
ISBN-10 0-133-57125-4

9 8 7 6 5 4 3 2 1

Printed and bound in the United States of America

Dedication

To Brian, my husband, best friend, and biggest fan. I love you!

Acknowledgments

There are a lot of things that go on behind the scenes when creating a publication, such as this book. This being my fifth print book with Peachpit, I've come to really appreciate the efforts and contributions that everyone puts into making things come together beautifully. With that said, I'd like to thank each and every one of the team who helped put together this book: Valerie Witte, Katerina Malone, Emily K. Wolman, Patricia J. Pane, WolfsonDesign, Valerie Haynes Perry, Aren Straiger, and Mimi Heft. Thank you all so much for your hard work!

I would also like to thank all of my readers for sticking with me through all of these years. I teach and write about photography because I truly want all of you to become skilled photographers and enthusiastic memory collectors, and also so that you may further enjoy the act of creating a photograph that you are proud of. Without you I would not be writing this book, so thank you!

And, last but not least, I'd like to thank my husband, Brian. It's an amazing thing to have a partner who is as passionate about photography and education as I am. Brian, you've given me so much creative freedom, and also made some amazing sacrifices, and I know we have our best years yet to come. I love you!

Contents

INTRODUCTION ix

CHAPTER 1: THE 70D TOP TEN LIST 1

Ten tips to make your shooting more productive
 right out of the box

Poring Over the Camera 2

Poring Over the Camera 4

1. Charge the Battery 5

2. Turn Off the Release Shutter Without Card Setting 6

3. Set Your RAW/JPEG Image Quality 7

4. Set Your ISO 10

5. Set the Correct White Balance 11

6. Set Your Color Space 15

7. Set Your Autofocus 18

8. Set Up Wi-Fi 21

9. Enable Highlight Alert 25

10. Review Your Photos 26

Chapter 1 Assignments 31

CHAPTER 2: FIRST THINGS FIRST 33

A few things to know and do before you
 start taking pictures

Poring Over the Picture 34

Poring Over the Picture 36

Choosing the Right Memory Card 38

Formatting Your Memory Card 38

Using the Right Format: RAW vs. JPEG 40

Lenses and Focal Lengths 43

Understanding Aperture, Shutter Speed, and ISO 48

Motion and Depth of Field 51

Chapter 2 Assignments 55

CHAPTER 3: CAMERA SHOOTING MODES 57

Using the camera's mode settings

Poring Over the Picture	58
Poring Over the Picture	60
The Basic Zone	62
The Creative Zone	68
The Custom Setting Mode	88
How I Shoot: A Closer Look at the Camera Settings I Use	90
Chapter 3 Assignments	91

CHAPTER 4: SAY CHEESE! 93

Settings and features to make great portraits

Poring Over the Picture	94
Poring Over the Picture	96
Using Aperture Priority Mode	98
Lighting Is Everything	100
Focusing: The Eyes Have It	106
Composing People and Portraits	111
Quick Tips for Shooting Better Portraits	115
Chapter 4 Assignments	123

CHAPTER 5: LANDSCAPE & NATURE PHOTOGRAPHY 125

Tips, tools, and techniques to get the most out of
your landscape photography

Poring Over the Picture	126
Poring Over the Picture	128
Sharp and In Focus: Using Tripods	130
Camera Modes and Exposure	132
Selecting the Proper ISO and White Balance	134
Balancing Your Image with the Electronic Level	136
The Golden Hour	138
Focusing Tips for Landscape Photography	140
Making Water Look Silky	140
Composing Landscape Images	143
Advanced Techniques to Explore	146
Chapter 5 Assignments	152

CHAPTER 6: MOVING TARGET **155**

Techniques and tricks with action photography

Poring Over the Picture	156
Stop Right There!	158
Using Shutter Priority (Tv) Mode to Stop Motion	160
Using Aperture Priority (Av) Mode to Isolate Your Subject	164
Setting Up Your Camera for Continuous Shooting and Autofocus	165
Manual Focus for Anticipated Action	170
A Sense of Motion	172
Tips for Shooting Action	174
Chapter 6 Assignments	179

CHAPTER 7: MOOD LIGHTING **181**

Shooting when the lights get low

Poring Over the Picture	182
Poring Over the Picture	184
Raising the ISO: The Simple Solution	186
Controlling the Minimum and Maximum ISO	187
Using a Very High ISO	188
Stabilizing the Situation	190
Focusing in Low Light	191
Shooting Long Exposures	194
Using the Built-in Flash	196
Compensating for the Flash Exposure	198
Reducing Red-Eye	199
Using Second Curtain Sync	202
A Few Words about External Flashes	204
Chapter 7 Assignments	206

CHAPTER 8: CREATIVE COMPOSITIONS **209**

Improve your pictures with sound compositional elements

Poring Over the Picture	210
Depth of Field	212
Backgrounds	214
Angles	214
Point of View	218

Patterns, Textures, and Shapes	219
Color	221
Leading Lines	223
Rule of Thirds	224
Frames within Frames	225
Chapter 8 Assignments	227

CHAPTER 9: LIGHTS, CAMERA, ACTION! **229**

Making movies with the Canon 70D

Poring Over the Video Camera	230
Getting Started	232
Exposure Settings for Video	238
Composition	240
Focusing	243
Audio	245
Tips for Shooting Video	246
Chapter 9 Assignments	249

CHAPTER 10: ADVANCED TECHNIQUES **251**

Customizing your camera and your creativity

Poring Over the Picture	252
Using a Custom White Balance	254
The My Menu Settings	255
In-Camera Image Editing	258
Picture Styles	263
Let's Get Creative	266
Conclusion	270
Chapter 10 Assignments	271

INDEX **272**

Introduction

If you are reading this book, there's a pretty good chance that you have read other "how-to" photography books. Many of those books will be either camera-specific (how to use the settings on your camera) or about the methods and techniques used to create specific types of images (landscape, portrait, HDR, etc.). In this book you get the best of both worlds—you learn how to use your 70D and its specific features as well as the different methods and photography techniques to capture those images.

Here's a quick Q&A about the book to help you understand what you'll see in the following pages:

Q: What can I expect to learn from this book?

A: My goal in writing this book is to help owners of the Canon 70D learn more about the camera's specific settings and features, and put that knowledge to use to make great images. You'll also find a ton of general and advanced photography tips and tricks in each of the chapters to push your photography to the next level.

Q: Is every camera feature going to be covered?

A: No. I wrote about what I feel are some of the 70D's most important features, but don't worry! There's a lot of information in here. This is more than just a book on simple steps to get you started … . I really dig into some of the advanced features to make sure that you get as much as possible out of your 70D.

Q: So if I already own the manual, why do I need this book?

A: Your manual does a great job of explaining *how* to use the camera's features, but it doesn't necessarily tell you *why* or *when* to use them. I tried my best to do both so that not only do you know about the 70D's knobs, buttons, and settings, but also what the best situations are to make use of the camera's features and settings.

Q: What are the challenges all about?

A: At the end of each chapter, I list a few exercises you can do to practice and solidify some of the techniques and settings you learned about in that chapter. Feel free to try them out if you like, and if you do, be sure to check out the Flickr group and share what you've learned!

Q: Should I read the book straight through or can I skip around from chapter to chapter?

A: Well, both! The first few chapters are going to give you a lot of basics about your 70D and digital photography in general, so if you don't quite have a grasp on either of those yet, it's a good idea to read through them before heading on to the rest of the book.

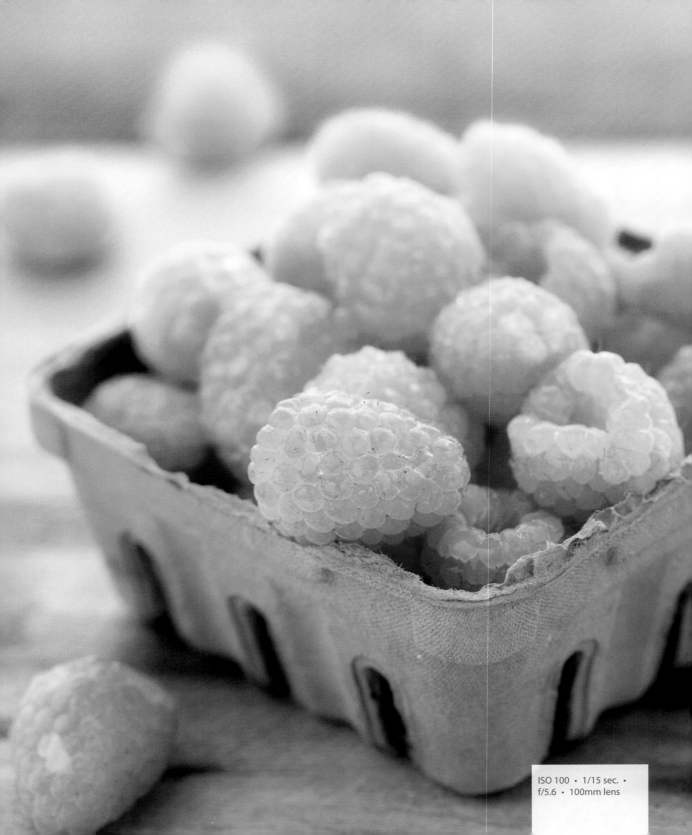

ISO 100 • 1/15 sec. •
f/5.6 • 100mm lens

1

The 70D Top Ten List

Ten tips to make your shooting more productive right out of the box

Getting a new camera is always a lot of fun. There's usually something new, upgraded, or unique about the camera you just acquired, so the first thing I do is jump into taking photos right away. But what I really should be doing is digging into the menu and reading the manual to see what the camera's insides look like. This might seem boring, but learning the new features of the camera can be quite advantageous, since there might be improvements I'm not aware of yet.

If this is your first DSLR (digital single-lens reflex) camera, then you might be a little bit overwhelmed by all of the different features in the 70D. Manuals tend to tell you a lot of "how" but not a lot of "why," and initially, jumping straight into the manual may do more harm than good if you're not sure where to start. If you don't have a grasp of the general settings, then some of the information in the manual won't really have any meaning.

To help you understand more about your camera, in this first chapter I'll be discussing the top ten things that you should know before beginning any major photo-taking endeavors.

Poring Over the Camera

Camera Front

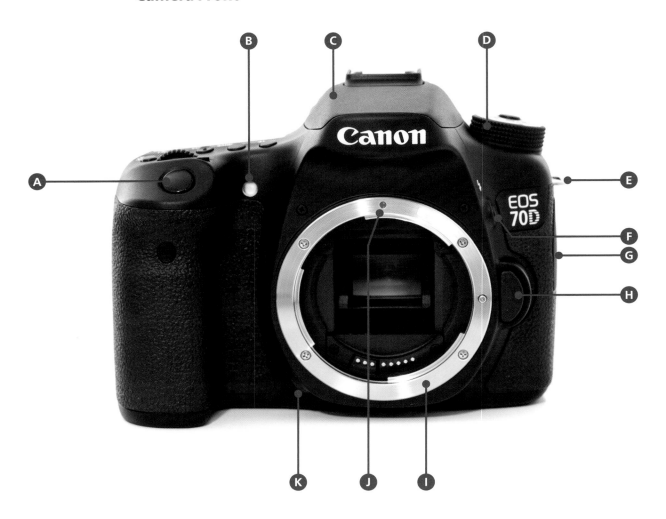

A Shutter Button	E Strap Mount	I Lens Mount
B Red-Eye Reduction/Self-Timer Lamp	F Flash Button	J EF Lens Mount Index
C Built-in Flash	G Terminal Cover	K Depth-of-Field Preview Button
D Mode Dial	H Lens Release Button	

Camera Back

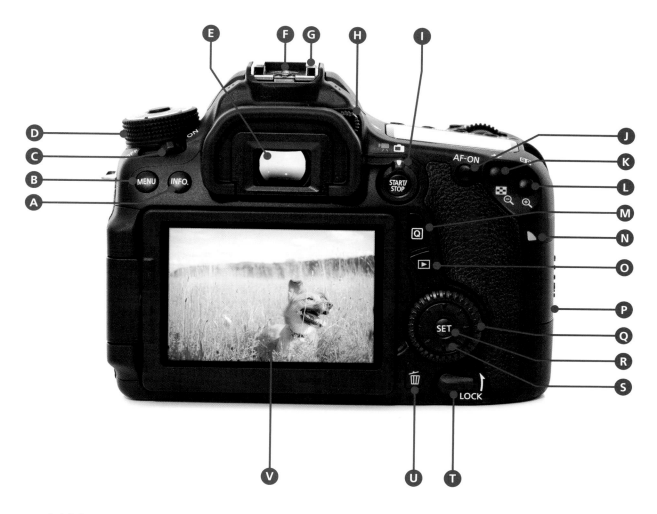

A Info Button
B Menu Button
C Power Switch
D Mode Dial
E Viewfinder
F Flash-Sync Contacts
G Hot Shoe
H Dioptric Adjustment Knob

I Live View & Movie Shooting Switch
J AF Start Button
K AE Lock/FE Lock/Index/Reduce Button
L AF Point Selection/Magnify Button
M Quick Control Button
N Access Lamp (Card Busy Indicator)
O Playback Button
P SD Card Slot

Q Quick Control Dial
R Setting (Set) Button
S Multi-Controller
T Multi-Function Lock Switch
U Erase Button
V LCD Monitor

Camera Top

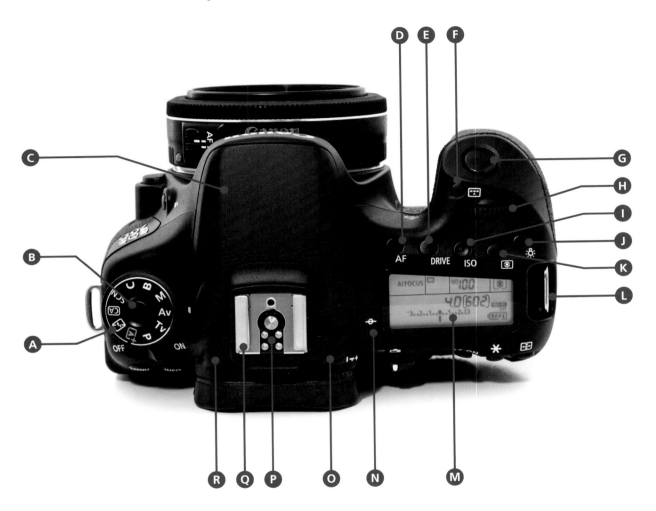

A	Mode Dial	G	Shutter Button	M	LCD Panel
B	Mode Dial Lock-Release Button	H	Main Dial	N	Focal Plane Mark
C	Built-in Flash	I	ISO Speed Setting Button	O	Microphone
D	AF Mode Selection Button	J	LCD Panel Illumination Button	P	Flash-Sync Contacts
E	Drive Mode Selection Button	K	Metering Mode Selection Button	Q	Hot Shoe
F	AF Area Selection Mode Button	L	Strap Mount	R	Microphone

1. Charge the Battery

This might sound obvious, but it's important to charge your battery fully before you begin taking photos. If you insert the battery into your camera right away, you will find that it has a little bit of juice in it, but plugging it in with the battery charger will give you more shooting time and get the battery off to a good start.

Once you've got a fully charged battery in your camera, you can register it from the setup menu. This is extremely helpful when you have more than one battery because it will tell you information about each individual battery, such as the remaining charge, the number of photos you have taken with that battery since its last charge, and the recharge performance (**Figure 1.1**).

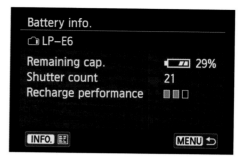

Figure 1.1 **The LCD monitor shows information such as the remaining shutter count, recharge performance, and how much charge is left on your battery.**

Registering your camera's battery

1. Turn on the camera.
2. Press the Menu button on the back of the camera to bring up the menu list.
3. Use the Multi-Controller to select the last setup menu tab (third tab from the right).
4. Select the Battery Info option using the Set button (**A**).
5. Press the Info button on the top-left portion of the back of your camera.
6. On the bottom left, select Register to register your battery (**B**).
7. On the next screen, press OK. Your battery is now registered.

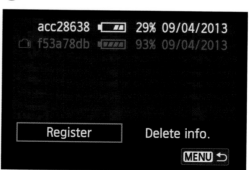

2. Turn Off the Release Shutter Without Card Setting

Immediately after I've inserted a battery in my new camera, I ensure that I won't take a photo without a memory card accidentally by turning off the Release Shutter Without Card setting. This step is so important that, if I happen to be holding a friend's camera and notice that they don't have this feature disabled, I do it for them (usually they don't seem to mind). The benefit to doing this is that if you forget to put in your card and you start shooting, the camera won't let you take a photo. There's nothing worse than spending time photographing something only to realize that none of those images were saved, especially when the mishap could have been easily avoided. This feature has prevented me from losing photos on several occasions, securing it a spot on this Top Ten list.

Turning off the Release Shutter Without Card setting

1. Turn on the camera.
2. Press the Menu button on the back of the camera to bring up the menu list.
3. Scroll to the far-left menu tab.
4. Using the Quick Control Dial, scroll down to the Release Shutter Without Card option and press the Set button (**A**).
5. Use the Quick Control Dial to select the Disable option, and then press the Set button again (**B**).
6. Press the Menu button again to return to shooting mode.

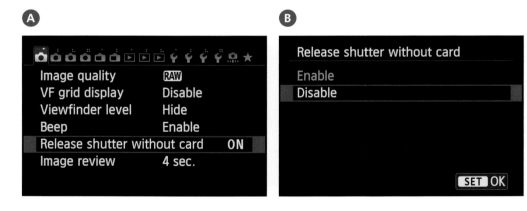

Now when you try to take a photo without a memory card inserted in the camera, you will see a message at the bottom of your viewfinder that flashes the words "CARD" along with a notice on the LCD monitor, which means there is no Secure Digital (SD) card in the camera. This is your clue that you need to insert your memory card before the camera will fire. The top LCD panel will also display the "CARD" message if you activate the Shutter button.

For an in-depth discussion of memory cards and proper formatting, see Chapter 2, "First Things First."

LCD touch-screen features

One of my favorite new features of the 70D is the ability to touch the screen to make changes. This ranges from selecting items in the menu, using the keyboard to enter specific data (such as copyright information), and the new touch-to-focus feature. I'll discuss some of these features in-depth in future chapters, but until then, give them a try and discover for yourself how easy it is to navigate the menus and focus your images with just a simple touch of the screen.

3. Set Your RAW/JPEG Image Quality

If you are upgrading from a digital point-and-shoot camera to the 70D, then you are probably already familiar with the JPEG (Joint Photographic Experts Group) file format. With DSLR cameras you also have the option of using the RAW format. In this section, I will discuss the basics of the two file types, and in Chapter 2 you'll find much more detailed information on their differences, benefits, and disadvantages.

Let's start with the JPEG file format, which was developed as a method of shrinking digital images in order to reduce large file sizes while retaining the original information. (Technically, JPEG is a mathematical equation for compressing a file format, but we'll refer to it as a file format to keep things simple.) Your camera will embed all information into the photograph at the time of exposure. When you shoot in JPEG you have smaller file sizes, but that also means that each image has less information and lower quality; making any extreme enhancements or edits to the image could degrade the image quality even more. However, using JPEG you can fit many more images on your memory card and the images will write to the card faster, which can make this type of file format desirable to many wedding and sports photographers.

RAW files, on the other hand, retain much more information than JPEG files, are not compressed, and offer a lot more "wiggle room" during your editing process (things like exposure and white balance can easily be adjusted without extreme loss of image quality). The downside to this format is that your file sizes will be much larger, and you won't be able to fit as many images on your memory card as you could using JPEG. You'll also need to have a good understanding of photo editing, along with the corresponding software, to edit and share your images.

The 70D has several options for shooting modes. You have the choice to shoot in JPEG only, RAW only, or a combination of the two. If you're not comfortable with shooting RAW yet, that's okay! However, I do encourage you to learn about the RAW format since it can be *extremely* useful to work with when post-processing the images on your computer. If you aren't sure what you want to do and you happen to have a lot of card space, then you can always shoot in both RAW and JPEG at the same time. So, to get you started I'm going to help you get set up to shoot in RAW, JPEG, or both.

When shooting in JPEG format, you need to make some decisions that will determine the file size and quality of your images. There are three different sizes—Large, Medium, and Small—which indicate the actual physical size of your image in pixels. When picking the quality setting, you have two choices: Fine (high quality) and Normal (lower or normal quality). If you prefer to shoot in JPEG, my recommendation is to select the highest image size and quality setting—*Large* size and *Fine* quality. It's always best to start with the highest-quality image possible, right?

The RAW format offers you the ability to set it to different pixel sizes, just like you did with the JPEG quality; however, for RAW files they are listed differently—RAW (large), mRAW (medium), and sRAW (small). Unless you have a reason to reduce the pixel size, such as if you are very limited on space or size is not important, then I would highly recommend that you keep the setting to the largest size (RAW). This will give you the largest possible size your camera can create, and, because it's a RAW file, it also gives you the post-processing benefits of RAW imagery, such as nondestructively changing your white balance setting (see Chapter 2, "Using the Right Format: RAW vs. JPEG," for more information on the benefits of RAW files).

Setting the RAW and/or JPEG image quality

1. Turn on the camera.
2. Press the Menu button on the back of the camera to bring up the menu list.
3. Use the Multi-Controller to select the far-left menu tab.
4. At the top of this menu tab, locate the Image Quality option (**A**), then press the Set button.
5. Use the Main Dial to select your RAW quality and the Quick Control Dial to select the JPEG quality; the "—" option indicates that no option is selected for that setting. If you would like to shoot in both RAW and JPEG, then select an option from each (**B**).
6. Press the Set button to lock in this change.

A

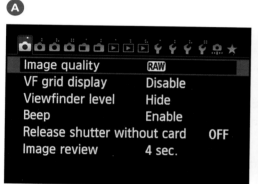

B

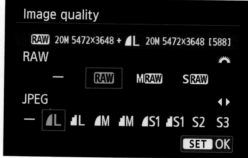

When scrolling through the quality settings, you will see that the higher the quality, the fewer pictures you will be able to fit on your card. If you have an 8 GB memory card, the quality setting we have selected will allow you to shoot about 1000 Large JPEG and 260 RAW photographs before you fill it. *Always* try to choose quality over quantity. Your pictures will be the better for it!

Manual callout

For a complete chart that shows the image-quality settings with the number of possible shots for each setting, turn to page 99 in the EOS 70D Basic Instruction Manual.

4. Set Your ISO

Digital photography has opened up a whole new world when it comes to setting the ISO speed on your camera. With a film camera you were bound to whatever film speed you loaded in your camera or carried with you in your camera bag. But with a digital camera, you can adjust the ISO on the fly, depending on your lighting conditions.

The ISO setting in your camera is the baseline that helps determine your aperture and shutter speed settings. It allows you to choose the camera sensor's level of sensitivity to light. It also makes a big difference in image quality. With a film camera, the ISO is also called "film speed," and the higher the ISO number, the grainier your images will be. With digital photography, that grain is referred to as "digital noise," but the principle is the same: The higher the ISO number, the more digital noise you will see in your image. As I mentioned earlier, digital cameras offer an amazing amount of flexibility when it comes to setting your ISO. This is very useful, but it can affect the quality of your images if you set the ISO too high.

Which ISO you choose depends on your level of available, or ambient, light. For sunny days or very bright scenes, use a low ISO such as 100 or 200. As the level of light is reduced, raise the ISO level. Cloudy days or indoor scenes might require you to use ISO 400. For low-light scenes, such as nighttime shots, you'll probably need to bump up that ISO to 1600. The thing to remember is to shoot with the lowest setting possible for maximum quality.

There is also the option to set your ISO using the Auto ISO feature. I use this from time to time, but I don't recommend new photographers use this feature until they have a strong grasp of how aperture, shutter speed, and ISO work together to produce a proper exposure. While quite powerful at times, Auto ISO can be confusing if you are not sure what your camera is doing.

Noise

Noise is the enemy of digital photography, but it has nothing to do with the loudness of your camera operation. It refers to the electronic artifacts that appear as speckles in your image. They generally appear in darker shadow areas and are a result of the camera trying to amplify the signal to produce visible information. The more the image needs to be amplified—raising the sensitivity through higher ISOs—the greater the amount of noise will be.

Setting the ISO

1. Turn on the camera.

2. Press the Quick Control button on the back of the camera (the "Q" button) to bring up the shooting function settings (**A**).

3. Scroll to the ISO setting in the top-right of the LCD monitor, press the Set button, and then use either the Main Dial or Quick Control Dial to change the ISO setting (**B**).

4. When you are finished, press the Set button to lock in your changes.

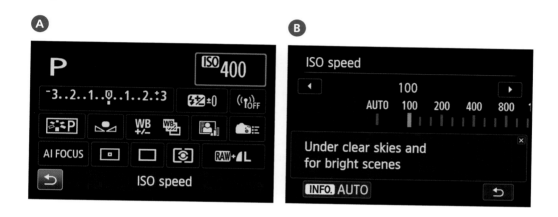

Set your ISO on the fly

There's an additional way to change the ISO without taking your eye from the viewfinder: Press the ISO button on the top of your camera and you will see all of the camera settings in the viewfinder disappear, leaving just the ISO information viewable. Use the Main Dial or Quick Control Dial to adjust your ISO, and once it's at the preferred setting, it will remain locked in until you change it again.

5. Set the Correct White Balance

White balance refers to the process of balancing the color temperature to the light in the location where you are shooting, so that the colors appear "normal." Our eyes have the ability to adjust to these changes so quickly that we don't even realize that certain lights give off different colors.

Most of the film used in traditional film photography was daylight balanced, meaning that the color in photos taken outdoors or with a flash looks correct. Another option, tungsten, balanced film for indoor use. But anything beyond that had to be adjusted with colored

filters to match the light. With the advances in digital photography, we are able to input any color temperature we want to balance the images with the surrounding light.

It's extremely important to set the white balance in your images correctly, especially if you are shooting in JPEG mode. (With RAW images you can adjust the white balance in editing software, but the color information in a JPEG image is permanently embedded into the file, so trying to bring the image back to its correct color temperature can be a difficult task.)

The 70D can perform this task automatically and it usually does a pretty good job, but your goal should be to maintain as much control as possible with your images. You don't need to have a deep understanding of color temperature to find the correct white balance. Your camera comes with easy-to-understand presets and even an option to customize or preset your white balance in the camera. Your white balance choices are

- **Auto:** The default setting for your camera. The camera determines the color temperature of each photo based on the available light coming through the lens.
- **Daylight:** Most often used for general daylight/sunlight shooting.
- **Shade:** Used when working in shaded areas that are still using sunlight as the dominant light source.
- **Cloudy, twilight, sunset:** The choice for overcast or very cloudy days. This and the Shade setting will eliminate the blue color cast from your images.
- **Tungsten light:** Used for any occasion when you are using regular household-type bulbs as your light source. Tungsten is a very warm light source and will result in a yellow/orange cast if you don't correct for it.
- **White fluorescent light:** Used to get rid of the green-blue cast that can result from using regular fluorescent lights as your dominant light source. Some fluorescent lights are actually balanced for daylight, which would allow you to use the Daylight white balance setting.
- **Flash:** Used whenever you're using the built-in flash or a flash on the hot shoe. You should select this white balance to adjust for the slightly cooler light that comes from using a flash. (The hot shoe is the small bracket located on the top of your camera, resting just above the viewfinder.)
- **Custom:** This setting gives you the option of photographing something that is pure white and using it as the baseline for your color temperature. The camera will balance its color temperature settings with that particular photograph.
- **Color temperature:** Here you have the option to actually dial in the Kelvin temperature that matches the light in your setting (from 2500 to 10,000).

Setting the white balance

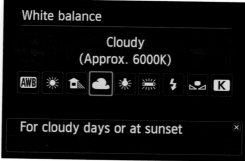

1. After turning on or waking the camera, select one of the shooting modes from the Creative Zone, such as P, Av, Tv, or M (you can't select a white balance when using any of the Basic Zone shooting modes).

2. Press the Quick Control button on the back of the camera to bring up the shooting function settings (**A**).

3. Using the Multi-Controller, scroll to the white balance setting, and click the Set button (**B**). (Note: This icon may look different on your display, depending on which white balance setting is currently selected.)

4. Use the Quick Control Dial to select the white balance setting you would like to use (**C**).

5. When you are done, press Set to lock in your changes.

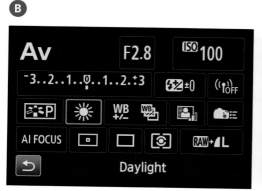

Live View and white balance

One really cool feature of the 70D is the ability to shoot in Live View. This feature can also come in handy when changing settings such as the white balance. To give it a try, press the Live View shooting button (Start/Stop) on the back of the camera to activate Live View (**Figure 1.2**). Then press the Quick Control button and scroll to the white balance setting so that it is highlighted. Then, make your changes by turning the Main Dial or Quick Control Dial. You will see an immediate change in the colors of your image as you set it on different white balance settings (**Figure 1.3**).

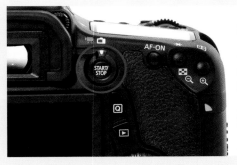

Figure 1.2 With Live View shooting activated, you can change your white balance and view the changes to the image on the rear LCD monitor.

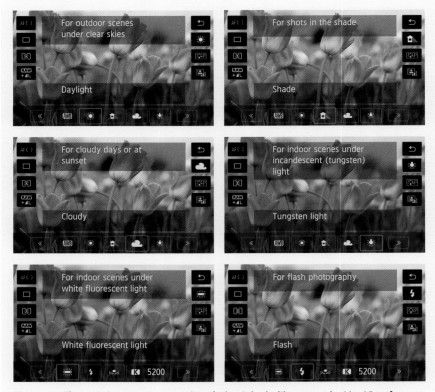

Figure 1.3 These six images are examples of what it looks like to use the Live View feature to preview white balance settings for your image. It's easy to identify which setting will give you the correct color temperature even before taking your photograph.

White balance and the temperature of color

When you select different white balances in your camera, you will notice that underneath several of the choices is a number—for example, 5200K, 7000K, or 3200K. These numbers refer to the Kelvin temperature of the colors in the visible spectrum. The visible spectrum is the range of light that the human eye can see (think of a rainbow or the color bands that come out of a prism). The visible spectrum of light has been placed into a scale called the Kelvin temperature scale, which identifies the thermodynamic temperature of a given color of light. Put simply, reds and yellows are "warm," and greens and blues are "cool." Even more confusing can be the actual temperature ratings. Warm temperatures are typically lower on the Kelvin scale, ranging from 3000 degrees to 5000 degrees, while cool temperatures run from 5500 degrees to around 10,000 degrees. Take a look at this list for an example of Kelvin temperature properties.

Kelvin temperature properties			
Flames	1700K–1900K	Daylight	5000K
Incandescent bulb	2800K–3300K	Camera flash	5500K
White fluorescent	4000K	Overcast sky	6000K
Moonlight	4000K	Open shade	7000K

The most important thing to remember here is how the color temperature of light will affect the look of your images. If something is "warm," it will look reddish-yellow, and if something is "cool," it will have a bluish cast.

6. Set Your Color Space

The *color space* is a set of instructions that tells your camera how to define the colors in your image and then output them to the device of your choice, be it your monitor or a printer. Your camera has a choice of two color spaces: sRGB and Adobe RGB.

The first choice, sRGB, was developed by Hewlett-Packard and Microsoft as a way of defining colors for the Internet. This space was created to deal with the way that computer monitors actually display images using red, green, and blue (RGB) colors. Because there are no black pixels in your monitor, the color space uses a combination of these three colors to display all of the colors in your image.

In 1998, Adobe Systems developed a new color space, Adobe RGB, which was intended to encompass a wider range of colors than was obtainable using traditional cyan, magenta, yellow, and black colors (called CMYK), but doing so using the primary colors red, green, and blue. It uses a wider-defined palette of colors than the sRGB space and, therefore, looks better when printed.

When selecting your color space, base your choice on whether you intend to use your photographs for prints or for online applications. Remember that the color space does not affect the color information of your images directly. It simply embeds the color space profile into the image file as instructions for your computer so that your output device (monitor or printer) can interpret the colors correctly.

Setting the color space

1. With the camera turned on, press the Menu button.

2. Use the Multi-Controller to select the third menu tab, and then scroll down to Color Space using the Quick Control Dial (**A**).

3. Press the Set button, and then highlight your desired color space and press the Set button again (**B**).

4. Press the Menu button to leave the menu and begin shooting with your new color space.

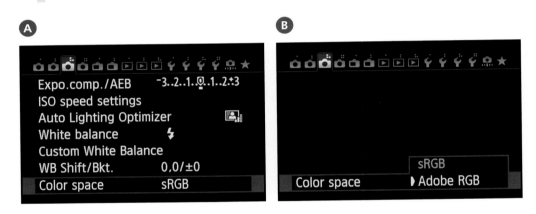

There will be no future indication of which space you have selected, so it's important to set this early and make adjustments if your output intentions change. Typically, I use the Adobe RGB space when shooting, because I'm not sure of the end usage of my images— and if I decide to use them online, I can use image software to change the color space to sRGB. It is always better to go from a larger color space to a smaller one.

Setting copyright information

One thing you may want to consider is adding your copyright information into the camera. The information you enter here will be saved into the photograph's metadata, the data and information stored into each image file.

Here's how to add your copyright information into the Canon 70D:

1. With your camera turned on, press the Menu button.

2. Scroll to the last Setup tab (third tab from the right), select the Copyright Information menu item, and click the Set button (**A**).

3. Select the Enter Author's Name option and click the Set button again (**B**).

4. In the screen that appears, enter your copyright information, which will usually be your name or business (**C**). (Hint: Use the touch screen to expedite the process.)

5. Press the Menu button and, on the next screen, select OK.

6. If you like, you can also enter your copyright details. To do this, select Enter Copyright Details from the Copyright Information screen and press the Set button. Enter your details (I use "All Rights Reserved" for my images) and, when finished, press the Menu button (**D**). Click OK on the next screen and you're done!

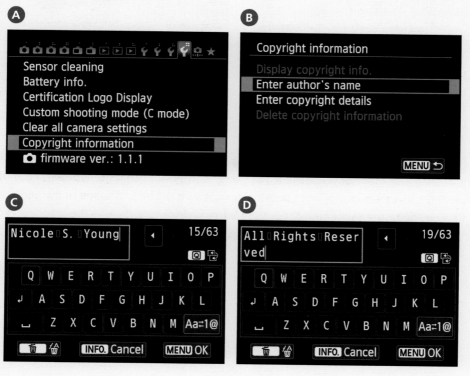

7. Set Your Autofocus

It's important to understand how to use all of the different autofocus modes on your 70D in order to increase your chances of producing sharp, well-focused images. Here are descriptions of each of the autofocus modes:

- **One Shot:** Use to focus on a subject that is not moving, like a person posing for a portrait.

- **AI Servo:** Use for subjects that are in motion. The focusing system will track the subject that falls within the focus area.

- **AI Focus:** Use to focus on something that is not moving, and the focusing system will track the subject if it starts to move (pets or small children, for example).

There are three ways to prompt your 70D camera to start autofocusing. (Before you get started, however, make sure that the focus mode switch on your lens is set to "AF"):

1. Press the shutter button down halfway, just enough to activate the camera and the focusing system but not enough to actually take a photo. Then, when you're ready to take your photo, press the shutter button all the way down.

2. Use the AF-ON button on the back of the camera to set focus without worrying about accidentally tripping the shutter (**Figure 1.4**). With the One Shot focus mode, once you've set your focus, that focus point will remain the same as long as you hold down your focus button (regardless of where you point the camera). However, half-pressing the shutter button or pressing the AF-ON button while using the AI Servo mode will tell the camera to keep searching for something to focus on and will continuously find a new focus point.

Figure 1.4 The AF-ON button will set focus without activating the shutter.

3. Set the camera to Live View and then use the LCD touch screen to select your focus point. By default, once you press the screen, the lens will focus on that spot and you will also take a photo at the same time. (To change this, go into the first Live View menu item and set the "Touch Shutter" to "Disable" (**Figure 1.5**).

Figure 1.5 With the Touch Shutter set to Enable, you will take a photo just by pressing the LCD monitor when in Live View. When it is set to Disable, touching the LCD monitor will only focus the lens—it will not trip the shutter.

Setting the autofocus

1. Wake the camera (if necessary) by lightly pressing the shutter button.
2. Press the Quick Control button, located on the back of the camera.
3. Scroll down to the focus mode selection in the lower-left portion of the LCD monitor and press the Set button (**A**).
4. Choose a focus mode (AF operation) from the list and click the Set button (**B**).

Next, you'll decide where you want your camera to find the focus in the viewfinder. This is called an *AF area,* and it determines the points in your viewfinder that will be in focus when you create your photographs. The 70D allows you to choose one of three different AF areas:

- **Single Point AF:** With this setting, you get to choose the point where the lens will be focused when creating your images. Once you set the point, each time you half-press the shutter button or press the AF-ON button, the lens will focus on that spot. This is a good option to use when you want to be very selective and control the focus in each of your images.

- **Zone AF:** This autofocus mode allows you to select an area (zone) in your viewfinder, and the camera will then select a point in that area to focus on. This is good if you need to be selective of the area of focus but also need to be quick with your photographs, such as when photographing pets or small children, or in sports and other high-speed photography.

- **19-Point Automatic Selection AF:** This setting is complete automatic focus selection; the camera determines the focus spot for you.

Note: You are able to choose the focus mode only when in any of the Creative Zone shooting modes (P, Tv, Av, M, B, or C). When using any mode in the Basic Zone, you are able to use only the 19-Point AF mode.

Setting the AF Area

1. Wake the camera (if necessary) by lightly pressing the Shutter button.

2. Set your camera to one of the Creative Zone shooting modes, such as Av, Tv, or P.

3. While looking through the viewfinder, press the AF Area selection mode button (**A**) or the AF point selection button (**B**). You will see the focus areas highlighted in red while looking through the viewfinder.

4. To scroll through the different selection modes, press the AF Area selection mode button again. Then use the Main Dial or Multi-Controller to select one of the 19 focus points or a focus area, depending on the focusing mode you selected.

A

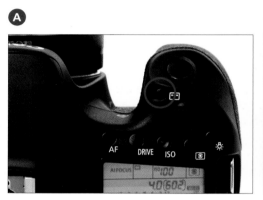

B

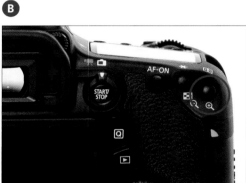

Manual focusing

If you find that the autofocus system won't find your image, it's really easy to switch over to manual focusing. On each lens there is a switch; just change it from AF (autofocus) to MF (manual focus) and use the focus ring to adjust focus by hand (**Figure 1.6**). If you half-press your shutter button during manual focusing, just as you would if you were auto-focusing, and you are focusing in the same area as the autofocus point, then you will hear a beep when the camera senses that the image is in focus.

Figure 1.6 **You can set the focusing mode on your lens to switch from autofocus to manual focus.**

8. Set Up Wi-Fi

One of the cool new features of the Canon 70D is the ability to set it up so that it works with a Wi-Fi signal, enabling you to connect the camera to certain applications and hardware. The best part about it is that the camera itself acts as a Wi-Fi access point, so no other access point is necessary. This gives you the ability to connect in the field or on the road—basically, anywhere! Here, I'll walk through the steps of setting up your smartphone so that you can view your images and download them directly to your phone. (This setup requires a smartphone with either Apple iOS or Android.)

Connecting a smartphone to the Canon 70D

1. Download the EOS Remote app to your smartphone (iOS or Android) from the Apple iTunes App Store or Google Play store (**A**).

2. Press the Menu button (on the back of your camera) and use the Quick Control Dial to get to the third setup menu (fourth menu item from the left).

3. Scroll down to the Wi-Fi setting and make sure that it is set to Enable (**B**). If is isn't, highlight it, press the Set button, choose Enable on the next screen, and then press the Set button again to return to the previous menu.

A

B

4. Scroll to the Wi-Fi function menu item and press the Set button. The first thing you will do is register a nickname (SSID) for the camera (**C**). This nickname is what will appear in your Wi-Fi list on your smartphone when you are looking for the access point; I recommend naming it something that is easily recognizable (**D**). When you are finished, press the Menu button, and then select (or touch) the OK item on the screen.

5. Now it's time to connect the smartphone to your camera. On your camera, select (or touch) the Connect to Smartphone option (**E**). (For this setup, we'll go ahead and connect the camera via the Camera access point mode, so you won't need to be in a location with active Wi-Fi for this to work.)

6. Select the Camera access point mode option from the list, and then scroll down to the OK button and press the Set button (**F**).

7. Select Easy Connection, scroll down to the OK button, and press the Set button again. The next screen will show you the Wi-Fi SSID and encryption key; keep this menu item open so you can use it for the next step (**G**).

8. Now you'll need to go into the Wi-Fi settings on your smartphone and locate the SSID (your camera's Wi-Fi nickname) and use that as the Wi-Fi for your phone. To do this, go into the phone's Wi-Fi settings, select the Wi-Fi SSID from the list (the nickname you chose from in step 4), and use the encryption key on the camera's LCD monitor as the password (**H** and **I**).

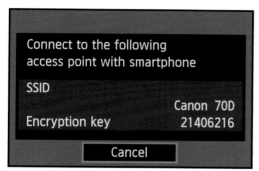

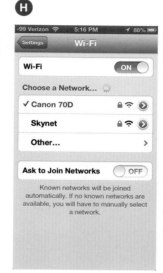

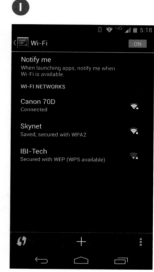

9. Once you've connected your smartphone, your camera will display a new screen with your phone's IP address and MAC address (**J**). This information is telling you that the phone and camera are now connected.

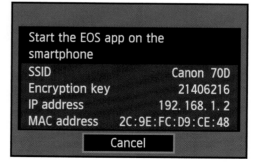

10. Open the EOS Remote app on your phone and click Camera Connection at the bottom. On your camera, a new screen will pop up asking if you want to connect to your smartphone.

11. Click OK on your camera (**K**); your phone and camera are now connected. From the main screen on your smartphone, select Remote Shooting to shoot remotely (**L**) or Camera Image Viewing to view images (**M**). To save these settings and use them in the future, select OK in the Save Settings window on your camera (and you can also rename them if you desire) (**N**).

12. The camera connection will continue until you press the Menu screen from your camera's Connection window. You can continue shooting and accessing photos and remote shooting from your smartphone until you disconnect the camera from this screen (**O**).

Note: Using Wi-Fi on your camera will drain the battery much more quickly than when it is disabled. Also, you are unable to use your camera for video shooting when Wi-Fi is enabled.

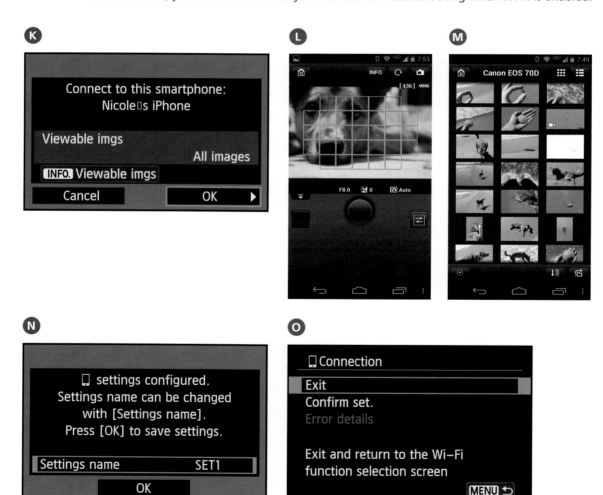

Manual callout

There are many more ways to enable the Wi-Fi function on your Canon 70D. For full instructions, I recommend taking a look at the EOS 70D Wi-Fi Instruction Manual, available for download on the Canon website. This manual is preferred to the "Basic" Wi-Fi manual you received in the box with your camera, as it includes much more detail and a step-by-step guide on setting up Wi-Fi with your camera to pair it with other apps and hardware.

9. Enable Highlight Alert

The LCD monitor on the back of the camera provides wonderful feedback on image exposure and color quality, but if your screen happens to be set too bright or too dark, then the image you are seeing may be deceptive. When you take a photograph, you usually want to keep detail in the highlight areas and not "blow out" anything. In other words, you don't want certain areas of your image to be completely white. For example, if you use your flash while photographing a person and the image is overexposed, the light could flood his or her face. One way to prevent this loss of detail is by enabling Highlight Alert.

Enabling the Highlight Alert setting

1. Turn on the camera, or wake the camera (if necessary) by lightly pressing the Shutter button.

2. Press the Menu button and use the Multi-Controller to select the third playback tab in the menu.

3. Select Highlight Alert and press the Set button (**A**).

4. Use the Quick Control Dial to select Enable, and then press the Set button again (**B**).

5. Press the Menu button to leave the menus and continue shooting.

Now that you have enabled Highlight Alert, you will see a difference in your images while you review them. If you photograph something that is pure white (255, 255, 255 on the RGB color model), then that part of the image will blink red on the LCD monitor when you review your shot. At first you might find this a bit annoying, but trust me, it's extremely useful. This feedback will help you expose your images properly. It's very difficult to pull in detail from the areas that blink, so if it's blinking somewhere you don't want it to (someone's face, for example), you should probably dial down your exposure a bit.

10. Review Your Photos

Digital cameras are amazing because of the immediate feedback you get after taking a photo. You can make changes to the exposure and white balance, and see the results on the LCD monitor to tell instantly if you got the shot you wanted.

Out of the box, your camera will have a very short review time—that is, when you take a photo and it shows up on the LCD monitor, you will see it for only a few seconds. I like shots to stay on until I decide to keep shooting or turn off the camera, so I have it set to the Hold setting. This setting allows you to review the image you photographed for as long as you like (pressing the shutter button lightly will get you back into shooting mode and turn off the LCD monitor). Note that this option will drain your batteries faster than the default setting.

Changing your Review Time setting

1. Press the Menu button and use the Main Dial to select the leftmost menu tab.
2. Using the Quick Control Dial, scroll down to Image Review and press the Set button (**A**).
3. Scroll down to the setting you prefer and press the Set button again (**B**). (If you don't want the LCD monitor to show an image after each shot, just set the review time to OFF.)
4. Press the Menu button to leave the menus and continue shooting.

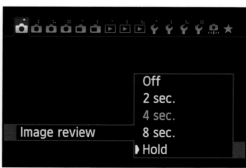

Now that you have the image display set, let's check out some of the other visual information that will really help you when shooting.

- When you press the Playback button on the back of the camera, you will see the default screen, which shows only the image and no information (**Figure 1.7**).

- If you press the Info button while in the default playback screen, then you will see basic information on your image, such as shutter speed, aperture, exposure compensation, and image number (**Figure 1.8**).

- Press the Info button again and it will take you to the Shooting Information Display. This shows you more details, such as your white balance, camera mode, and file size, and offers more information about your image than any of the other display settings (**Figure 1.9**).

- The last display will give you detailed histogram information (**Figure 1.10**). This is useful if you need to see each individual color channel, but I find that the basic histogram display in the Shooting Information Display is sufficient for most images.

If you prefer one display mode to another, press the Info button until you reach the display mode you like best; if you leave it in that mode, you will see your images in that display mode every time you press the Playback button. I usually use the default display (Single Image Display) and will sometimes click through the display modes if I need to view more information about a specific shot.

Figure 1.7 **The default display mode on the 70D.**

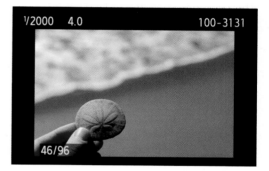

Figure 1.8 **By pressing the Info button you can scroll through the camera's four display modes.**

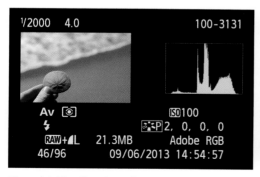

Figure 1.9 **The Shooting Information Display gives you the most information about your photograph.**

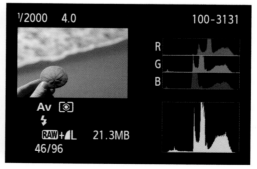

Figure 1.10 **The fourth display option shows you a color histogram.**

The value of the histogram

Simply put, histograms are two-dimensional representations of your images in graph form. There are two different histograms that you should be concerned with: the luminance and the color histograms. Luminance is referred to in your manual as "brightness" and is most valuable when evaluating your exposures.

In **Figure 1.11**, you see what looks like a mountain range. The graph represents the entire tonal range that your camera can capture, from the whitest whites to the blackest blacks. The left side represents black, all the way to the right side, which represents white. The heights of the peaks represent the number of pixels that contain those luminance levels (a tall peak in the middle means your image contains a large amount of medium-bright pixels). Looking at this figure, I can see that the largest peak of the graph is in the middle and trails off as it reaches the edges. In most cases you would look for this type of histogram, indicating that you captured the entire range of tones, from dark to light, in your image. Knowing that is fine, but here is where the information really gets useful.

When you evaluate the histogram that has a spike or peak riding up the far left or right side of the graph, it means that you are clipping detail from your image. In essence, you are trying to record values that are either too dark or too light for your sensor to accurately record. This is usually an indication of over- or underexposure. It also means that you need to correct your exposure so that the important details will not record as solid black or white pixels (which is what happens when clipping occurs). There are times, however, when some clipping is acceptable. If you are photographing a scene where the sun will be in the frame, you can expect to get some clipping because the sun is just too bright to hold any detail. Likewise, if you are shooting something that has true blacks in it—think coal in a mineshaft at midnight—there are most certainly going to be some true blacks with no detail in your shot.

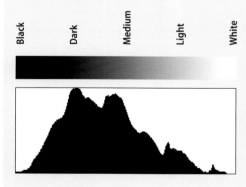

Figure 1.11 **This is a typical histogram, where the dark to light tones run from left to right. The black to white gradient above the graph demonstrates where the tones lie on the graph and would not appear above your camera's histogram display.**

The main goal is to ensure that you aren't clipping any "important" visual information, and that is achieved by keeping an eye on your histogram. Take a look at **Figure 1.12**. The histogram displayed on the image shows a heavy skew toward the left with almost no part of the mountain touching the right side. This is a good example of what an underexposed image histogram looks like. Now look at **Figure 1.13** and compare the histogram for the image that was correctly exposed. Notice that even though there are two distinct peaks on the graph, there is an even distribution across the entire histogram.

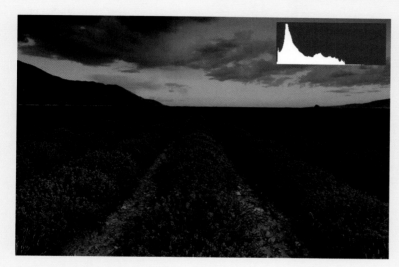

Figure 1.12
This image is about two stops underexposed. Notice the histogram is skewed to the left.

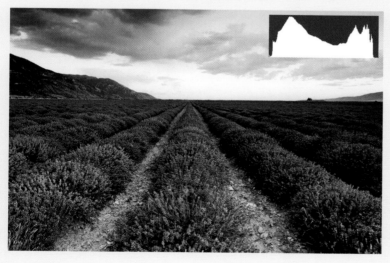

Figure 1.13
This histogram reflects a properly exposed image.

Index display

You can view up to nine images at a time on the LCD monitor by using index display. To do this, press the Playback button to get into the review mode, and then press the Index button (**A**). Pressing Index once will show you six images, and pressing it twice will show you nine at once (**B**). To view any image up close, just highlight it and press the Set button, and it will bring you back to the default display mode.

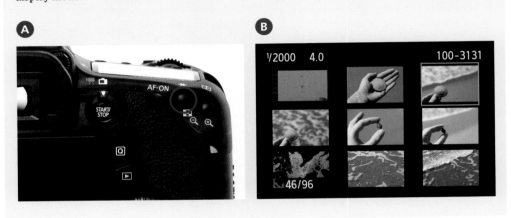

Chapter 1 Assignments

Let's begin our shooting assignments by setting up and using all of the elements of the Top Ten list. If you're not yet familiar with the shooting modes (more information on them will be covered in Chapter 3, "Camera Shooting Modes"), then go ahead and set your camera to the P (Program) mode. This will allow you to interact with the various settings and menus that have been covered thus far.

Basic camera setup

Charge your battery to 100 percent and register it in the camera. Next, set up your camera to address the following: shooting without a card, image quality, ISO, and color space.

Select the proper white balance

Take your camera outside into a daylight environment and photograph the same scene using different white balance settings. Pay close attention to how each setting affects the overall color cast of your images. Next, try moving inside and repeat the exercise while shooting in a tungsten lighting environment. Finally, find a fluorescent light source and repeat once more.

Play with the focus settings

Change your camera setting so that you have one focus point selected. Try using all of the different focus points to see how they work in focusing your scene. Next, set your focus mode to One Shot and practice focusing on a subject and then recomposing before actually taking the picture. Try doing this with subjects at varying distances. Then set the camera to Live View mode by pressing the Start/Stop button on the back of the camera (to the right of the viewfinder) and focus your scene by pressing on the LCD monitor.

Discover the Manual focus mode

Change your focus mode from Autofocus to Manual and practice a little manual-focus photography. Get familiar with where the focus ring is and how to use it to achieve sharp images.

View your images on a smartphone over Wi-Fi

Follow the instructions in this chapter to set up your camera for Wi-Fi use with your smartphone. Then select the Camera Image Viewing option on your smartphone to view the images. Play around with the different options on your phone, such as downloading the image, rating it with stars, or even cleaning up your memory card by deleting unwanted photographs.

Enable Highlight Alert and review your images

Enable Highlight Alert and set up your image-display properties, and then review some of your previous images using the different display modes. Watch how the Highlight Alert will flash in some areas on your LCD monitor, especially when an image is overexposed.

Share your results with the book's Flickr group!
Join the group here: flickr.com/groups/canon70dfromsnapshotstogreatshots

ISO 800 • 1/45 sec. •
f/4.5 • 100mm lens

2
First Things First

A few things to know and do before you start taking pictures

So now you have a basic grasp of the top ten tips to get you started shooting with your 70D, but there are still a few important details that need mentioning before you can take full advantage of your camera. In this chapter, we'll review some 70D basics on lenses and exposure, and get you started formatting your memory card and preparing the camera for use. Let's start with the very first thing you will need before you can run out and take photos: a memory card.

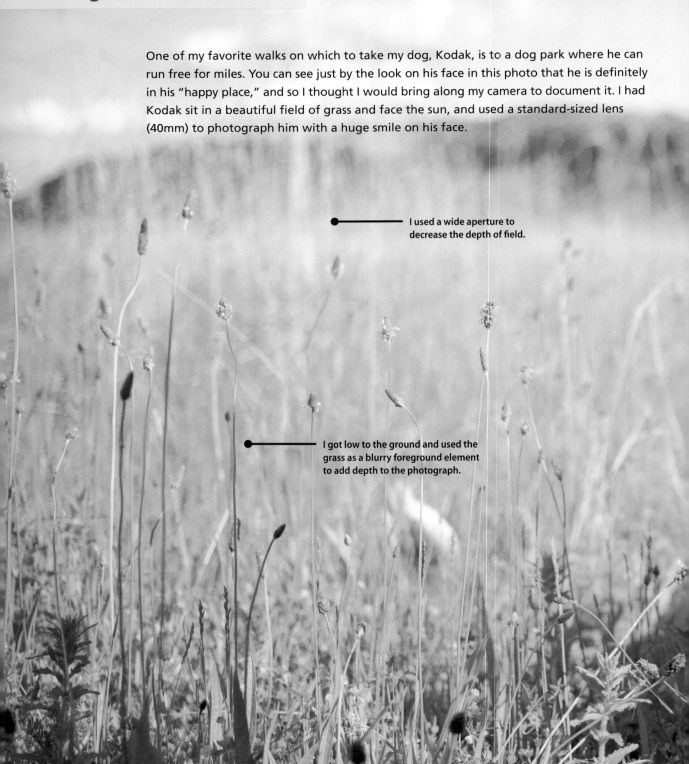

Poring Over the Picture

One of my favorite walks on which to take my dog, Kodak, is to a dog park where he can run free for miles. You can see just by the look on his face in this photo that he is definitely in his "happy place," and so I thought I would bring along my camera to document it. I had Kodak sit in a beautiful field of grass and face the sun, and used a standard-sized lens (40mm) to photograph him with a huge smile on his face.

I used a wide aperture to decrease the depth of field.

I got low to the ground and used the grass as a blurry foreground element to add depth to the photograph.

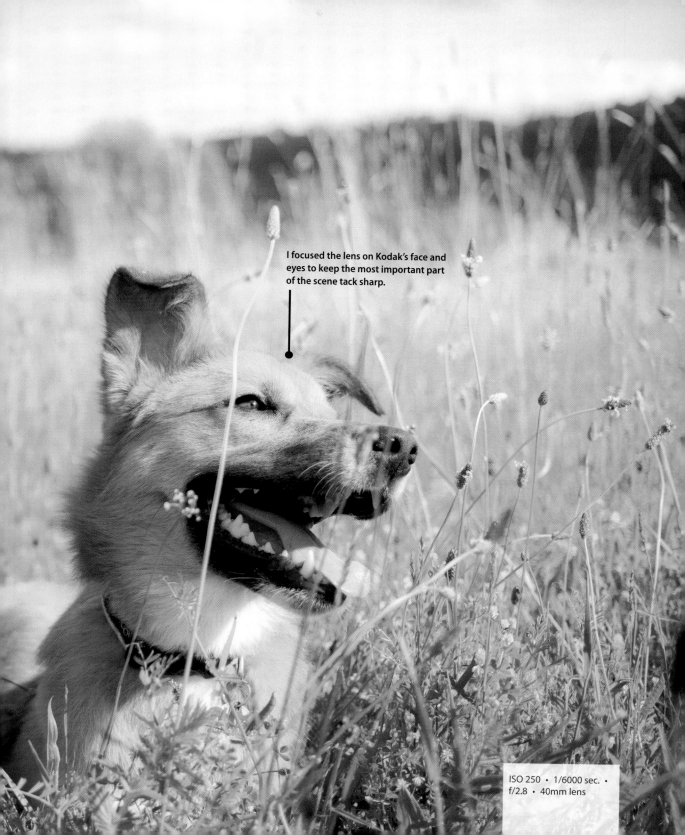

I focused the lens on Kodak's face and eyes to keep the most important part of the scene tack sharp.

ISO 250 · 1/6000 sec. · f/2.8 · 40mm lens

I used a small aperture with this image (f/16), but because I used a long macro lens and am very close to my subject, the background still became slightly blurry.

ISO 400 · 1/8 sec. ·
f/16 · 100mm lens

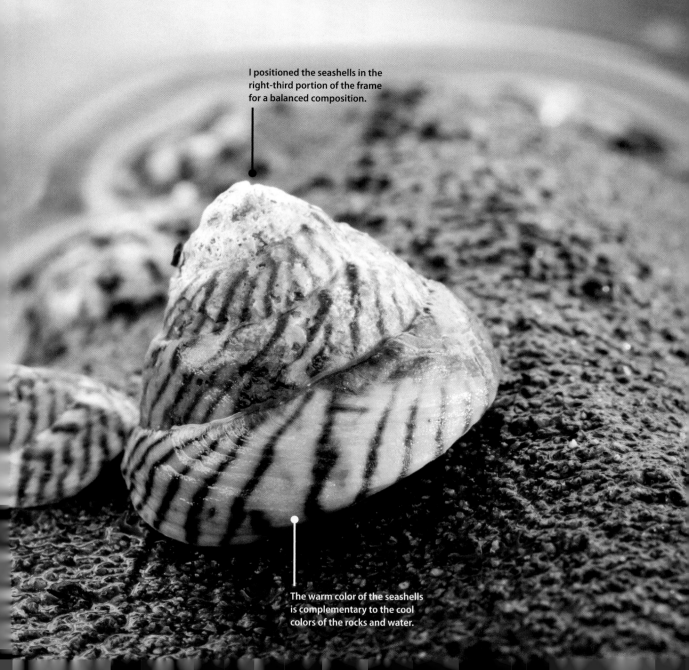

While traveling through Australia, I was on a beach to photograph the sunset. I had created several wide-angle shots of the sky and ocean, but then noticed all of the details and tiny objects in the tide pools nearby. So I got down low, used a macro lens, and found these tiny little seashells to photograph.

I positioned the seashells in the right-third portion of the frame for a balanced composition.

The warm color of the seashells is complementary to the cool colors of the rocks and water.

Choosing the Right Memory Card

The *memory card* is where your camera will store all of the images you photograph until you offload them to your computer or hard drive. It's a very important accessory to own, since you can't create any images until you have one in your camera. The 70D uses *Secure Digital (SD) cards,* so if you own a digital point-and-shoot camera you are most likely already familiar with using them (**Figure 2.1**).

There are many different brands and sizes to choose from, and there's a lot to consider when buying SD cards for your camera. Here are some tips to help you make your purchase:

Figure 2.1
Make sure you select an SD card that has enough capacity to handle your photographic needs. For the Canon 70D, I recommend an SD card that is at least 8 GB.

- The card size is very important, especially since the 70D can shoot up to 20.2 megapixels in both RAW and JPEG file formats. You can find SD cards in many sizes, but you probably won't want anything smaller than 8 GB per card. It's also a good idea to have more than one card tucked away in your camera bag to use as backup.

- Don't skimp on quality because of a good price. Remember, the card is the only place that your image files are stored until you can transfer them to a computer. A high-quality card might cost a few dollars more but will be more reliable and will last much longer than a less expensive one. You don't always know that something is wrong with a card until it's too late, so having a reliable card is one way to help prevent that.

Along with a memory card, it's also a good idea to have an SD card reader. It is possible to connect your camera to the computer to retrieve the files, but over time you will drain your camera's battery unnecessarily.

Formatting Your Memory Card

The first thing to do when you have a new SD card is format it. When you format a card, the camera creates a layout for the images to be written more easily and saved properly. Formatting also "cleans" your card, making it a blank slate to which to write new images, and is the recommended way of deleting data from the card. You should always format the card within the camera itself, because formatting it from the computer could render the card useless. You also want to be certain that a card's images and files have been safely transferred over to another source before formatting it.

I try to reformat a card before each use and after I have uploaded the images to my hard drive. I also format a card if it's brand new or has been used in a different camera. I like to start with a fresh card each time I shoot to simplify my workflow when I'm taking a lot of photos, so I can keep them organized and separate from my other images.

Formatting a memory card

1. Insert the memory card into your camera.

2. Press the Menu button and navigate to the first setup menu tab (the sixth from the right).

3. Rotate the Quick Control Dial on the back of the camera to highlight the Format Card option, and then press Set (**A**).

4. The default selection for the Format screen is Cancel, just in case you didn't really want to format the card. Rotate the Quick Control Dial to highlight OK (**B**). (Make sure that you have saved any images that you want onto your computer or elsewhere before formatting!)

5. Press the Set button to finalize the formatting of the card.

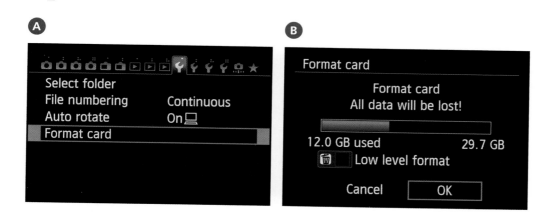

Low-level formatting

If your card seems to be dragging and the images are writing to it more slowly than usual, then it might be a good idea to select the Low Level Format check box when formatting your card. This differs from "normal" formatting because it restores your SD card to a completely empty card, whereas normal formatting makes the card appear empty, but really it is just rewriting the directory so that you can overwrite the existing data. It's a good idea to use the low-level feature whenever you are discarding your SD card to prevent anyone from recovering data that may still be on it.

Using the Right Format: RAW vs. JPEG

The 70D gives you the option to shoot and save your images to your memory card in RAW, JPEG, or both. Most people are already familiar with JPEG, since it's one of the most common file formats for anyone using a digital camera. This topic was discussed briefly in Chapter 1, "The 70D Top Ten List," so you already have a basic understanding of RAW and JPEG.

You may be tempted to set your camera to JPEG and start shooting, never bothering with the other settings. After all, a JPEG is a very simple file to work with! It's ready to go right out of the camera, and you can store a lot more JPEG files on your memory card than you can RAW files. JPEG will also write to the card much more quickly, making it a good choice for photographers who do a lot of high-speed photography (such as sports photographers or photojournalists).

So what's the drawback of JPEG? There's really nothing wrong with it if you can create your photos in-camera exactly how you want them to look (proper exposure, white balance, and so on). However, as I mentioned in Chapter 1, JPEG is not actually an image format. It is a compression standard—and compression is where things go bad. When your camera is set to JPEG, you are telling the camera to process the image however it sees fit and then throw away enough image data to make it shrink into a smaller space. In doing so, you give up subtle image details that you will never get back in post-processing.

So What Does RAW Have to Offer?

The RAW format is an uncompressed file that stores as much data as it can possibly collect from each image you take. Unlike JPEG, it is *lossless compression,* which means that it loses no image data when it writes to the memory card. Photographing with the RAW format means that you have a lot of room to edit the photo, but it also requires the use of software to share or print the image.

RAW images have a greater dynamic range than JPEG-processed images. This means that you can recover image detail in the highlights and shadows that just isn't available in JPEGs.

There's more color information in a RAW image because it's a 14-bit image, meaning it contains more color information than a JPEG, which is almost always an 8-bit image. More color information means more to work with and smoother changes between tones, and it will preserve the quality of your image while you edit.

Regarding sharpening, a RAW image offers more control because you are the one applying the sharpening according to the effect you want to achieve. Once again, JPEG processing applies a standard amount of sharpening that you cannot change after the fact. Once it's done, it's done.

Finally, and most importantly, a RAW file is the digital photography equivalent of a film negative. No matter what you do to it, you won't change it unless you save your file in a different format. This means that you can come back to that RAW file later and try different processing settings to achieve differing results without ever harming the original image. By comparison, if you make a change to your JPEG and accidentally save the file, guess what? You have a new original file, and you will never get back to that first image. That alone should make you sit up and take notice.

Advice for New RAW Shooters

If you are used to using only the JPEG format, moving to RAW is a big step—but a very worthwhile one. Using the RAW format means more work at your computer, but don't give up just because it takes a few extra minutes to process each image. It will also take up more space on your SD card, but that's an easy fix—go buy more cards, or get them in larger sizes (I like to use 16 GB or 32 GB cards with my cameras). Also, don't worry about needing to purchase expensive software to work with your RAW files; you already own a program that allows you to work with them. Canon's Digital Photo Professional software comes bundled in the box with your camera and enables you to work directly on the RAW files and then output the enhanced results.

RAW processing software

If you're interested in other versions of professional-level RAW processing software, you may want to consider purchasing either Adobe Photoshop Lightroom or Apple Aperture. These applications allow you to organize and process your RAW files quickly and easily, and also offer several other features you can use with your images.

Selecting a RAW Format

The 70D has the ability to capture different-sized RAW files. This means you can now have all of the benefits of a RAW file in a smaller image size. The standard RAW file uses the full sensor resolution of 5472 by 3648 pixels. If you want the flexibility and power of using the RAW format but don't necessarily need an image that large, you can select one of the smaller RAW files: mRAW (4104x2736) or sRAW (2736x1824). These smaller RAW files will also take up less space on your memory card, allowing you to shoot more images.

Image resolution

When discussing digital cameras, image resolution is often used to describe pixel resolution, or the number of pixels used to make an image. This can be displayed as a dimension such as "5472x3648." This is the physical number of pixels in width and height of the image sensor. Resolution can also be referred to in megapixels (MP), such as 20 MP. This number represents the number of total pixels on the sensor and is commonly used to describe the amount of image data that a digital camera can capture.

Selecting your image-quality setting

1. Press the Menu button and use the Main Dial to select the first shooting menu tab.
2. Use the Quick Control Dial to highlight the Image Quality setting and press the Set button to enter the Quality setting page (**A**).
3. Use the Main Dial to change the RAW setting and the Quick Control Dial to change the JPEG setting (**B**).
4. Press the Menu button to lock in your changes.

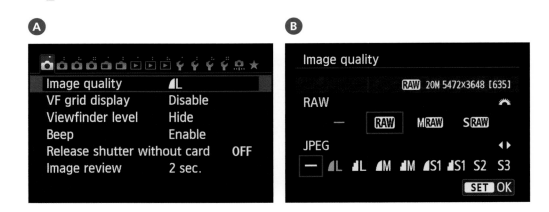

If you are uncomfortable shooting in RAW, that is perfectly OK. My recommendation is to use what works best for your photography, but don't be afraid to try new things. One great feature of the 70D is that you don't have to pick one or the other—the camera gives you the option to shoot in both RAW and JPEG simultaneously (**Figure 2.2**). This will take up a significant amount of space on your memory card, but it's a good way to transition over, or just to give RAW a chance.

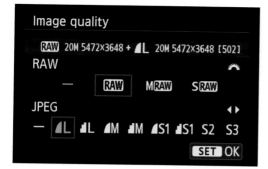

Figure 2.2 **To shoot in both RAW and JPEG simultaneously, follow the steps above to change your quality setting, and use the Main Dial and Quick Control Dial to select both a RAW and JPEG image. Then press Set to lock in your changes.**

Crop sensor vs. full frame

The 70D is what we consider a "crop sensor" camera. Many digital SLR cameras have one of two different types of sensors: full-frame or crop. The sensor is the area in the camera that converts the image you see through the view-finder into the digital file that writes to the memory card. All full-frame sensors have an area of 36 by 24mm (the same size as a 35mm negative). The crop sensor on the 70D is slightly smaller, at 22.5 by 15mm (**Figure 2.3**). This will increase your focal length by a crop factor of 1.6, so if you have a 50mm lens attached to your 70D, then you are actually seeing the equivalent of 80mm when you look through the viewfinder.

Figure 2.3 **The red rectangle in this image represents the visible area that the 70D will capture in relation to what a full-frame sensor would photograph with the same setup and lens.**

Lenses and Focal Lengths

If you ask most photographers what they believe to be their most critical piece of photographic equipment, they would undoubtedly tell you that it's their lens (also referred to as "glass"). The technology and engineering that goes into your camera is a marvel, but it isn't worth much if it can't get the light from the outside onto the sensor. Most photographers will happily put their resources into purchasing high-quality lenses before they get a new camera body, since lenses can be passed on from one camera to the next and are a huge factor in overall image quality.

The 70D, as a digital single-lens reflex (DSLR) camera, uses the lens for a multitude of tasks, from focusing on a subject to metering a scene to delivering and focusing the light onto

the camera sensor. The lens is also responsible for the amount of the scene that will be captured (the frame). With all of this riding on the lens, let's take a more in-depth look at the camera's eye on the world.

Lenses are composed of optical glass that is both concave and convex in shape. The alignment of the glass elements is designed to focus the light coming in from the front of the lens onto the camera sensor. The amount of light that enters the camera is also controlled by the lens, the size of the glass elements, and the aperture mechanism within the lens housing. The quality of the glass used in the lens will also have a direct effect on how well the lens can resolve details and the contrast of the image (the ability to deliver great highlights and shadows). Most lenses now include things like the autofocus motor and, in some cases, an image-stabilization mechanism.

There is one other aspect of the camera lens that is often the first consideration of the photographer: lens length. Typically, lenses are divided into three or four groups depending on the field of view they deliver.

Wide-angle lenses cover a field of view from around 110 degrees to about 60 degrees (**Figure 2.4**). There is a tendency to get some distortion in your image when using extremely wide-angle lenses. This will be apparent toward the outer edges of the frame. As for which lenses would be considered wide angle, anything 35mm or smaller could be considered wide.

Figure 2.4
I used a very wide lens to photograph this scene of Delicate Arch at Moab National Park.

ISO 100 • 1/15 sec. • f/10 • 14mm lens

Wide-angle lenses can display a large depth of field, which allows you to keep the foreground and background in sharp focus. This makes them very useful for landscape photography. They also work well in tight spaces, such as indoors, where there isn't much elbow room available. They can also be handy for large group shots but can create an odd distortion for close-up portrait work (**Figure 2.5**).

Figure 2.5
While a wide-angle lens works for this unique perspective, it is not ideal for a traditional portrait due to the extreme distortion near the edges of the frame.
ISO 400 · 1/400 sec. · f/7.1 · 14mm len

A *normal* lens has a field of view that is about 45 degrees and delivers approximately the same view as the human eye. The perspective is very natural and there is little distortion in objects. A normal lens will have a focal length between 35mm and 80mm. Normal lenses are useful for photographing people and architecture, as well as for most other general photographic needs, as they have very little distortion and offer a moderate range of depth of field (**Figures 2.6** and **2.7**).

Figure 2.6
Using a normal focal length will produce very little distortion in your images.

ISO 100 · 1/2000 sec. · f/4 · 40mm lens

Figure 2.7 Normal lenses are great for close-up portrait work.

ISO 100 · 1/320 sec. · f/2.8 · 50mm lens

Most longer focal-length lenses are referred to as *telephoto* lenses. They can range in length from 135mm up to 800mm or longer and have a field of view that is about 35 degrees or smaller. These lenses have the ability to greatly magnify the scene, allowing you to capture details of distant objects, but the angle of view is greatly reduced.

Telephoto lenses are most useful for sports or wildlife photography, or any application where you just need to get closer to your subject. They can have a compressing effect—making objects look closer together than they actually are—and a very narrow depth of field when shot at their widest apertures (**Figure 2.8**).

A *zoom* lens is a great compromise to carrying a bunch of single focal-length lenses (also referred to as *prime* lenses). Zoom lenses can cover a wide range of focal lengths because of the configuration of their optics. However, because it takes more optical elements to capture a scene at different focal lengths, the light must pass through more glass on its way to the image sensor. The more glass, the lower the quality of the image sharpness. The other sacrifice that is made is in aperture. Zoom lenses typically have smaller maximum apertures than prime lenses, which means they cannot achieve a narrow depth of field or work in lower light levels without the assistance of image stabilization, a tripod, or higher ISO settings. (We'll discuss all this in more detail in later chapters.)

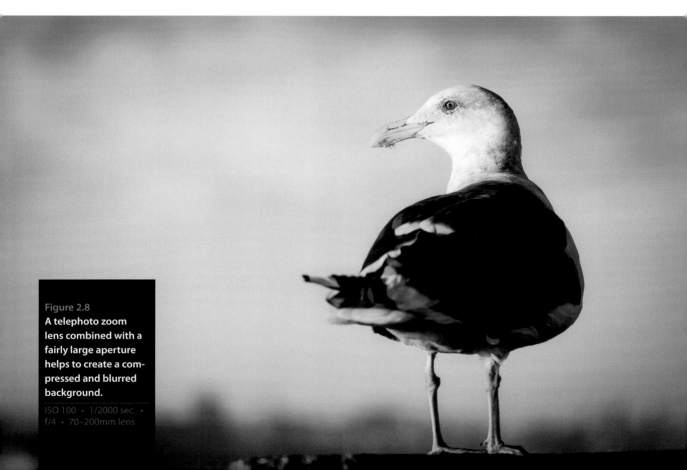

Figure 2.8
A telephoto zoom lens combined with a fairly large aperture helps to create a compressed and blurred background.

ISO 100 · 1/2000 sec. · f/4 · 70–200mm lens

The 70D can be purchased with the body only, but many folks will purchase it with a *kit* lens, especially if this is their first DSLR camera. One common kit lens is the 18–135mm. This is a great all-purpose "walkaround" lens that will give you a lot of flexibility with your shooting. One of my favorite lenses is the 70-200 f/4L IS; the "L" series of Canon lenses is their top-of-the-line glass, and also comes at a much higher price than the other lenses.

Understanding Aperture, Shutter Speed, and ISO

Proper exposure is crucial to creating a good image, and if you're not sure what's going on inside the camera, it can be difficult to grasp many of the concepts you will read about in this book. Your camera can, and will, make a lot of decisions during the shooting process, and it's important that you understand what it's doing and why. Here, I'll cover some of the basic principles of exposure, so you have the tools to move forward and improve your photography.

Exposure is the process whereby the light reflecting off a subject reflects through an opening in the camera lens for a defined period of time onto the camera sensor. The combination of the lens opening, shutter speed, and sensor sensitivity is used to achieve a proper exposure value (EV) for the scene. The EV is the sum of the components necessary to properly expose a scene.

A relationship exists between these factors that is sometimes referred to as the "exposure triangle." At each point of the triangle lies one of the factors of exposure:

- **ISO:** Determines the sensitivity of the camera sensor. ISO stands for the International Organization for Standardization, but the acronym is used as a term to describe the sensitivity of the camera sensor to light. The higher the sensitivity, the less light is required for a good exposure. These values are a carryover from the days of traditional color and black-and-white films.

- **Aperture:** Also referred to as the *f-stop,* this determines how much light passes through the lens at once.

- **Shutter speed:** Controls the length of time that light is allowed to hit the sensor.

Here's how it works. The camera sensor has a level of sensitivity that is determined by the ISO setting. To get a proper exposure—not too much, not too little—the lens needs to adjust the aperture diaphragm (the size of the lens opening; think of it as the pupil in your eye increasing and decreasing in size) to control the volume of light entering the camera. Then the shutter is opened for a relatively short period of time to allow the light to hit the sensor long enough for it to record on the sensor.

ISO numbers for the 70D start at 100 and then double in sensitivity as you double the number. So 200 is twice as sensitive as 100. The camera can be set to use 1/2- or 1/3-stop increments, but for ISO just remember that the base numbers double: 100, 200, 400, 800, and so on. There are also a wide variety of shutter speeds that you can use. The speeds on the 70D range from as long as 30 seconds to as short as 1/8000 of a second. When using the camera, you will not see the "1" over the number, so you will need to remember that anything shorter than a second will be a fraction. Generally speaking, for handheld photography you should stay at 1/60 of a second for the slowest speed (or 1/30 if you have steady hands), so you will most likely be working with a shutter speed range from around 1/30 of a second to about 1/2000. These numbers will change depending on your circumstances and the effect that you are trying to achieve. Because different lenses have different maximum apertures, the lens apertures will vary slightly depending on which lens you are using. The typical apertures at your disposal are f/4, f/5.6, f/8, f/11, f/16, and f/22.

When it comes to exposure, a change to any one of these factors requires changing one or more of the other two. This is referred to as *reciprocal change.* If you let more light into the lens by choosing a larger aperture opening, you will need to shorten the amount of time the shutter is open. If the shutter is allowed to stay open for a longer period of time, the aperture needs to be smaller to restrict the amount of light coming in.

How Is Exposure Calculated?

Now we know about the exposure triangle—ISO, shutter speed, and aperture—so it's time to put all three together to see how they relate to one another and how you can change them as needed.

When you point your camera at a scene, the light reflecting off your subject enters the lens and is allowed to pass through to the sensor for a period of time as dictated by the shutter speed. The amount and duration of the light needed for a proper exposure depends on how much light is being reflected and how sensitive the sensor is. To figure this out, your camera utilizes a built-in light meter that looks through the lens and measures the amount of light. That level is then calculated against the sensitivity of the ISO setting, and an exposure value is rendered. Here's the catch: There is no single way to achieve a perfect exposure, because the f-stop and shutter speed can be combined in different ways to allow the same amount of exposure. Deciding which combination to use is one of the fun, creative aspects of being a photographer.

Here is a list of reciprocal settings that would all produce the same exposure result. Let's use the "sunny 16" rule, which states that, when using f/16 on a sunny day, you can use a shutter speed that is roughly equal to your ISO setting to achieve a proper exposure. For simplification purposes, we will use an ISO of 100.

Reciprocal Exposures: ISO 100								
F-STOP	2.0	2.8	4.0	5.6	8	11	16	22
SHUTTER SPEED	1/8000	1/4000	1/2000	1/1000	1/500	1/250	1/125	1/60

If you were to use any of these combinations, each would have the same result in terms of the exposure (that is, how much light hits the camera's sensor). Also note that every time we cut the f-stop in half, we reciprocated by doubling our shutter speed. For those of you wondering why f/5.6 is half of f/8, it's because those numbers are actually fractions based on the opening of the lens in relation to its focal length. This means that a lot of math goes into figuring out just what the total area of a lens opening is, so you just have to take it on faith that f/5.6 is half of f/8 but twice as much as f/4. A good way to remember which opening is larger is to think of your camera lens as a pipe that controls the flow of water. If you had a pipe that was 1/2-inch in diameter (f/2) and one that was 1/8-inch (f/8), which would allow more water to flow through? It would be the 1/2-inch pipe. The same idea works here with the camera f-stops; f/2 is a larger opening than f/4 or f/8 or f/16.

Now that we know this, we can start using this information to make intelligent choices in terms of shutter speed and f-stop. Let's bring the third element into this by changing our ISO by one stop, from 100 to 200.

Reciprocal Exposures: ISO 200								
F-STOP	2.0	2.8	4.0	5.6	8	11	16	22
SHUTTER SPEED	–	1/8000	1/4000	1/2000	1/1000	1/500	1/250	1/125

Notice that since we doubled the sensitivity of the sensor, we now require half as much exposure as before. We have also reduced our maximum aperture from f/2 to f/2.8, because the camera can't use a shutter speed that is faster than 1/8000 of a second.

So why not just use the exposure setting of f/16 at 1/250 of a second? Why bother with all of these reciprocal values when this one setting will give us a properly exposed image? The answer is that the f-stop and shutter speed also control two other important aspects of our image: motion and depth of field.

Motion and Depth of Field

Now, let's discuss how adjusting shutter speed and aperture can enhance your images. Shutter speed controls the length of time the light has to strike the sensor; consequently, it also controls the motion blurriness (or lack of blurriness) of the image. The less time that light has to hit the sensor, the less time your subjects have to move around and become blurry. This can give you more control to freeze the motion of fast-moving subjects (**Figure 2.9**), for example, or intentionally blur a subject or scene to give the feel of energy and motion (**Figure 2.10**).

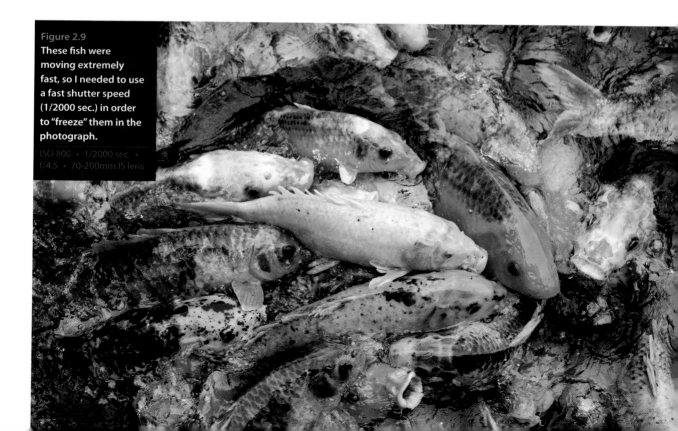

Figure 2.9
These fish were moving extremely fast, so I needed to use a fast shutter speed (1/2000 sec.) in order to "freeze" them in the photograph.

ISO 800 · 1/2000 sec. · f/4.5 · 70-200mm IS lens

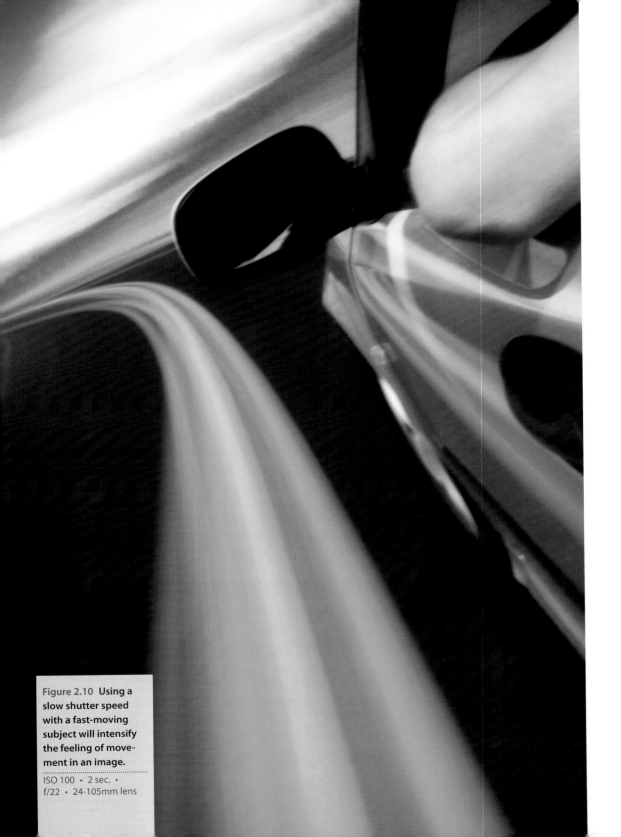

Figure 2.10 Using a slow shutter speed with a fast-moving subject will intensify the feeling of movement in an image.

ISO 100 · 2 sec. ·
f/22 · 24-105mm lens

The aperture controls the amount of light that comes through the lens, but it also determines what areas of the image will be in focus. This is referred to as *depth of field* and is an extremely valuable creative tool. The smaller the opening (the larger the number, such as f/16), the greater the sharpness of objects from near to far (**Figure 2.11**).

A large opening (or small number, like f/2.8) means more blurring of objects that are not at the same distance as the subject you are focusing on (**Figure 2.12**).

As we explore the features of the camera further, we will learn not only how to utilize the elements of exposure to capture properly exposed photographs, but also how to make adjustments to enhance the outcome of your images. It's the manipulation of these elements—motion and focus—that will take your images to the next level.

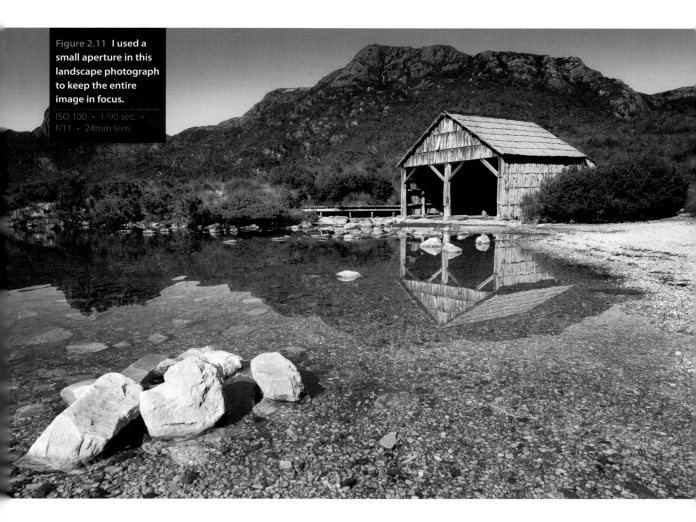

Figure 2.11 **I used a small aperture in this landscape photograph to keep the entire image in focus.**
ISO 100 · 1/90 sec. · f/11 · 24mm lens

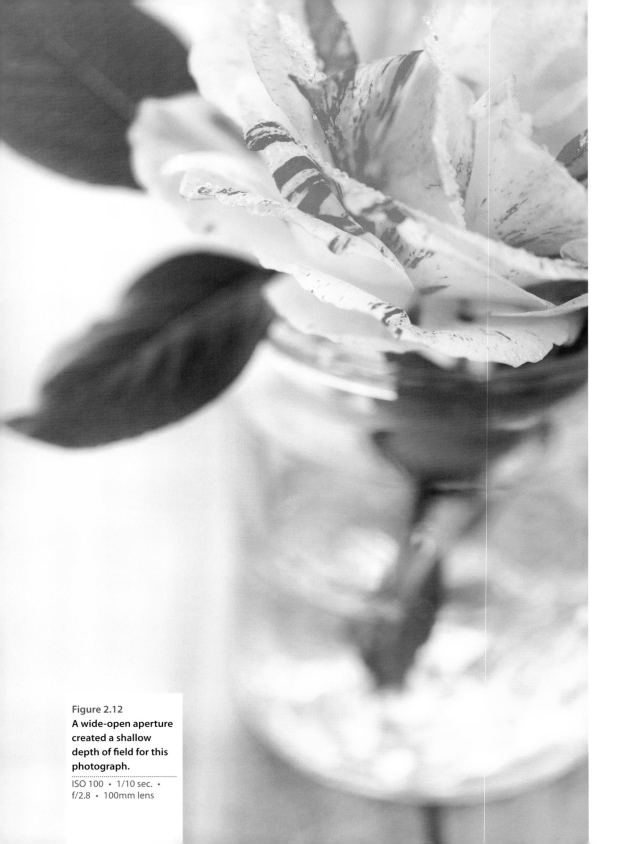

Figure 2.12
A wide-open aperture created a shallow depth of field for this photograph.

ISO 100 · 1/10 sec. ·
f/2.8 · 100mm lens

Chapter 2 Assignments

Format your card

Even if you have already begun using your camera, make sure you are familiar with formatting the SD card. If you haven't done so already, follow the directions given earlier in the chapter and format as prescribed (first make sure to save any images that you may have taken already). Then perform the format function each time after you have downloaded or saved your images or use a new card.

Explore your image formats

Take a look at all of the image formats in your menu settings and become familiar with what your options are. If you are not yet familiar with the RAW file format, take a few photos and try opening them up in the Canon software supplied with your camera.

Explore your lens

If you are using a zoom lens, spend a little time shooting with all of the different focal lengths, from the widest to the longest. See just how much of an angle you can cover with your widest lens setting. How much magnification will you be able to get from the telephoto setting? Try shooting the same subject with a variety of different focal lengths to note the differences in how the subject looks, and also the relationship between the subject and the other elements in the photo.

Practice with different apertures

Set your camera to Av (Aperture Priority) on the Mode Dial, find something outside to photograph up close (such as a portrait or flower), and then set your camera to a small aperture (such as f/16). Then change the aperture to its lowest setting (such as f/2.8 or f/4) and photograph the same subject. Review the images on your camera and notice the difference in depth of field—the second image should have a much blurrier background than the first. Also, take notice of the shutter speed and watch how it changed between the two images, even though the exposure of each photograph is balanced in the same way.

Share your results with the book's Flickr group!
Join the group here: flickr.com/groups/canon70dfromsnapshotstogreatshots

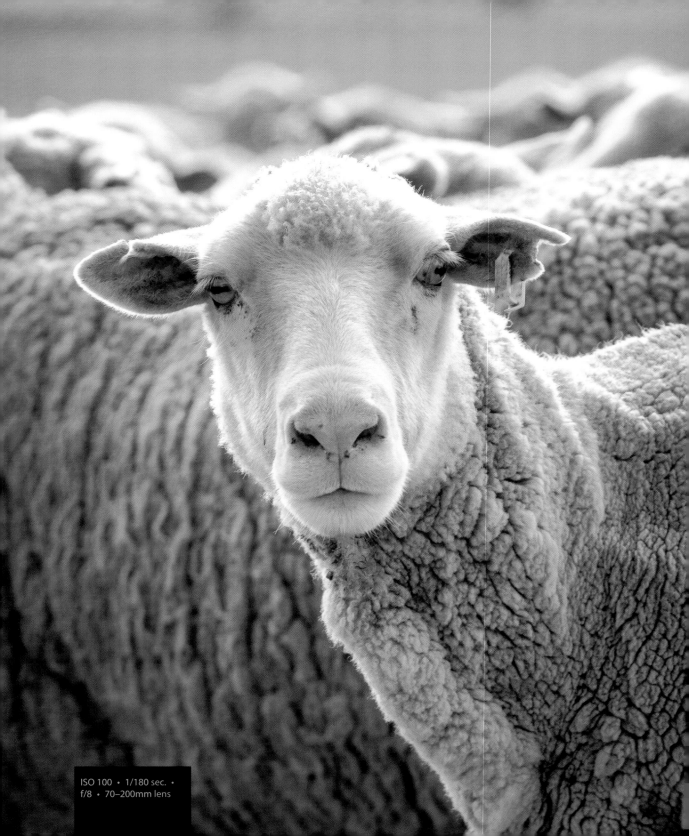

ISO 100 • 1/180 sec. •
f/8 • 70–200mm lens

3
Camera Shooting Modes

Using the camera's mode settings

The Canon 70D has several different shooting modes located on the Mode Dial on the top of your camera. Each setting is unique, and each allows you to have as much or as little control as you would like when taking pictures. It might be tempting to turn to the mode that you're most familiar with and start shooting without ever learning about the other settings, but what fun would that be? If you've never used an SLR camera before, some of these settings may be new to you and maybe even a bit confusing. My goal is to introduce these settings so you can decide which ones best suit your photography style.

We're going to start with the modes that give you the least amount of control, and work our way through the settings to the more advanced modes. By the end of this chapter, you should have enough information to start taking your photography to the next level by harnessing control over your camera's features and developing a better grasp of the fundamental principles of photography.

Poring Over the Picture

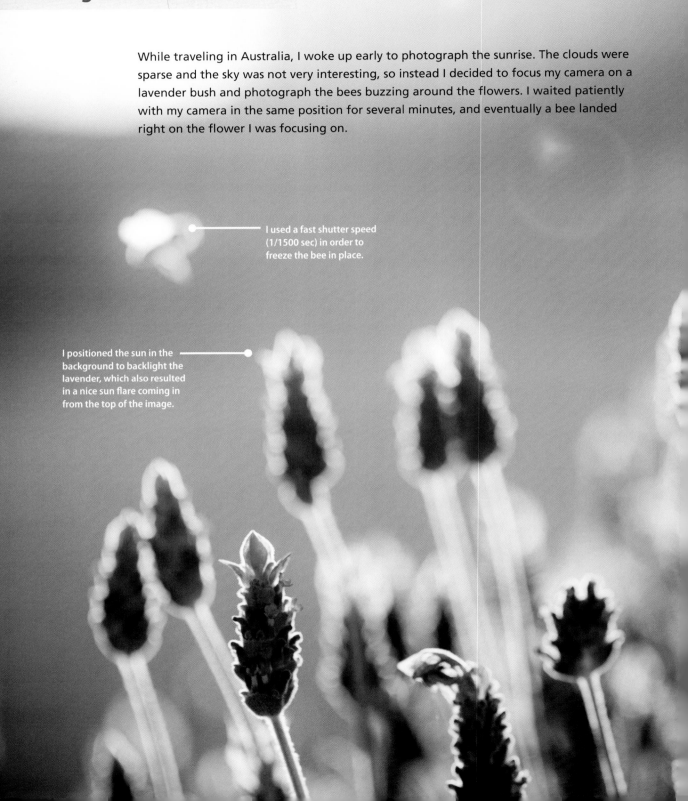

While traveling in Australia, I woke up early to photograph the sunrise. The clouds were sparse and the sky was not very interesting, so instead I decided to focus my camera on a lavender bush and photograph the bees buzzing around the flowers. I waited patiently with my camera in the same position for several minutes, and eventually a bee landed right on the flower I was focusing on.

I used a fast shutter speed (1/1500 sec) in order to freeze the bee in place.

I positioned the sun in the background to backlight the lavender, which also resulted in a nice sun flare coming in from the top of the image.

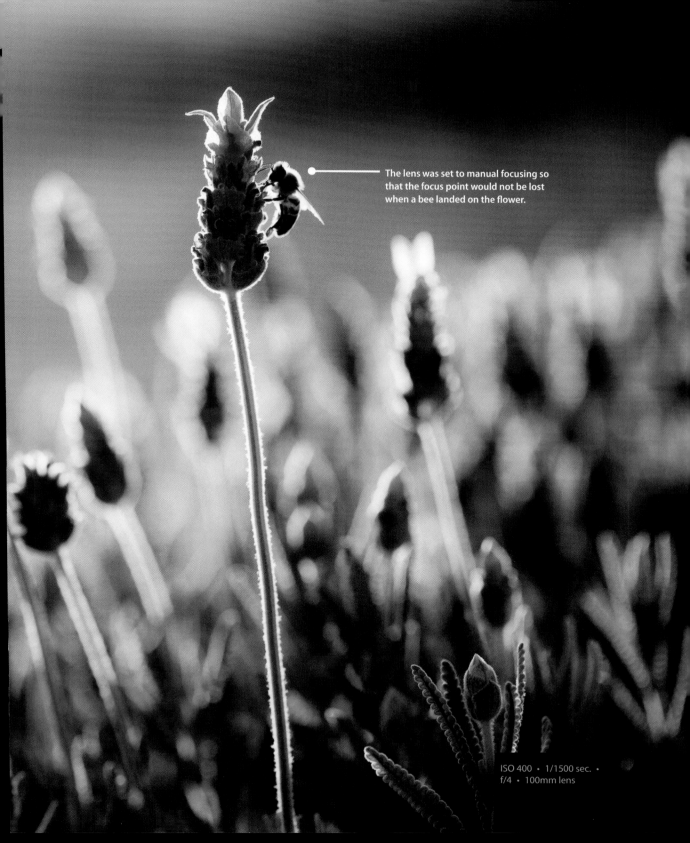

The lens was set to manual focusing so
that the focus point would not be lost
when a bee landed on the flower.

ISO 400 · 1/1500 sec. ·
f/4 · 100mm lens

Poring Over the Picture

I used a small aperture (f/11) to maintain detail in the background.

Photographing long exposures of water is one of my favorite things to do, and when I spotted this mossy rock at sunset, I knew it would be a beautiful scene to shoot. I set up my camera with a long lens, and also used a neutral density filter (a dark piece of glass that blocks light) in order to achieve a very long exposure. The resulting image was filled with soft, cotton candy-like water flowing over the shiny and moss-covered rocks.

ISO 100 • 76 sec. • f/11 • 70–200mm lens

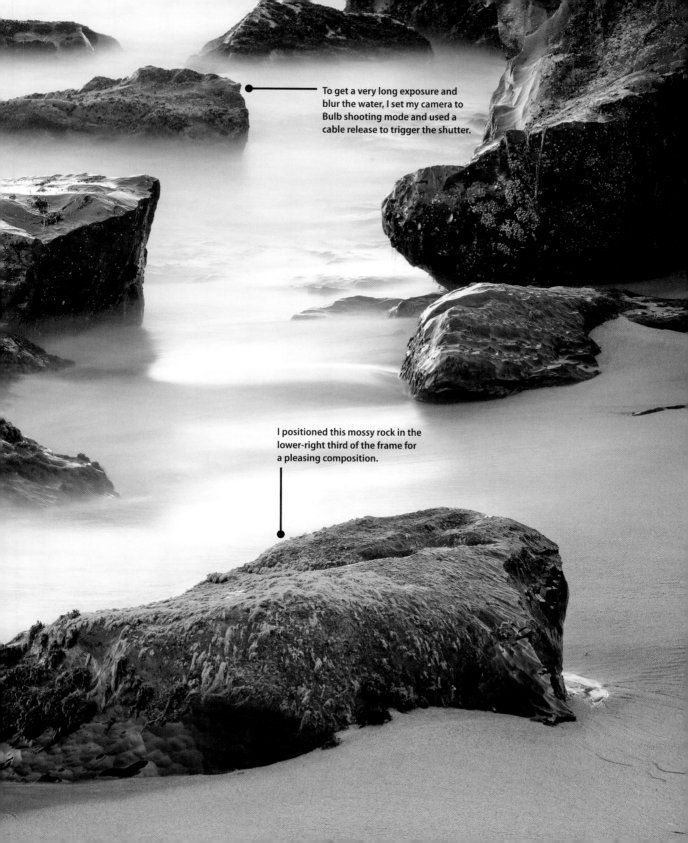

To get a very long exposure and blur the water, I set my camera to Bulb shooting mode and used a cable release to trigger the shutter.

I positioned this mossy rock in the lower-right third of the frame for a pleasing composition.

The Basic Zone

The 70D has two basic "zones" to set your shooting mode to—Basic and Creative. The Basic Zone is a group of settings that give the *camera* full control of most settings, whereas the Creative Zone has the more advanced shooting modes that will give *you* more control over the camera and your images. In this section, I will list all of the Basic Zone shooting modes, explain what the camera controls versus what you can control, and show you when it's best to use the various modes.

Setting up and shooting in the Basic Zone

1. While pressing down the Mode Dial lock-release button, turn the Mode Dial to align one of the four shooting modes with the indicator line.

2. Make sure your preferred image-quality setting is selected (RAW or JPEG—see Chapter 2, "First Things First," for more information on quality settings).

3. To make changes to the settings, press the Q button on the back of the camera and use the Multi-Controller to scroll through the options.

4. Point the camera at your subject and press the shutter to take a photo. The camera will determine its settings based on the shooting mode you have selected.

Fully Automatic Mode

Full Auto mode, indicated on the Mode Dial by a green square, is exactly what it sounds like—fully automatic shooting. This means that the camera decides practically all of your in-camera settings and essentially turns your camera into a "point and shoot." It chooses the ISO, shutter speed, aperture, white balance, and whether or not you will use the built-in flash. You have control over only the quality settings (RAW or JPEG) and drive mode. Because this mode allows you very little control over your camera settings, it's best to use it sparingly.

Disabling Flash Mode

There may be times when you want to shoot in Fully Automatic mode but are unable to use your flash, such as when you are indoors at an event that prohibits flash photography or at a museum. This mode is identical to Fully Automatic mode except that it completely disables the use of the 70D's built-in flash.

CA: Creative Auto Mode

 One good alternative for new photographers is to start out in Creative Auto (CA) mode. It's very similar to Full Auto, so it's something you might want to use in moderation, but you do have a bit more control over some of the settings. You have the ability to change the drive mode, flash, ambience setting (which controls the colors in the image), and the blurriness of the background in each image, along with your quality setting (RAW or JPEG). The camera will decide the rest for you. It's a good option if you know what you want your image to look like but are still not familiar with how aperture and shutter speed function to expose your image properly.

Figure 3.1
The display on the LCD enables you to adjust some of the settings while in CA mode. This is an example of changing the setting so that your background is blurry.

One feature of CA mode that is unique to the other Basic Zone shooting modes is the ability to control the blurriness of the background (**Figure 3.1**). This setting tells the camera where to set the aperture so you get the effect you want to see. (Note that the background-blur function will be disabled when the built-in flash is popped up. To re-enable this function and adjust its setting, just push the flash back into the camera, change your settings, and then continue shooting.)

Ambience setting

The Ambience setting is a feature you are able to select in all of the Basic Zone shooting modes except for Fully Automatic and Disable Flash. These settings affect the color intensity of your image and are permanently embedded into your image when shooting in JPEG quality (using the RAW format will allow you to change and manipulate your image in post-processing without loss of quality).

Menu items in the Basic Zone

One important detail to know when using Full Auto and Creative Auto modes is that your menu tabs are limited. Only 10 out of the 15 tabs that are normally visible when shooting in all other mode settings will be displayed (**Figure 3.2**). Since the camera decides the majority of the exposure and color settings when in the fully automatic modes, the information in some menu tabs is not necessary.

More information on all features and settings of the Basic Zone can be found in pages 65–86 in your user's manual.

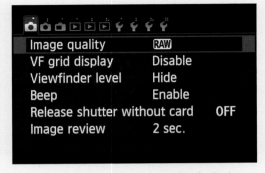

Figure 3.2 The menu tabs are limited in the Basic Zone shooting modes.

Special Scene Mode

The Canon 70D also comes with an option where you can select the type of scene you are working in, and it will automatically adjust the settings to work with that environment. These settings are good to use if you are not quite sure what settings to use in special situations, such as night portraits or landscapes, for example. Don't get too comfortable using them, though! While they can be convenient for a new user, they are still very limiting in many ways. My recommendation is to try them out, and then see if you can replicate the results with a more advanced shooting mode (which you'll learn about later in this chapter). After all, digital cameras are just tools and can never fully replace the eye and vision of a creative human being.

Setting up and shooting in Special Scene mode

1. While pressing down the Mode Dial lock-release button, turn the Mode Dial to align with the SCN option on the Mode Dial.

2. Press the Q button on the back of the camera.

3. Use the Main Dial or the Quick Control Dial to scroll between the seven different scene options (Portrait, Landscape, Close-up, Sports, Night Portrait, Handheld Night Scene, or HDR Backlight control.)

Portrait Mode

Portrait mode blurs the background by opening the aperture wide, and also gives skin tone a warmer and softer look than Full Auto mode. If there's not enough light on your subject, then the built-in flash will pop up automatically. You have control over the image quality (RAW or JPEG), ambience setting, drive mode (low-speed continuous or self-timer), and white balance (a.k.a. lighting/scene type). This mode is best used when photographing people.

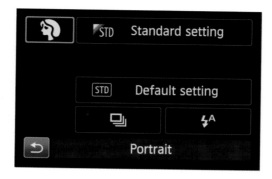

For more detailed information on photographing portraits, please turn to Chapter 4, "Say Cheese!"

Landscape Mode

Landscape mode is for photographing wide scenes, nighttime scenes, or anytime you want the majority of your image in focus. This mode will default to using a smaller aperture for greater depth of field, and it also enhances the color saturation of the greens and blues in your images. You have control over the image quality (RAW or JPEG), ambience setting, drive mode (single shooting or self-timer), and white balance (a.k.a. lighting/scene type). When using this mode, the built-in flash is disabled.

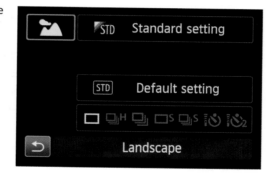

For more detailed information on photographing landscapes, please turn to Chapter 5, "Landscape & Nature Photography."

Close-up Mode

Use Close-up mode when getting in close to your subject—for example, when photographing flowers or small objects, or when using a macro lens. The settings will default to using a wide aperture for shallow depth of field to make the background look blurry, and the built-in flash will also pop up automatically if the scene is too dark. You can control the image quality (RAW or JPEG), ambience setting, drive mode (single shooting or self-timer), and white balance (a.k.a. lighting/scene type).

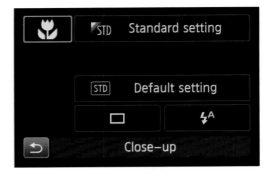

Sports

Moving Subjects mode is for when you want to photograph a moving subject, such as a child playing sports, an active pet, or a moving vehicle. The settings will default to using a fast shutter speed to "freeze" the action and will continually try to find focus if you keep the shutter button half-pressed (or when pressing the AF-ON button). You have control over the image quality (RAW or JPEG), ambience setting, drive mode (high-speed continuous shooting or self-timer), and white balance (a.k.a. lighting/scene type).

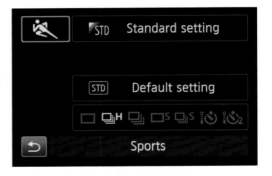

Night Portrait Mode

Night Portrait mode is for photographing people at night or in a darkened room. This differs from Portrait mode because it keeps the shutter open longer to allow the darker background to show up in the image and appear more natural. You will be using the built-in flash the majority of the time, since typically this mode will be used in low-light environments. You have

control over the image quality (RAW or JPEG), ambience setting, and drive mode (single shooting or self-timer).

Also, because the shutter will be open for a longer period of time, it's recommended that you use a tripod with this setting. This is to reduce the possibility of camera shake with the image (however, you may get interesting results if you try it handheld, so don't be afraid to go against the grain!).

Handheld Night Scene Mode

Typically, you will want to use a tripod for most nighttime scenes. However, that is not always going to be possible, so in those cases you may want to try using Handheld Night Scene mode on your Canon 70D. When using this mode, the camera quickly creates four photographs continuously of the same scene and then merges them together in-camera, resulting in a photograph with balanced light. RAW users be wary, however—this mode forces you to photograph in JPEG mode only! If you want to shoot in RAW, then you may want to use one of the other camera modes.

HDR Backlight Control

When photographing a scene that has a very high dynamic range—in other words, a location where there are a lot of both very dark and very bright areas—then you may want to try using HDR Backlight Control mode. This mode will quickly photograph three frames and then merge them together to create one photograph with balanced light. And, just like with the previous mode, this setting will force you to shoot in JPEG, so if you want to keep your image quality at RAW, then you may want to skip using this mode setting.

My advice on using the Basic Zone

The Basic Zone gives the camera a lot of control over the settings while you, the photographer, are creating images. New photographers who are still learning the ins and outs of the technical side of photography and their camera may find these settings useful, but using these modes basically reverts your camera to a glorified point-and-shoot camera set to automatic. Chances are that if you're reading this book, you want to take your photography a step further, and if you're only using the modes in the Basic Zone, you may find that over time you're not achieving the image results you want.

Now, there's absolutely nothing wrong with using the modes in the Basic Zone, and I'm not going to tell you that you shouldn't use them. However, if you haven't yet strayed from the Basic Zone, I would like to challenge and encourage you to try using the shooting modes in the Creative Zone (discussed in the next section of this chapter). Taking more control over your camera will help you gain a deeper understanding of how depth of field, light, and the exposure triangle work together to create those amazing images you've probably already visualized in your mind.

The Creative Zone

 The Creative Zone is a group of shooting modes that gives the user (that's you!) much more control over the camera settings. It's good to have a basic understanding of how aperture, shutter speed, and ISO work together to create a balanced exposure when using any of these modes (see Chapter 2 for more information). The remaining chapters in this book will focus on using the Creative Zone modes, so I highly recommend familiarizing yourself with these shooting modes and settings so that you can take full control of the overall quality of your images.

P: Program AE Mode

 Next up on the dial is Program Auto Exposure mode (P). This mode is somewhat similar to Full and Creative Auto modes in that it gives the camera control over some of the settings, but it leaves the rest of the decisions to the photographer.

So how do the Auto modes and Program AE mode differ? It's actually quite simple. In Program AE mode, the only settings that the camera determines are shutter speed and aperture. You choose the ISO, white balance, focus point, and so on, so you will still have a lot of control over the quality of your images. The camera is just making some of the last, yet still very important, decisions for you.

Here's when to use Program mode instead of the automatic modes:

- When shooting in a casual environment where quick adjustments are needed
- When you want control over the ISO
- If you want to make corrections to the white balance

Now, just because the camera chooses a starting point with an aperture and shutter speed doesn't mean that you are stuck with its first choice. The Canon 70D allows you to adjust the aperture and shutter speed on the fly while maintaining the same amount of light that is coming through the lens. Do you remember the Reciprocal Exposures charts in Chapter 2? That's the same principle applied here—if the camera wants the settings to be 1/250 of a second (shutter speed) at f/5.6 (aperture), you can turn the Main Dial to a reciprocal exposure of 1/60 of a second at f/11. You will get the same exposure in your image, but your depth of field will vary because of the different aperture settings.

The key to adjusting your exposure in Program AE mode is understanding what you want the overall image to look like. If you are photographing a fast-moving subject and need to freeze the action, then you will turn the Main Dial to the right to be sure that your shutter speed is fast enough to capture the movement. This also increases the size of the aperture, which can result in a blurred background, or shallow depth of field. Turning the Main Dial to the left will do just the opposite—it will slow your shutter speed, possibly increasing the likelihood of motion in the image, and it will shrink the size of the aperture, which will result in a more focused image, or greater depth of field.

Let's set up the camera for Program and Program AE modes, and see how we can make all of this come together.

Setting up and shooting in Program mode

1. Turn the Mode Dial to align the P with the indicator line.
2. Make sure that your ISO, white balance, and focus point are set appropriately (this is where you get to make the decisions!).
3. Point the camera at your subject, and then activate the camera meter by pressing the shutter button halfway.
4. View the exposure information while looking through the viewfinder (underneath the focusing screen) or at the LCD panel on the top of the camera.
5. To alter the shutter speed and aperture settings, use your index finger to roll the Main Dial left and right to see the changed exposure values.
6. Select the exposure that is right for you and start shooting. (Don't worry if you aren't sure what the right exposure is. We will start working on making the right choices for those great shots beginning with the next chapter.)

Tv: Shutter Priority Mode

 Shutter Priority mode, referred to on your Mode Dial as Tv (which stands for "Time Value"), is where you select the shutter speed and the camera adjusts the aperture accordingly. Use this mode to push yourself toward the more advanced modes with your camera. This will allow you an enormous amount of control with your final image.

Before we go any further, let me briefly explain the mechanics of the camera shutter. The shutter is like a curtain that opens and closes to allow light to hit the sensor. The speed is calculated in seconds and fractions of a second (which likely is what you will use most often), and the longer the shutter stays open, the more light will reach the sensor. Using a very fast shutter speed is ideal for capturing fast-moving subjects (think of a football player jumping in the air to receive a pass), while a slow shutter speed can show movement in an image (like creating a soft effect on the water in a flowing stream or waterfall). These settings are offset by a larger aperture for fast shutter speeds and a smaller aperture for slow shutter speeds.

It's important to understand that if the shutter speed gets too low, you won't be able to handhold the camera to take the photo. Doing so might introduce "camera shake" in your image, which often makes an image appear out of focus. A good rule of thumb is to keep your shutter speed the same as your lens's focal length. For example, if you are using a 200mm lens, try to keep the slowest handheld shutter speed no slower than 1/200 of a second. Because the 70D has a 1.6 crop factor, the number might be slightly off, but sticking to that basic principle will help you keep your images sharp and free of camera shake.

Here's when to use Shutter Priority (Tv) mode:

- When working with fast-moving subjects where you want to freeze the action (**Figure 3.3**) (There is much more on this in Chapter 6, "Moving Target.")

- When you want to emphasize movement in your subject with motion blur (**Figure 3.4**)

- When you want to create that silky-looking water in a waterfall or stream (**Figure 3.5**)

Figure 3.3 I used a fast shutter speed to freeze the chunk of dirt in midair.

ISO 400 · 1/3200 sec. · f/5.6 · 70–200mm lens

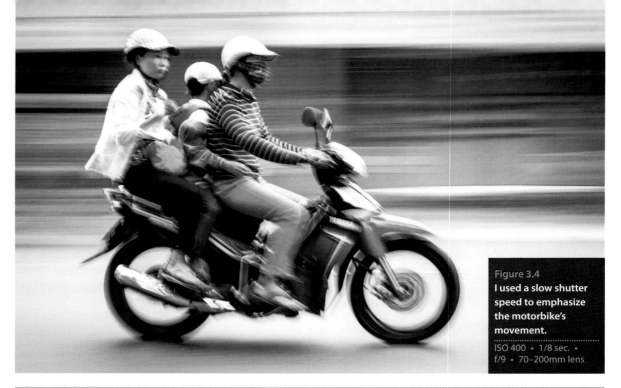

Figure 3.4
I used a slow shutter speed to emphasize the motorbike's movement.

ISO 400 · 1/8 sec. · f/9 · 70–200mm lens

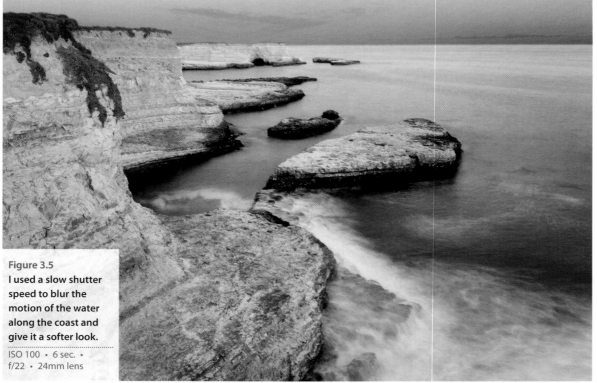

Figure 3.5
I used a slow shutter speed to blur the motion of the water along the coast and give it a softer look.

ISO 100 · 6 sec. · f/22 · 24mm lens

As you can see, the subject of your photo usually determines whether or not you will use Tv mode. It's important that you be able to visualize the result of using a particular shutter speed. The great thing about shooting with digital cameras is that you get instant feedback by checking your shot on the LCD screen. But what if you have only one chance to catch the

Shutter speeds

A slow shutter speed refers to leaving the shutter open for a long period of time, like 1/30 of a second or longer. A fast shutter speed means that the shutter is open for a very short period of time, like 1/250 of a second or less.

shot? Such is often the case when shooting sporting events. It's not like you can go ask the quarterback to throw that winning touchdown pass again because your last shot was blurry from a slow shutter speed. This is why it's important to know what those speeds represent in terms of their capabilities to stop the action and deliver a blur-free shot.

First, let's examine just how much control you have over the shutter speeds. The 70D has a shutter speed range from 1/8000 of a second all the way up to 30 seconds. With that much latitude, you should have enough control to capture almost any subject. The other thing to think about is that Tv mode is considered a "semiautomatic" mode. This means that you are taking control over one aspect of the total exposure while the camera handles the other. In this instance, you are controlling the shutter speed, and the camera is controlling the aperture. This is important, because there will be times when you want to use a particular shutter speed, but your lens won't be able to accommodate your request.

For example, you might encounter this problem when shooting in low-light situations. If you are shooting a fast-moving subject that will blur at a shutter speed slower than 1/125 of a second but your lens's largest aperture is f/3.5, you might find that the aperture display in your viewfinder and on the top LCD panel will begin to blink. This is your warning that there won't be enough light available for the shot—due to the limitations of the lens—so your picture will be underexposed.

Another case where you might run into this situation is when you are shooting moving water. To get that look of silky, flowing water, it's usually necessary to use a shutter speed of *at least* 1/15 of a second. If your waterfall is in full sunlight, you may get that blinking aperture display once again, because the lens you are using only stops down to f/22 at its smallest opening. In this instance, your camera is warning you that you will be overexposing your image. There are workarounds for these problems, which we will discuss later (see Chapter 5), but it's important to know that there can be limitations when using Tv mode.

Setting up and shooting in Tv mode

1. Turn the Mode Dial to align the Tv with the indicator line.

2. Select your ISO by pressing the ISO button on the top of the camera and then turning the Main Dial (the ISO selection will appear in the top LCD panel).

3. Point the camera at your subject and then activate the camera meter by pressing the shutter button halfway.

4. View the exposure information in the bottom area of the viewfinder or by looking at the top LCD panel.

5. While the meter is activated, use your index finger to roll the Main Dial left and right to see the changed exposure values. Roll the dial to the right for faster shutter speeds and to the left for slower speeds.

Image Stabilization lenses

Some Canon lenses come with a feature called Image Stabilization (IS) (**Figure 3.6**). It's a mechanism that's built directly into the lens and helps reduce motion blur due to camera shake when photographing at slower shutter speeds.

If you have this option on your lens, it's a good idea to leave it *turned on* when doing any handheld photography. Because the IS mechanism in the lens moves when turned on, you'll want to *turn it off* when using a tripod. It could introduce camera shake in

Figure 3.6 **The Image Stabilization switch on Canon IS lenses allows you to turn this feature on and off.**

your images if the camera is perfectly still on a tripod, so it is typically recommended only for handheld photography.

Av: Aperture Priority Mode

Aperture Priority mode, or Av ("Aperture Value"), is where you choose the aperture, and the camera selects the shutter speed—basically the reverse of Tv mode. This is a very popular setting for many photographers, since it offers the most creative control over depth of field (how much of your image appears in focus). This is my favorite setting when I'm not shooting in Manual mode, and I have a feeling that you will find it just as useful.

In Chapter 2, I discussed the basics of how the aperture works, so you should know that a wide, or large, aperture (smaller number) equates to more light coming through the lens, and vice versa. Av mode allows the camera to select the shutter speed. When you use a large aperture you will end up with a faster shutter speed, and since a smaller aperture allows in less light through the lens, the camera will give a slower shutter speed to compensate. Once you have a solid understanding of how aperture and shutter speed work together, you will have taken a giant leap toward gaining complete control over your photography.

The greatest benefit of using Av mode is that the photographer can control the depth of field in the image. Photographing something with a large aperture will decrease the depth of field and blur the background, while a small aperture will increase the depth of field so that more of the image is in focus (**Figures 3.7 and 3.8**).

Figure 3.7

This image of a flower was photographed with a large aperture of f/1.8, allowing me to blur the background significantly. This is an example of shallow depth of field.

ISO 100 • 1/2000 sec. • f/1.8 • 50mm lens

Figure 3.8

For this image, I reduced the size of the aperture to f/14. The focus is set on the flower, but you are still able to see a lot of detail in the background. This is an example of great depth of field.

ISO 100 • 1/30 sec. • f/14 • 50mm lens

Here's when to use Aperture Priority (Av) mode:

- When shooting portraits or wildlife (**Figure 3.9**)
- When shooting most landscape photography (**Figure 3.10**)
- When shooting macro, or close-up, photography (**Figure 3.11**)

It's important to note that because the aperture is physically located inside the lens (not the camera), your lens will determine how large an opening you can use. Lenses with a large maximum aperture are considered "fast" lenses and tend to be much more expensive. Canon's fastest glass goes to an f-stop of 1.2, which allows you to shoot at faster shutter speeds in lower-light situations. The largest aperture available for the majority of lenses on the market ranges from f/2.8 to f/4, which still allows a lot of light through to the sensor. The lens I use with my 70D for most of my work will go to only f/4, but I tend to work in brighter, more controlled lighting situations. Photographers who shoot weddings or events with uncontrollable lighting generally find that they need faster lenses with an opening of f/2.8 or larger.

Figure 3.9
A large aperture gave this image a blurry background.

ISO 100 ·
1/1500 sec. · f/4.5 ·
70–200mm lens

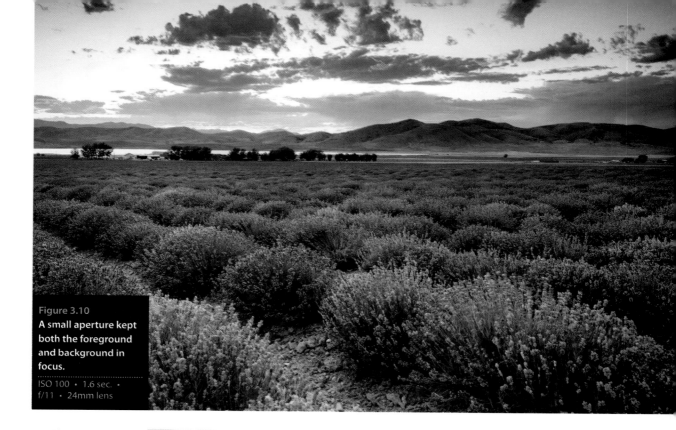

Figure 3.10
A small aperture kept both the foreground and background in focus.

ISO 100 · 1.6 sec. · f/11 · 24mm lens

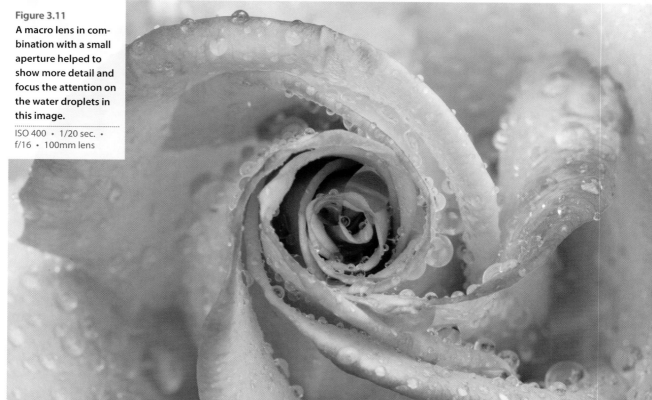

Figure 3.11
A macro lens in combination with a small aperture helped to show more detail and focus the attention on the water droplets in this image.

ISO 400 · 1/20 sec. · f/16 · 100mm lens

Setting up and shooting in Av mode

1. Turn the Mode Dial to align the Av with the indicator line.

2. Select your ISO by pressing the ISO button on the top of the camera and then turning the Main Dial (the ISO selection will appear in the top LCD panel).

3. Point the camera at your subject and then activate the camera meter by pressing the shutter button halfway.

4. View the exposure information in the bottom area of the viewfinder or by looking at the top display panel.

5. While the meter is activated, use your index finger to roll the Main Dial left and right to see the changed exposure values. Roll the dial to the right for a smaller aperture (higher f-stop number) and to the left for a larger aperture (smaller f-stop number).

F-stops and aperture

As discussed earlier, the numeric value of your lens aperture is described as an f-stop. The f-stop is one of those old photography terms that, technically, relates to the focal length of the lens (for example, 200mm) divided by the effective aperture diameter. These measurements are defined as "stops" and work incrementally with your shutter speed to determine proper exposure. Older camera lenses used one-stop increments to assist in exposure adjustments, such as 1.4, 2, 2.8, 4, 5.6, 8, 11, 16, and 22. Each stop represents about half as much light entering the lens iris as the larger stop before it. Today, most lenses don't have f-stop markings, since all adjustments to this setting are performed via the camera's electronics. The stops are also now typically divided into 1/3-stop increments to allow much finer adjustments to exposures, as well as to match the incremental values of your camera's ISO settings, which are also adjusted in 1/3-stop increments.

Zoom lenses and maximum apertures

Some zoom lenses (like the 18–55mm kit lens) have a variable maximum aperture. This means that the largest opening will change depending on the zoom setting. In the example of the 18–55mm zoom, the lens has a maximum aperture of f/3.5 at 18mm and only f/5.6 when the lens is zoomed out to 55mm.

Exposure compensation

One of my favorite features of Canon cameras is that they allow you to change the exposure compensation very quickly using the Quick Control Dial on the back of the camera. Exposure compensation is a way to trick the camera into thinking that there is more or less light coming through the lens than its light meter actually reads. This meter wants to balance the exposure so that it is equal to a neutral gray shade. For example, if you were to photograph in an all-white environment, such as in the snow, your camera would want to make all of the white areas look gray, and your image would end up dark and under-exposed. You can compensate for this by telling the camera to overexpose the image so that your white snow will look white in your photograph (**Figure 3.12**).

Figure 3.12 **The white color of the snow fooled my camera meter to underexpose the image, so I overexposed the image by one-third of a stop to add more light and keep the white areas white.**

ISO 100 • 1/80 sec. • f/2.8 • 18–50mm lens

To set exposure compensation:

1. Press the Q button on the back of your camera to bring up the Quick Control screen, and then use the Multi-Controller to select the Exposure Compensation setting (**A**).

2. Using the Quick Control Dial, scroll to the left (to underexpose your scene) or to the right (to overexpose your scene) (**B**). Note that you can also make these same changes while looking through the viewfinder.

This setting will stay in place until you change it back. If you want to lock it in to prevent unintentional changes, then be sure to enable the Quick Control Dial lock on the back of the camera.

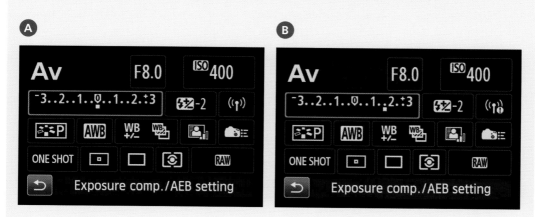

M: Manual Mode

 Before cameras had shooting modes such as Aperture Priority, Program, and so on, all exposures were set manually. This means that the photographer chose all of the settings, and since both the ISO and white balance were already decided depending on the kind of film loaded into the camera, the photographer was responsible for selecting only the proper aperture and shutter speed. As technology advanced and automatic features were added to cameras, many photographers discovered new ways of capturing their images. However, the

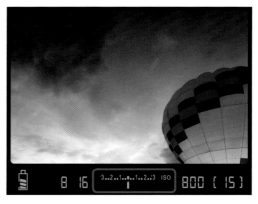

Figure 3.13 The light meter located in the camera ranges from –3 stops (underexposed) to +3 stops (overexposed).

"old-fashioned" method of taking pictures was never set aside or forgotten. You will find that using Manual (M) mode on the 70D will give you total control over your images.

When shooting in Manual mode, you choose both the aperture and shutter speed, and the camera will do nothing other than give you its feedback through the internal light meter. You can view how the meter is reading a scene by looking in one of three places: the LCD on the top of the camera, underneath the focusing frame while looking through the viewfinder (**Figure 3.13**), or on the back of the camera when in Live View. This meter is what the camera uses when shooting images in all other modes, and its goal is always to find the most balanced exposure. Sometimes the light meter reads the scene incorrectly or the photographer wants to have full control over the exposure, and in those scenarios using Manual mode is the best choice.

Here's when to use Manual (M) mode:

- When learning how each exposure element interacts with the others

- When your environment is fooling your light meter and you need to maintain a certain exposure setting, such as with a silhouette (**Figure 3.14**)

- When using an artificial light source, such as strobes or flashes, in a controlled environment (**Figures 3.15 and 3.16**)

I prefer to use Manual mode when using strobes or any other type of controlled light source in an unchanging environment. I also use it when I have my camera on a tripod while photographing things such as food or landscapes. The great thing about Manual mode is that it can be used in any circumstance and can yield some amazing results if you know what you're doing.

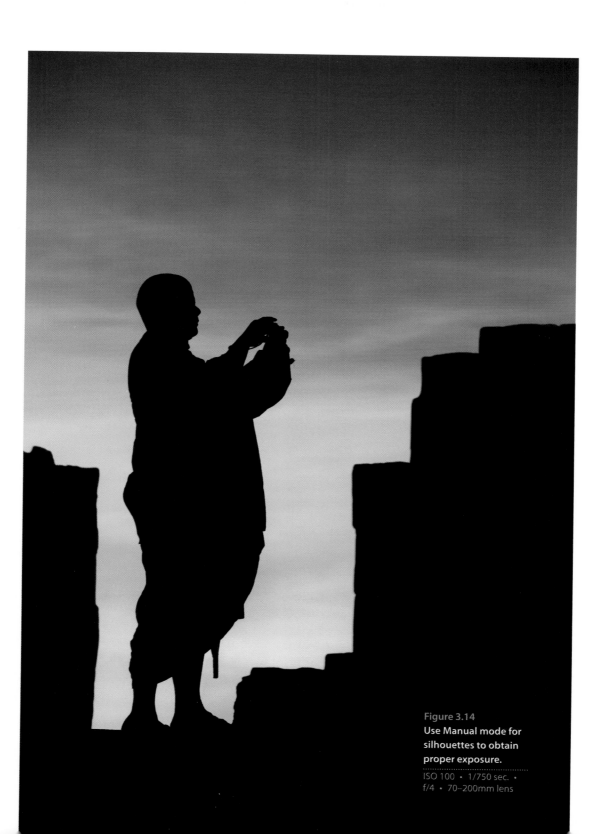

Figure 3.14
Use Manual mode for silhouettes to obtain proper exposure.

ISO 100 · 1/750 sec. · f/4 · 70–200mm lens

Figure 3.15
I needed to balance both ambient and strobe lights in this scene, so I used Manual mode to set my exposure.

ISO 100 · 1/60 sec. · f/4 · 70–200mm lens

Figure 3.16
It's necessary to use Manual mode for most studio portrait images when using strobe lights or flash units.

ISO 100 · 1/125 sec. · f/6.7 · 100mm lens

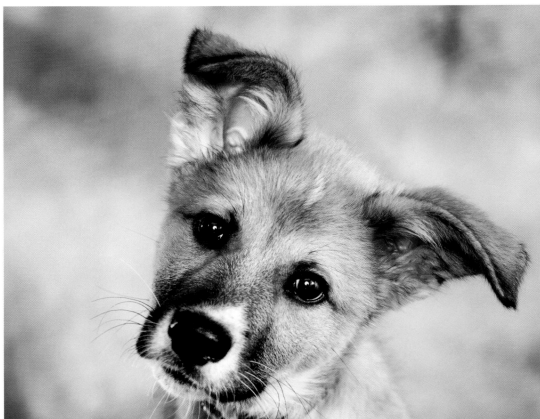

Setting up and shooting in Manual mode

1. Turn the Mode Dial to align the M with the indicator line.

2. Select your ISO by pressing the ISO button on the top of the camera and then turning the Main Dial (the ISO selection will appear in the top LCD panel).

3. Point the camera at your subject and then activate the camera meter by pressing the shutter button halfway.

4. View the exposure information in the bottom area of the viewfinder or by looking at the display panel on top of the camera.

5. While the meter is activated, use your index finger to roll the Main Dial left and right to change your shutter speed value until the exposure mark is lined up with the zero mark. The exposure information is displayed by a scale with marks that run from −3 to +3 stops. The camera will meter a "proper" exposure when it is lined up with the arrow mark in the middle. As the indicator moves to the left, it's a sign that you'll be underexposing (telling you that there is not enough light on the sensor to provide adequate exposure). Move the indicator to the right and you will be providing more exposure than the camera meter calls for (this is overexposure).

6. To set your exposure using the aperture, press the shutter button until the meter is activated. Then, using your thumb, scroll the Quick Control Dial to change the aperture: clockwise for a smaller aperture (large f-stop number) and counterclockwise for a larger aperture (small f-stop number). (If you have the Quick Control Dial lock enabled, you'll need to press the Unlock button before making any changes to the aperture.)

B: Bulb Mode

 Bulb (B) mode on your camera is another manual mode setting that gives you complete control over the shutter speed, but instead of choosing a specific setting, you are able to leave the shutter open for an indefinite period of time. The word *bulb* comes from the early days of photography when camera shutters were pneumatically activated, meaning a bulb was pressed and the air from it was released through a tube that caused the shutter to open and close. It's a mode that is typically used in dark environments to capture light that is sporadic or changing, such as fireworks or star trails. It can be extremely useful in creating images that need very long shutter speeds.

When using this mode, it's essential to use both a tripod and a cable release (an accessory that allows you to trigger the shutter remotely). A tripod will keep the camera steady while the shutter is open, and a cable release will open and close the shutter without you having to push the button on the top of the camera, reducing the likelihood of camera shake in your images.

Here's when to use Bulb (B) mode:

- When shooting fireworks displays (**Figure 3.17**)
- When you want to capture trails of lights, such as stars or cars moving down a street at night (**Figure 3.18**)
- When you want to photograph any image in a dark environment at a very small aperture (**Figure 3.19**)
- When photographing streams and waterfalls (**Figure 3.20**)

Using Bulb mode can bring a lot of creativity into your photography, and there are really no limits to what you can create. The wonderful thing about this mode is that you are able to capture images that are so different from what we see with our eyes.

Figure 3.17
A long shutter speed was necessary to capture the bursts of fireworks in the image.
ISO 100 · 3.6 sec. · f/9 · 18–50mm lens

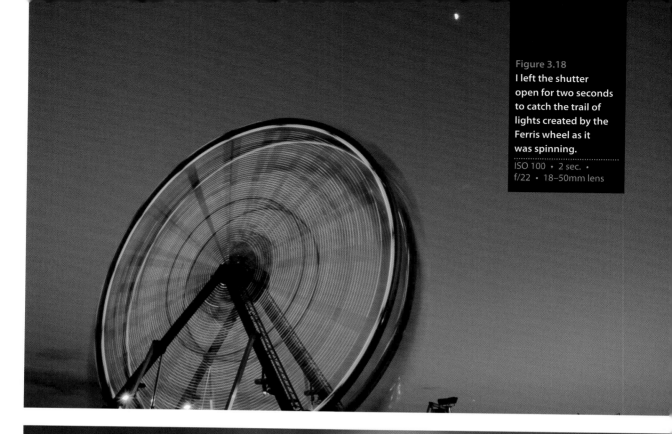

Figure 3.18
I left the shutter open for two seconds to catch the trail of lights created by the Ferris wheel as it was spinning.

ISO 100 • 2 sec. • f/22 • 18–50mm lens

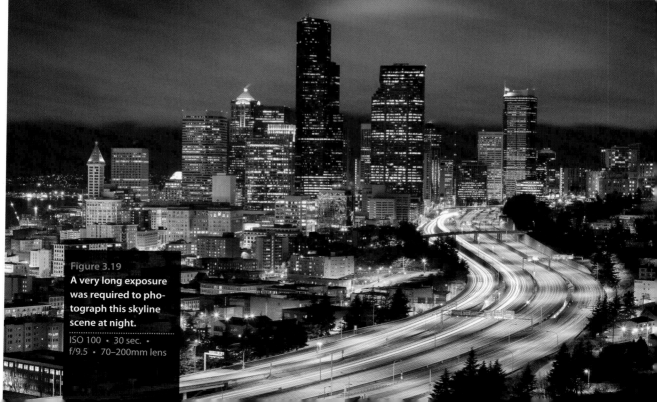

Figure 3.19
A very long exposure was required to photograph this skyline scene at night.

ISO 100 • 30 sec. • f/9.5 • 70–200mm lens

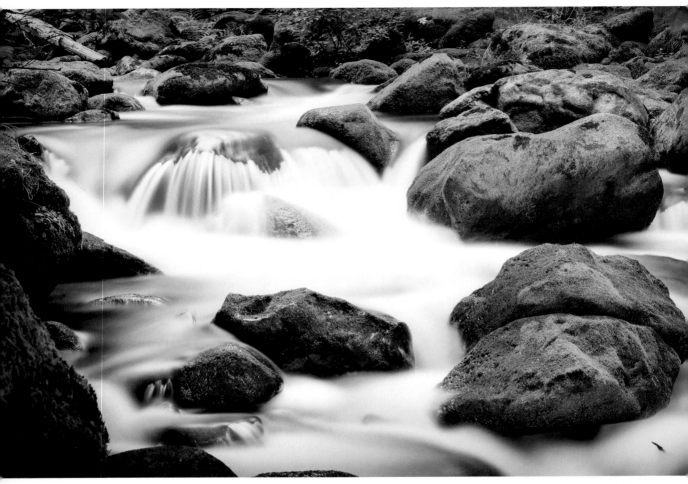

Figure 3.20 When photographing very long exposures of streams and waterfalls, oftentimes I will use Bulb mode and then use a separate timer to keep track of my exposures.

ISO 100 • 51 sec. • f/11 • 70–200mm lens

Digital noise and long exposures

One issue that arises when making extremely long exposures is that you are likely to introduce more digital noise into your images than with a normal exposure. This is one area in which film still has an advantage over digital (**Figure 3.21**). Digital noise due to long exposures is difficult to prevent, but there are some advanced ways to reduce its effect by using noise-reduction software while editing your images. You can also reduce the amount of noise in-camera by turning on the Long Exposure Noise Reduction setting in your 70D. Please turn to Chapter 7, "Mood Lighting," for more information.

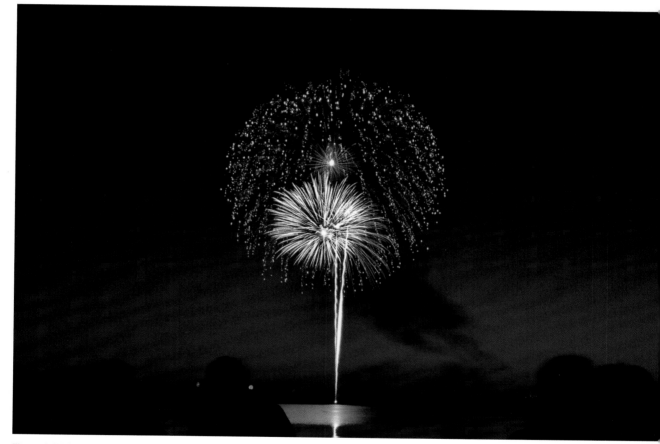

Figure 3.21 **Long exposures photographed with film, such as this image of fireworks at night, had a high dynamic range (more detail in the darker and brighter areas) and, unlike the digital cameras of today, did not introduce excess noise or grain in the images.**

Setting up and shooting in Bulb mode

1. Set your camera on a sturdy tripod and attach a cable release to the Remote Control terminal on the side of your camera.

2. Turn the Mode Dial to align the B with the indicator line.

3. Select your aperture by turning the Main Dial.

4. Select your ISO by pressing the ISO button on the top of the camera and then turning the Main Dial (the ISO selection will appear in the top LCD panel).

5. Position the camera toward your subject, focus the lens, and then press the button on the cable release. Hold down the button until you are satisfied with your exposure and then release the shutter.

6. If you want an extremely long exposure (several minutes or hours), lock the cable release by sliding the button up, which will allow you to lock the shutter in place indefinitely. The only limitation to your exposure is the amount of life left in your battery.

The Custom Setting Mode

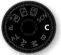 The 70D allows you to customize a shooting mode with the Custom User setting (C). This is useful if you frequently find yourself shooting in the same environment with the same settings. It allows you to completely customize a shooting setting any way you like and then record those settings as a preset.

One example of when you may want to use these settings is when shooting High Dynamic Range (HDR) images (more information on this technique is in Chapter 5). No matter where I am, what lens I'm using, or what time of day it is, I almost always use the same starting point. I set the ISO to 100, shoot in Av mode, set the drive mode to high-speed continuous shooting, and make sure that Auto Exposure Bracket mode is turned on. I can record all of these settings in one of the custom settings, and they will be ready anytime I want to photograph a series of images for HDR.

Another useful preset to create is one for using the Movie shooting mode. I like to have a good starting point for all of the movies I record, and I don't want to make a silly mistake like forgetting to turn on sound recording, shooting at too high a shutter speed, or using the wrong movie-recording size. Setting up a preset and using a customized camera user setting will guarantee that I won't make any of those mistakes. It also allows me to jump straight into movie shooting without having to think about my settings.

Setting up your own custom shooting modes

1. Make all of the adjustments to the camera that you want in your custom-shooting mode. For example, you might set the camera to Av mode, ISO 100, Daylight white balance, and RAW image quality (**A**).

2. Press the Menu button and use the Main Dial to get to the fourth setup tab.

3. Use the Quick Control Dial to highlight the Custom Shooting Mode (C Mode) option (**B**), and then press Set. Select Register Settings and press Set again (**C**).

4. Use the Quick Control Dial to select OK (**D**), and then press Set one last time.

5. Now, when you want to use these exact settings, just rotate the Mode Dial to the Custom Shooting (**C**) mode and those settings (Av mode, ISO 100, etc.) will be set for you automatically.

How I Shoot: A Closer Look at the Camera Settings I Use

I started my journey with photography before consumer digital cameras were affordable and available to the general public, so I had the advantage of learning how to photograph and develop film with a fully manual camera. When I finally upgraded to a camera with shooting modes, I had a solid understanding of how aperture and shutter speed worked together and knew how to create the look I wanted using certain settings. I also tend to want to control the depth of field in my images so that I have creative control over what parts are in focus and what areas are blurry. So, as you have probably guessed, the majority of my work is photographed using Aperture Priority (Av) mode. Since I also photograph a lot of landscape images and long exposures, I use Manual and Bulb modes as well.

Now, don't get me wrong—I play around with the other modes depending on what I'm shooting, but I find that I prefer to have as much control as possible so that I'm creating images that fit my style of photography. If you handed me a camera that had only Av, M, B, and no other modes, I would probably be able to photograph in any environment and capture the images that I wanted without any trouble.

What I love about Canon cameras is the ability to change the exposure compensation quickly when I'm using Av mode. This can make shooting in Av or Tv mode very similar to using Manual mode, because you regain control over your exposure. The internal light meter does an amazing job, but I find that when I'm in a tricky lighting situation, the Quick Control Dial can work wonders to help bring back the exposure to where it should be.

The last thing that I always have enabled on my camera is Highlight Alert (see Chapter 1, "The 70D Top Ten List," for more information). This tells me when my images are overexposed or whether I have lost detail in an area of a properly exposed image. The ability to adjust the exposure quickly using the Quick Control Dial makes it easy to capture as much detail in my images as possible.

As you work your way through the coming chapters, you will see other tips and tricks I use in my daily photography, but the most important tip I can give you is to understand the features of your camera so that you can leverage the technology in a knowledgeable way—and, ultimately, produce better photographs.

Chapter 3 Assignments

These will be more of a mental challenge than anything else, but you should put a lot of work into them, because the information covered in this chapter will define how you work with your camera from this point on. Granted, there may be times that you just want to grab some quick pictures and will resort to the automatic modes, but to get serious with your photography, you'll want to learn what the other modes have to offer.

Familiarize yourself with the Basic Zone

While you probably won't want to use these modes too often, it's still a good idea to understand how they work. If you're new to photography, go ahead and turn your camera to CA mode and play with the settings. See what happens when you take a photo after you increase the blurriness of the background, and then change your settings to make it sharper. Adjust the exposure to make it darker and brighter. After taking a few photos, review your images and pay attention to the shutter speed and aperture, and how each setting affected the outcome of your image.

Start off with Program mode

Set your camera to Program mode and start shooting. Become familiar with the adjustments you can make to your exposure by turning the Main Dial. Shoot in bright sun, deep shade, indoors, anywhere that you have different types and intensities of light. While you are shooting, make sure that you keep an eye on your ISO and raise or lower it according to your environment.

Learn to control time with Tv mode

Find some moving subjects, and then set your camera to Tv mode. Ask someone to ride a bike back and forth, or just photograph cars as they go by. Start with a slow shutter speed of around 1/30 of a second, and then start shooting with faster and faster shutter speeds. Keep shooting until you can freeze the action. Now find something that isn't moving (like a flower), set your shutter speed to something fast (like 1/500 of a second), and then work your way down. Don't brace the camera on a steady surface. Just try to shoot as slowly as possible, down to about 1/4 of a second. The point is to see how well you can handhold your camera before you start introducing camera shake into the image, making it appear soft and somewhat unfocused.

Control depth of field with Av mode

The key with Av mode is depth of field. Set up three items, like chess pieces or something similar, an equal distance from you. Focus on the middle item and set your camera to the largest aperture that your lens allows (remember, a large aperture means a small number like f/2.8). Now, while still focusing on the middle subject, start shooting with ever-smaller apertures until you are at the smallest f-stop for your lens. If you have a zoom lens, try doing this exercise with the lens at the widest and then the most telephoto settings. Now move up to subjects that are farther away, like telephone poles, and shoot them in the same way. The idea is to get a feel for how each aperture setting affects your depth of field.

Share your results with the book's Flickr group!
Join the group here: flickr.com/groups/canon70dfromsnapshotstogreatshots

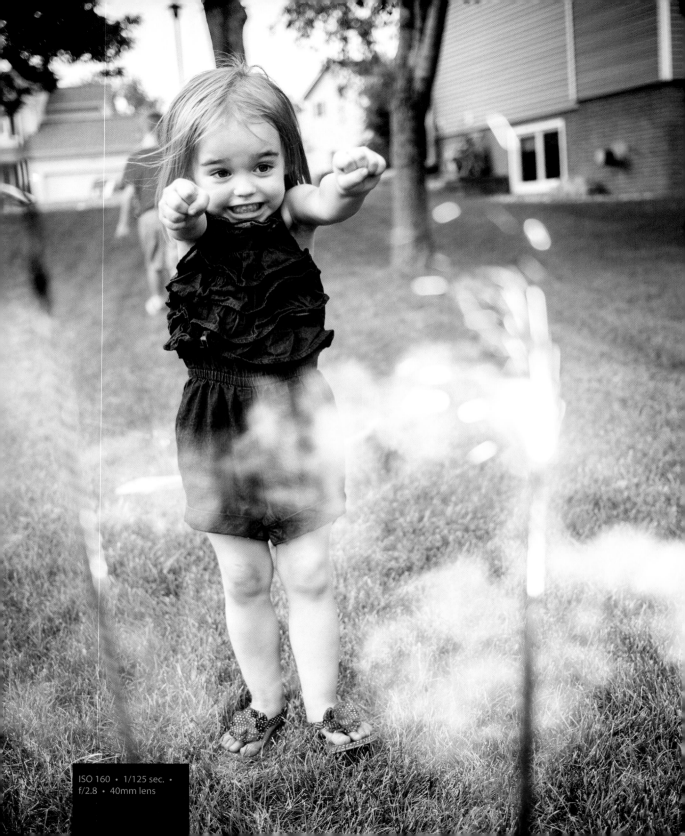

ISO 160 • 1/125 sec. •
f/2.8 • 40mm lens

4

Say Cheese!

Settings and features to make great portraits

Photographing people is challenging, rewarding, and fun all at the same time. When you photograph a person, you are capturing a memory, a moment in time. Images of friends and family often become our most cherished possessions. The people you photograph are depending on you to make them look good—and while you can't always change how a person looks, you can control the way you photograph that individual. In this chapter, we will explore some camera features and techniques that can help you create great portraits.

Whenever I visit my family back in Nebraska, my nieces and nephews end up being the main subjects of my photographs. Oftentimes I bring them outside and have them smile for me, or just play around, in order to get photos for the family. For this photo, the front yard was shaded, which gave me a good opportunity to get some nice images of my nephew playing in the grass. Overall, the kids are always good sports and give me just enough time not only to get nice, smiling images of them, but to let their personalities shine through as well.

I used a wide aperture to blur the background.

ISO 100 • 1/750 sec. • f/2.8 • 40mm lens

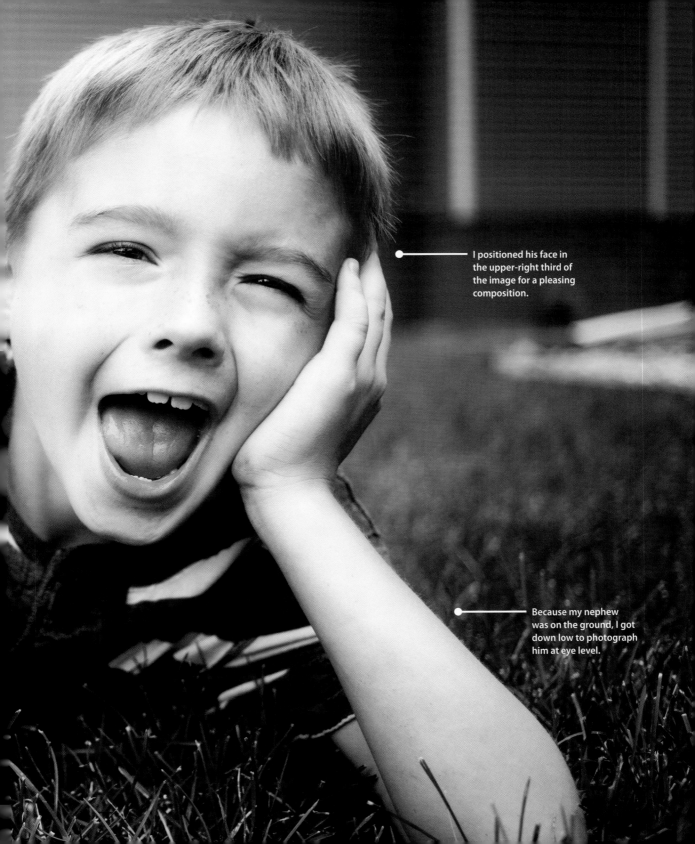

I positioned his face in the upper-right third of the image for a pleasing composition.

Because my nephew was on the ground, I got down low to photograph him at eye level.

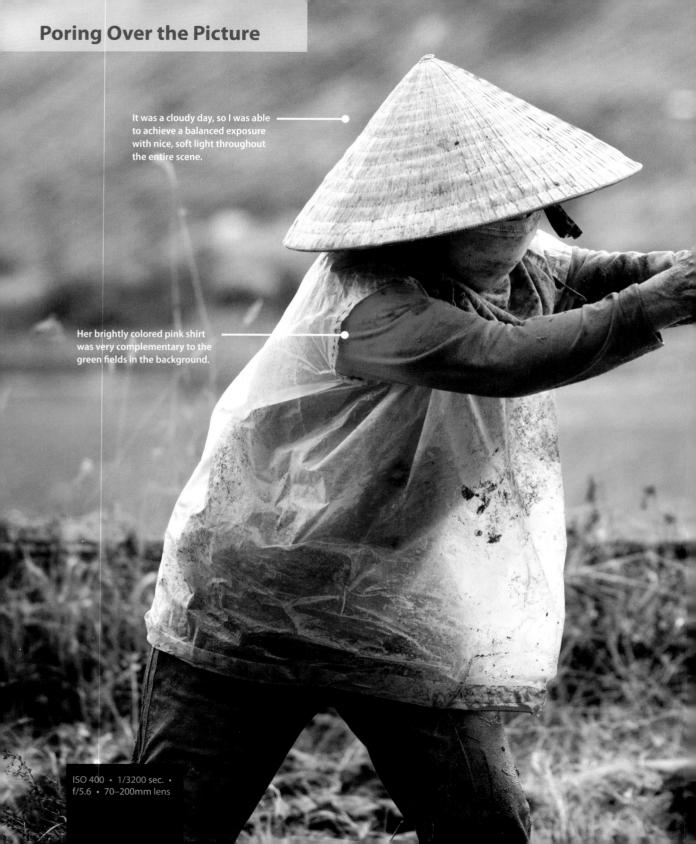

It was a cloudy day, so I was able to achieve a balanced exposure with nice, soft light throughout the entire scene.

Her brightly colored pink shirt was very complementary to the green fields in the background.

ISO 400 · 1/3200 sec. ·
f/5.6 · 70–200mm lens

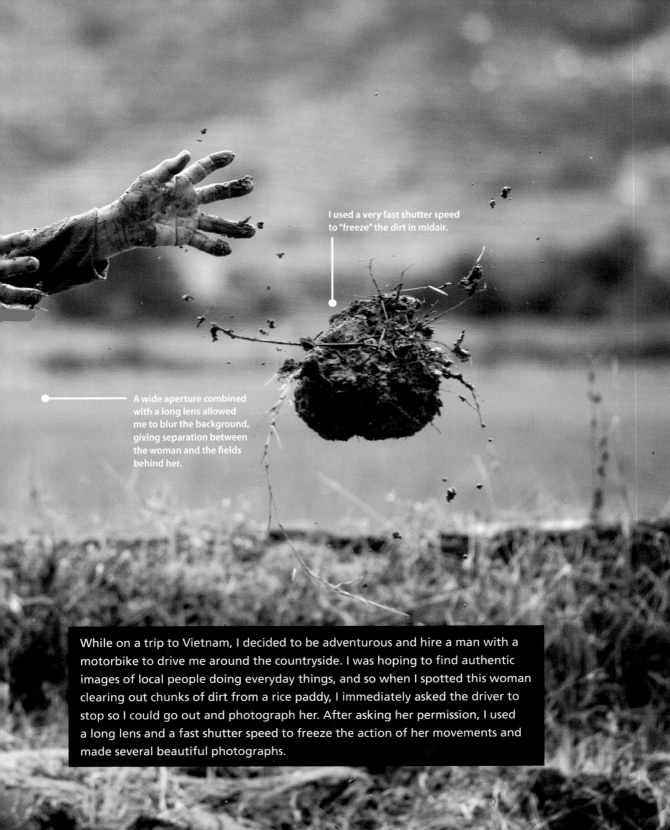

I used a very fast shutter speed to "freeze" the dirt in midair.

A wide aperture combined with a long lens allowed me to blur the background, giving separation between the woman and the fields behind her.

While on a trip to Vietnam, I decided to be adventurous and hire a man with a motorbike to drive me around the countryside. I was hoping to find authentic images of local people doing everyday things, and so when I spotted this woman clearing out chunks of dirt from a rice paddy, I immediately asked the driver to stop so I could go out and photograph her. After asking her permission, I used a long lens and a fast shutter speed to freeze the action of her movements and made several beautiful photographs.

Using Aperture Priority Mode

In the previous chapter, you learned about the different shooting modes, and that when photographing people you're likely to be most successful using Aperture Priority (Av) mode. With portraits, we usually like to see a nice, soft, out-of-focus background, and you can only guarantee that you'll achieve those results if you have control of the aperture setting (**Figure 4.1**). You'll also be letting more light into your camera, which means that your ISO can be set lower, giving your image less noise and more detail.

Now, don't think that you have to use a crazy-fast lens (such as f/1.2 or f/2.8) to achieve great results and get a blurry background. Often an f-stop of 4.0 or 5.6 will be sufficient, and you might even find that having an extremely wide-open aperture gives you too little depth of field for a portrait, since you want most of the face to be in focus. In fact, I shoot many of my portrait photographs with a lens that has a maximum aperture of f/4, and I always achieve the results I'm looking for.

Figure 4.1
For this image, I used a large aperture combined with a long lens to decrease the depth of field and make the background blurry.

ISO 100 • 1/50 sec. • f/4 • 70–200mm lens

Go Wide for Environmental Portraits

Sometimes you'll find that a person's environment is important to the story you want to tell. When photographing people this way, you will want to use a smaller aperture for greater depth of field (which will put more of your background in focus) so that you can include details of the scene surrounding the subject.

Also keep in mind that in order to capture the person and their surroundings, you'll need to adjust your view and use a wider than normal lens. Wide-angle lenses require less stopping down of the aperture to achieve greater depth of field. This is because wide-angle lenses cover a greater area, so the depth of field appears to cover a greater percentage of the scene.

A wider lens might also be necessary to relay more information about the scenery (**Figure 4.2**). Select a lens length that is wide enough to tell the story but not so wide that you distort the subject. There's nothing quite as unflattering as giving someone a big, distorted nose (unless you are going for that sort of look). When shooting a portrait with a wide-angle lens, keep the subject away from the edge of the frame. This will reduce the distortion, especially in very wide focal lengths.

Figure 4.2
A wide-angle lens and a small aperture allowed me to show as much detail as possible in the room.

ISO 400 · 1/10 sec. · f/7.1 · 18–50mm lens

Lighting Is Everything

Photography is all about capturing light, so the most important thing in all of your images is the quality of the light on your subject. When you photograph people, you typically have a lot of control over when and where the image is taken, so you can manipulate your environment and find the best-possible light for your subject.

Before I get into what you should do, let me first talk about what *not* to do. It's a common misconception that bright sunlight is great for portrait photographs. Of course, this is not entirely untrue, since there are some creative and amazing ways to use harsh natural sunlight and make great portraits. The problem is that when the sun is at its highest point, in the middle of the day, it's going to cast some very harsh shadows on your subject and probably make them squinty-eyed as well.

There are several easy ways to achieve beautifully lit portraits in an outdoor setting, and here are my two favorites. The first is to find shade. It might not seem like it at first, but on a sunny day an extraordinary amount of light fills shaded areas, for example, on the side of a building or underneath a covered patio. This is diffused sunlight and will give a very soft, even light on your subject's face (**Figure 4.3**).

Figure 4.3
The light was diffused evenly across the little boy's face in this image, taken in a shady area in the grass.

ISO 160 · 1/180 sec. · f/6.7 · 40mm lens

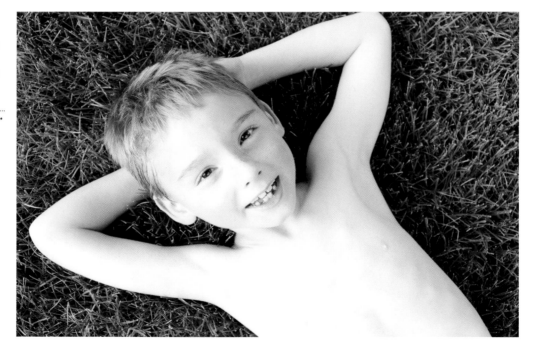

The second way to light your images outdoors is to use the light that occurs during the "golden hour" of the day. This is the time period that occurs one hour after sunrise and one hour before sunset (many photographers are more likely to use the evening light since it's more convenient). The quality of this light is soft, warm-toned, and very pleasing for portraits (**Figure 4.4**).

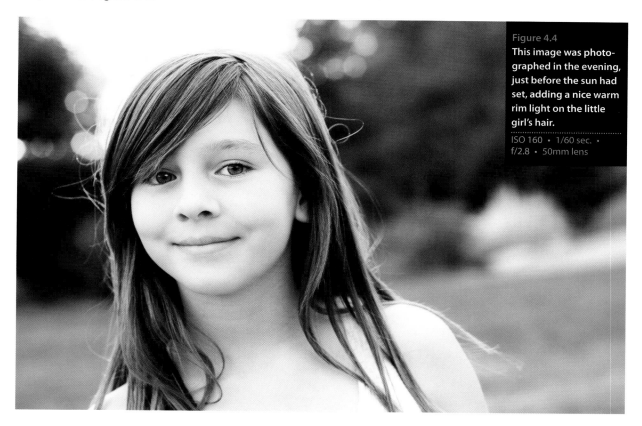

Figure 4.4
This image was photographed in the evening, just before the sun had set, adding a nice warm rim light on the little girl's hair.

ISO 160 • 1/60 sec. • f/2.8 • 50mm lens

When to Use a Flash

I'm not usually a big fan of using the pop-up flash or any type of on-axis flash, which is a light source that comes from the same direction as the camera. It usually results in lighting that is very flat, and often adds harsh shadows behind the subject. But you won't always have the perfect lighting situation for each photograph, so keeping an on-camera, ready-to-go flash on hand can be very practical. It's also good for those moments when you just have to get the shot and there's not a lot of light available, for example, if your baby takes his or her first steps in a darkened room. You wouldn't want to miss that, and the pop-up flash is a handy tool to help capture those moments.

The flash can also be useful if you are in a situation where the afternoon sunlight is the only light available and you need to use a fill light. A fill light will "fill in" the areas in your subject that are not already lit by the main light—in this case, the sun. When photographing people outdoors in the direct sunlight, you don't want them to face directly into the light. Try to position your subject so the sun is off to their side or behind them. This is a good situation in which to use a fill light, such as the pop-up flash on your 70D, to expose their face properly (**Figure 4.5**).

Figure 4.5
I positioned this family with the sun out of their faces and filled in the shadows with a flash.

ISO 100 • 1/250 sec. • f/5.6 • 70–200mm lens

Setting up and shooting with the pop-up flash

1. Press the Flash button on the front of the camera to raise your pop-up flash into the ready position (**A**). Take a photo with the camera at its current settings.

2. Press the Q button on the back of the camera to bring up the Quick Control screen.

3. Use the Multi-Controller to select Flash Exposure Compensation (**B**), and then press the Set button.

4. Use any dial to increase or decrease the flash exposure (this is similar to exposure compensation, but you are affecting only the amount of light that your flash will generate for each shot). If your original image from step 1 was too dark, move the dial to the right to make the flash output more intense; if the image was too bright, move the dial to the left (**C**).

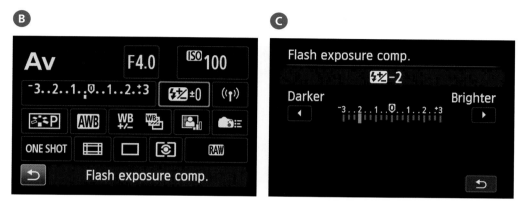

5. Take another photograph with these new settings and compare it with the original on the LCD monitor to see if it looks good. If not, try increasing or reducing the flash meter in one-third-stop increments until you get the correct amount of fill flash for your shot. For example, my first image (**D**) was overexposed, so I reduced the flash compensation by two stops and ended up with a nicer balance of light from the flash that wasn't too bright (**E**).

There are other options for filling in areas of your image that need additional light. A reflector is a very common and inexpensive accessory that you can use to bounce light back onto your subject. You can buy these at any camera store, but you could even use a large piece of white foam core or anything that is reflective (like a sunshade for the windshield of your car) to get similar results.

Metering Mode for Portraits

Your camera gives you four different metering modes that tell it where and how to meter the light. Each mode has a unique way of reading the scene, and which mode you use will depend on the environment you are shooting in.

I use the Evaluative metering mode for the majority of my work, and this mode is ideal for portraits. However, sometimes you'll run into situations where the background is much darker or lighter than the person you are photographing, which could give you an incorrect exposure. In these cases, you'll want to use Partial metering, which will meter a smaller portion of the center of the frame (**Figure 4.6**). The great thing about digital SLRs is that with instant feedback on the LCD, you are able to make adjustments as needed if the metering mode didn't measure the light properly.

Figure 4.6 **The shaded circle in the center represents the area in your image from which the Partial metering mode will meter while you are looking through the viewfinder.**

ISO 100 · 1/125 sec. · f/6.7 · 40mm lens

Selecting a metering mode

1. Press the Q button on the back of the camera to bring up the Quick Control screen, and then use the Multi-Controller to select the metering mode at the bottom of the screen (**A**).

2. Press the Set button, and then choose the metering mode that you would like to use (I recommend starting with Evaluative) (**B**).

3. You can also change this setting on the LCD panel on the top of the camera. Just press the Metering Mode selection button and use the Main Dial to scroll through the different settings (**C**).

B

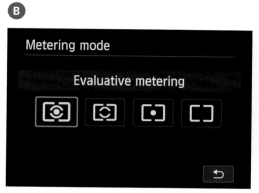

C

Shooting with the AE Lock feature

Once you select your metering, you can lock that setting in your camera temporarily if you want to recompose your image—for example, if you are in an environment where there is sufficient light on your subject but the background is significantly brighter or darker. The metering in your camera is continuous, meaning it will change depending on where the center of the viewfinder is pointed. If you want to compose the image so that the person is off-center, the camera will meter the wrong part of the scene.

To correct this, you can meter for one part of the image (your subject), lock down those settings so they don't change, and then recompose the scene and take your photo. Here's how to use the AE Lock feature on the 70D:

1. While looking through the viewfinder, place the center focus point on your subject.

2. Press the AE Lock button to get a meter reading and lock the exposure settings (**Figure 4.7**). You'll notice an asterisk just to the right of the Battery check icon inside of the viewfinder, which indicates that you have locked your exposure.

3. Now recompose your shot and then take the photo; your camera will maintain the exposure of the area where you originally locked it.

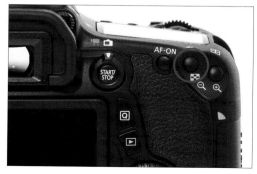

Figure 4.7

Focusing: The Eyes Have It

When you look at a person, probably the very first thing you notice is their eyes—it's just natural to make eye contact with other people, and we even do this with pets and other animals. This is extremely important when creating photographs, because you want to be sure that your focus is on your subject's eyes (**Figure 4.8**). Also keep in mind that if the subject is positioned at an angle, it's best to focus on the eye that is nearest the camera, since that's where we naturally tend to look first (**Figure 4.9**).

In Chapter 1, "The 70D Top Ten List," I discussed autofocus on the 70D. For the most control, the best option for portrait work is to pick one of the nine focus points and stay away from automatic selection. You can move the focus around within your viewfinder to find the eye, ensuring that you are focusing on the proper part of the image before taking your photo. Leaving the focusing decision up to the camera means you could end up with an in-focus nose and blurry eyes, or, even worse, it might try to focus on the background instead of the person.

Figure 4.8
It's important to set your focus on the eyes when photographing portraits, which is important for both people and animal portraits.

ISO 2000 •
1/1000 sec. •
f/2.8 • 40mm lens

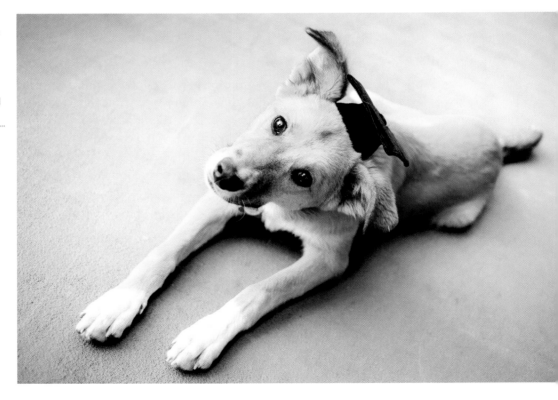

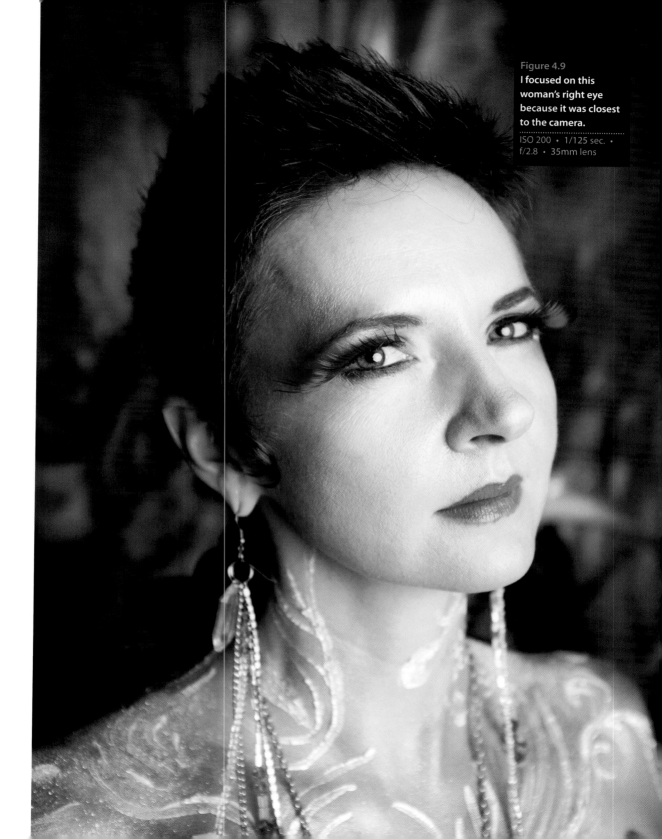

Focusing tip for portrait work

When focusing on your subject's eyes, do your best to focus on the iris (the colored part of the eyeball). This is especially important if you are doing a very close-up portrait where the person's face fills most of the frame, since the focus area will be much more noticeable. If you're shooting with a large aperture and have shallow depth of field, sometimes it's easy to miss focus and instead have the eyelashes in focus and the eyeball a bit blurry.

Selecting and setting the AF point

1. Press the Q button on the back of your camera to bring up the Quick Control screen, and then scroll down to the AF area selection mode option (**A**). Then press the Set button.

2. Next, press the AF Area Selection Mode button on the top of the camera to cycle through the different AF options (**B**). Choose the one you want to use, and then use the Multi-Controller to select the area of focus. I set mine to an off-center Single-Point AF (Manual Selection) (**C**).

3. You can also make these changes by looking through the viewfinder and pressing the AF Area Selection Mode button; you'll see the same screen you would when using the Quick Control screen. Then follow step 2 to change your point or area of autofocus.

One easy way to work is to set the focus point location in the middle, find your subject's eye, and press the shutter button halfway to set focus. With your finger still holding the shutter halfway down, recompose and take the photo. The "focus and recompose" method is a quick way to photograph people and can work for many situations. Speed is important because people tend to move around during the shooting process, and keeping the focus point in the middle can simplify things for you.

Catchlight

A *catchlight* is that little sparkle that adds life to the eyes (**Figure 4.10**). When you are photographing a person with a light source in front of them, you will usually get a reflection of that light in the eye, be it your flash, the sky, or something else brightly reflecting in the eye. The light reflects off the eye surface as bright highlights and serves to bring attention to the eyes. Larger catchlights from a reflector or studio softbox tend to be more attractive than tiny catchlights from a flash.

Another option for photographing people is to use Live View's facial detection features. The Canon 70D has the ability to detect and track human faces, allowing you to focus on those faces quickly. Basically, the camera keeps a track on the faces it can find in your scene, and then once you press the shutter it focuses on the face onto which it is locked. This is great for fast-moving subjects, but I wouldn't recommend it for close-up work with a very shallow depth of field (such as an aperture set to f/2.8), as you'll want to make sure that the focus is always set to the eyes instead of another portion of the face.

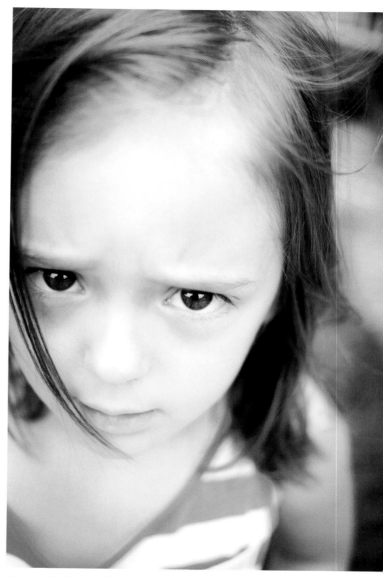

Figure 4.10 The catchlights in this image add a sparkle to the little girl's somber expression.

ISO 100 · 1/500 sec. · f/2.8 · 40mm lens

Setting up face tracking in Live View

1. Click the Menu button and scroll to the first Live View shooting menu item (the fifth menu item from the left). Scroll down to the AF Method option and press the Set button (**A**). (Also make sure that your lens is set to AF.)

2. Scroll up to the Face Detection + Tracking option and press the Set button to lock it in (**B**).

3. Once you've chosen your subject, enter into Live View shooting by pressing the Start/Stop button on the back of the camera (make sure the knob is turned to the white camera icon) (**C**).

4. As your subject moves around, keep the camera positioned so that their face is in the frame, and watch the camera's facial detection at work as a broken white box follows their face (**D**). When you're ready, press the shutter button; the camera will focus on the subject's face just before you take the photo.

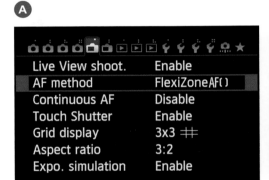

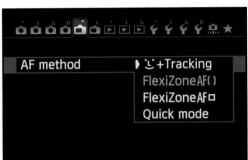

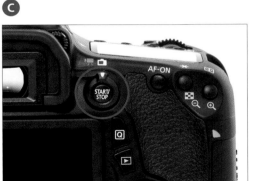

Note: If you have more than one person in the scene, the camera will recognize this and give you the option to select which face you would like to focus on and track (**E**). When this happens, two arrows will appear on either side of the white frame; to select a face, use the Multi-Controller to move the frame to the left or right.

Composing People and Portraits

When photographing people, it can be easy to get carried away with focusing on their expressions and checking your exposure, but it's always crucial to consider how the photo is composed. The placement of the person, as well as the perspective and angle you are using, can make or break the shot. Here are a few simple tips to help you create some amazing portrait compositions.

Rule of Thirds

One of the most basic rules of composition, the "rule of thirds," is a very good principle to stick with when photographing people. It states that you should place the subject of your photograph on a "third-line" within the frame of your viewfinder. Imagine a tic-tac-toe board, with two lines spaced evenly down the center of the frame both horizontally and vertically (**Figure 4.11**). Your goal is to place the subject on one of the intersecting lines—basically, you're trying to keep the person off-center without pushing them too close to the edge of the frame.

Another thing to keep in mind is that you want to fill the frame as much as possible with your subject. This doesn't mean that

Figure 4.11
The little girl's face in this photo was positioned on one of the intersecting third-lines for a pleasing composition.

ISO 800 • 1/320 sec. • f/5.6 • 70–200mm lens

you should get in so close that you have nothing in the shot but your subject's face, but rather that you should be close enough so that you aren't adding anything to the image that you don't want to see. This is usually done by sticking to the third-line principle of framing the head near the top third of the frame. When I hand my camera to someone else to take my photo, I always chuckle to myself when I look at the image afterwards and my head is completely centered in the frame. I usually just go into editing software and crop out the excess headroom, making it look like it was composed properly. However, it's much easier and more efficient to do as much of the work in-camera as possible.

The great thing about the 70D is that you can add a grid overlay to your LCD monitor when shooting in Live View to help you with the composition.

Setting up the grid display for Live View shooting

1. Press the Menu button and go to the first Live View shooting menu tab (fifth tab from the left).

2. Use the Quick Control Dial and scroll down to the Grid Display menu item (**A**).

3. Press the Set button and select the grid of your choosing (**B**). I prefer the 3x3 grid because it clearly shows the third-lines on the frame without too much distraction. Press the Set button to lock in this change.

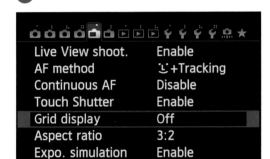

4. Press the Live View shooting button, located on the back of your camera, and you'll see a grid overlay on your LCD monitor (**C**).

Perspective

When shooting with your 70D, it's very easy to take all of your images from a standing position. This of course will vary in height from person to person, but so will the people you are photographing. I usually carry a small stepladder when I go on location so I can vary my height with the people I'm photographing, especially since I'm shorter than most other people. The basic rule to follow is to try to stay at eye level with your subject, which could mean flopping down on your belly to photograph a child or baby (**Figure 4.12**).

Another technique I like to use is to shoot my photos three different ways—vertical, horizontal, and slanted. I will often do one of each with the subject I'm photographing, and these are all very good ways to angle your camera for portraits. Sometimes you don't realize what will make a pleasing image until you try it out,

Figure 4.12 Photographing your subjects at eye level can give your image a friendly and more approachable quality.

ISO 100 • 1/160 sec. • f/11 • 100mm lens

so it's good to experiment a little bit to see what works best. One fun angle to use is a slanted angle, also referred to as the "Dutch angle" (**Figure 4.13**). I find that doing this gives my images a sense of motion and uniqueness, since our eyes want to see things straight up and down.

Figure 4.13
This image was photographed from a position sometimes referred to as the "Dutch angle."

ISO 100 • 1/60 sec. • f/4 • 70–200mm lens

Break the Rules!

So now that I've given you all of these great rules to follow when composing your image, the last rule I'm going to tell you is to break all of them! Don't think that you always need to keep an image off-center or that you have to photograph children at their level all the time (**Figure 4.14**). Experiment and find new ways to capture your images—you just might find that breaking the rules was the best thing you could have done for your image.

Figure 4.14
Breaking rules can sometimes yield great results—this image was photographed from high up, a perspective from which usually you would not photograph children.
ISO 100 · 1/1000 sec. · f/2.8 · 40mm lens

Beautiful black-and-white portraits

Sometimes a portrait just looks better in black and white—we see more of the person and their expression rather than their surroundings or the color of their clothing (**Figure 4.15**). You can change the picture style to Monochrome in your camera so that you are photographing the image in black and white, but when you do this and shoot in JPEG-only mode, you are giving yourself only one option. If you decide you liked it better in color, you have no way to change it back.

I prefer to do all of my black-and-white conversions while editing the photo on my computer, and I encourage you to do the same. You can make black-and-white conversions, along with many other types of adjustments to your images, using the Canon Digital Photo Professional software on the disc included with your camera. Another option is to play with the 70D's "Grainy Black and White" Creative filter. More info on this feature is detailed in Chapter 10, "Advanced Techniques."

Figure 4.15 **A black-and-white portrait eliminates the distraction of color and puts all the emphasis on the subject.**

ISO 100 · 1/125 sec. · f/5.6 · 50mm lens

Quick Tips for Shooting Better Portraits

Before we get to the challenges for this chapter, I thought it might be a good idea to discuss some tips that don't necessarily have anything specific to do with your camera. There are entire books that cover things like portrait lighting, posing, and so on. But here are a few pointers that will make your people photos look a lot better.

Avoid the Center of the Frame

This falls under the category of composition. Place your subject to the side of the frame (**Figure 4.16**)—it just looks more interesting than plunking them smack dab in the middle.

Figure 4.16
An off-center image creates a pleasing composition.

ISO 100 · 1/125 sec. · f/4 · 70–200mm lens

Choose the Right Lens

Choosing the correct lens can make a huge impact on your portraits. A wide-angle lens can distort the features of your subject, which can lead to an unflattering portrait. Try to use a standard or long focal length, such as 50mm to 200mm, if you want to photograph a head-and-shoulders portrait (**Figure 4.17**).

Figure 4.17 **I used a standard focal length to minimize the distortion in this photograph.**

ISO 100 · 1/250 sec. · f/2.8 · 50mm lens

Use Your Surroundings

Close-up portraits are always nice, but don't forget about what's all around you! Including a person's surroundings and environment can add a lot to a portrait image, and even tell a story or help portray a person's personality (**Figure 4.18**).

Sunblock for Portraits

The midday sun can be harsh and can do unflattering things to people's faces. If you can, find a shady spot out of the direct sunlight (**Figure 4.19**). You will get softer shadows, smoother skin tones, and better detail. This holds true for overcast skies as well. Just be sure to adjust your white balance accordingly.

Figure 4.18 My niece was so excited to see sparklers set up in the lawn, so I included them in the shot to give a better explanation for her expression.

ISO 160 · 1/125 sec. · f/2.8 · 40mm lens

Figure 4.19 A shady area will give you beautiful, diffused lighting for portraits.

ISO 100 · 1/180 sec. · f/6.7 · 40mm lens

Keep an Eye on Your Background

Sometimes it's so easy to get caught up in taking a great shot that you forget about the smaller details. Try to keep an eye on what is going on behind your subject so they don't end up with things popping out of their heads. You can also use a wide aperture to blur the background, which will help eliminate distractions (**Figure 4.20**).

More Than Just a Pretty Face

Most people think of a portrait as a photo of someone's face. Don't ignore other aspects of your subject that reflect their personality—hands, especially, can go a long way toward describing someone (**Figure 4.21**).

Figure 4.20 **The background in this image was very busy, so I used a wide aperture to help blur it and keep the image distraction-free.**

ISO 100 · 1/125 sec. · f/2.8 · 50mm lens

Figure 4.21 **A person's hands can tell a story all on their own, just like the hands of this potter in Vietnam.**

ISO 800 · 1/40 sec. · f/5.6 · 70–200mm lens

Get Down on Their Level

If you want better pictures of children, don't shoot from an adult's eye level. Getting the camera down to the child's level will make your images look more personal (**Figure 4.22**).

Don't Be Afraid to Get Close

When you are taking someone's picture, don't be afraid of getting close and filling the frame (**Figure 4.23**). This doesn't mean you have to shoot from a foot away; try zooming in and capturing the details.

Figure 4.22 Children look their best when photographed from their level.

ISO 100 · 1/30 sec. · f/13 · 14mm lens

Figure 4.23
Fill the frame to focus the attention on the person rather than their surroundings.

ISO 100 · 1/500 sec. · f/2.8 · 50mm lens

Find Candid Moments

Sometimes the best images are the ones that aren't posed. Find moments when people are just being themselves (**Figure 4.24**) and use a faster shutter speed to capture expressions that happen quickly (**Figure 4.25**).

Figure 4.24
Sometimes the best photos are the ones that weren't planned—find these moments in your models and you can capture their true selves.

ISO 100 · 1/60 sec. · f/4 · 70–200mm lens

Figure 4.25
Be sure to create photographs of moments that are spontaneous!

ISO 100 · 1/80 sec. · f/2.8 · 24–70mm lens

Find Different Angles and Perspectives

Portraits don't always need to be photographed at eye level. Try moving up, down, and all around to find unique ways to photograph people (**Figures 4.26 and 4.27**).

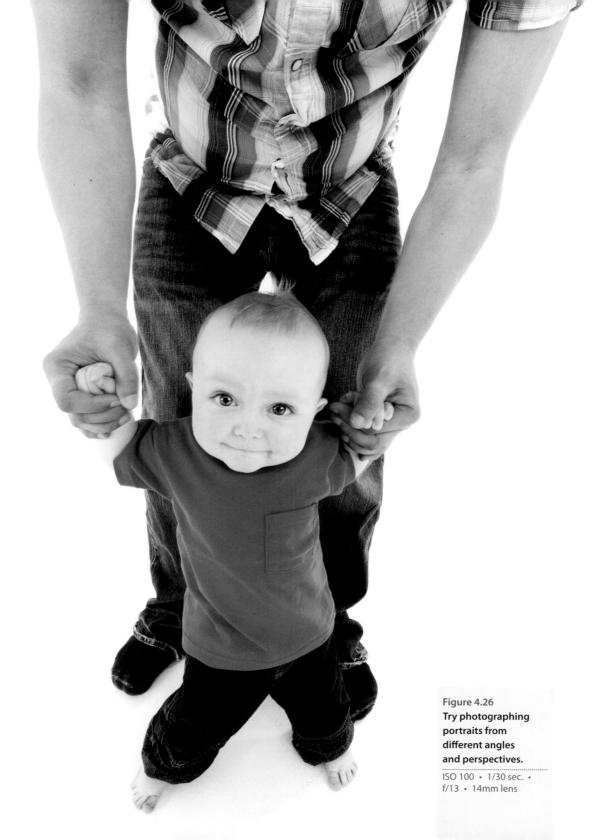

Figure 4.26
Try photographing portraits from different angles and perspectives.

ISO 100 • 1/30 sec. •
f/13 • 14mm lens

Figure 4.27 **Unique points of view can make a photograph fun and exciting.**

ISO 100 • 1/1000 sec. • f/4.5 • 18–50mm lens

Chapter 4 Assignments

Play with depth of field in portraits

Let's start with something simple. Grab your favorite person and start experimenting with using different aperture settings. Shoot wide open (the widest your lens goes, such as f/2.8 or f/4) and then really stopped down (such as f/22). Look at the difference in the depth of field and the important role it plays in placing the attention on your subject. (Make sure your subject isn't standing directly against the background, or you won't see much of a difference in your photographs. Give some distance so that there is a good blurring effect of the background at the wider f-stop setting.)

Discover the qualities of natural light

Pick a nice sunny day and try shooting some portraits in the midday sun. If your subject is willing, have them turn so the sun is in their face (they may want to close their eyes!). Then ask them to turn their back to the sun. Try this with and without the fill flash so you can see the difference. Finally, move them into a completely shaded spot and take a few more shots.

Pick the right metering method

Find a very dark or light background and place your subject in front of it. Take a couple of shots, giving a lot of space around your subject for the background to show. Now switch metering modes and use the AE Lock feature to get a more accurate reading of your subject. Notice the differences in exposure between the metering methods.

Share your results with the book's Flickr group!
Join the group here: flickr.com/groups/canon70dfromsnapshotstogreatshots

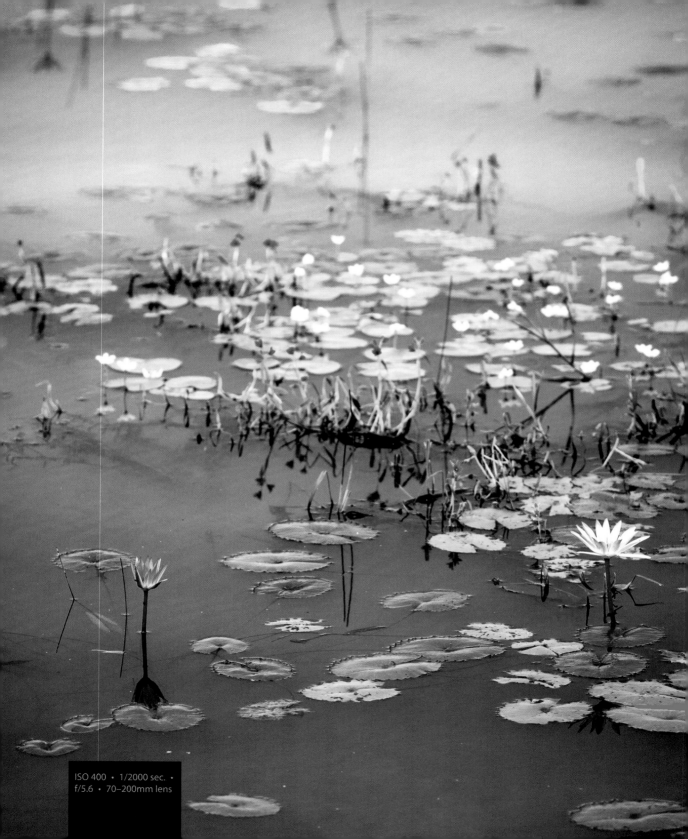

ISO 400 · 1/2000 sec. ·
f/5.6 · 70–200mm lens

5

Landscape & Nature Photography

Tips, tools, and techniques to get the most out of your landscape photography

There's something fun and challenging about relying on Mother Nature when trying to capture great landscape images, because a scene can change dramatically from moment to moment depending on the weather. I feel that I lose some control over my images, but that's what makes photographing nature so intriguing. Now, I'll be honest—I'm not a huge fan of getting up at 5 a.m., before the sun rises. But on the rare occasions that I've found myself out in the middle of nowhere with a tripod and camera in tow, I have experienced some of my most relaxing and peaceful photographic moments.

In this chapter, we will explore some of the features of the 70D that not only improve the look of your landscape photography, but also make it easier to take great shots. We will also explore some typical scenarios and discuss methods that will bring out the best in your landscape photography.

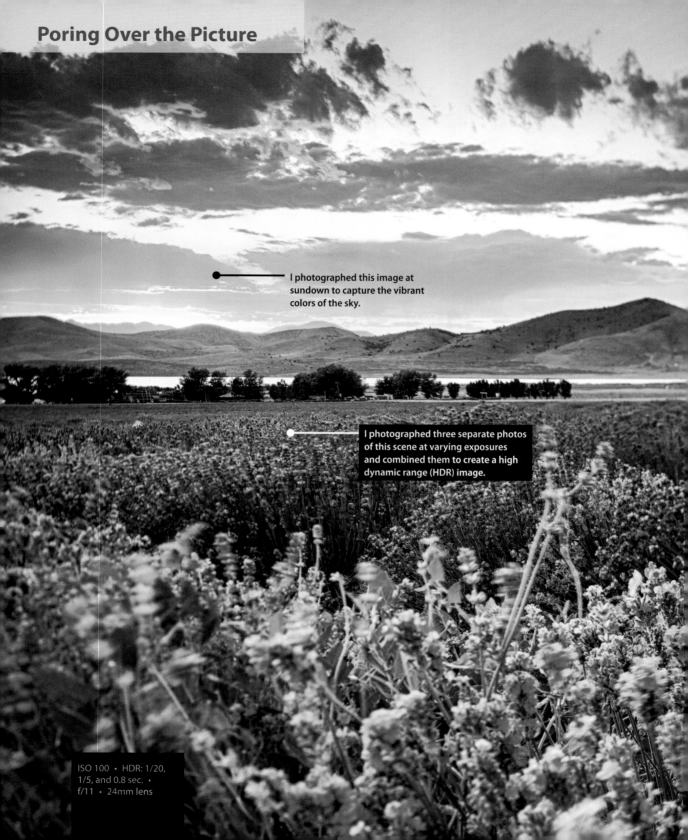

I photographed this image at sundown to capture the vibrant colors of the sky.

I photographed three separate photos of this scene at varying exposures and combined them to create a high dynamic range (HDR) image.

ISO 100 · HDR: 1/20, 1/5, and 0.8 sec. · f/11 · 24mm lens

A large field filled with purple flowers is definitely a beautiful sight, especially when purple is one of your favorite colors (like it is mine). What's even better is when you have hills and a sun setting in the background, just like I did in this photograph. Before shooting at this location I was hoping for two things: a pink sky and a purple field, and fortunately the weather was in our favor that day and delivered on both accounts—and gave me the perfect opportunity to create a colorful and beautiful landscape photograph.

I used a tilt-shift lens to add a creative blur to the scene.

It was a windy evening, which added an interesting element of motion into the shot.

One of my favorite places to visit is Silver Falls State Park in Oregon. The endless sea of green moss, dirt trails, and tall trees are a wonderful escape from life in the city. I can walk these trails for hours and find dozens of unique compositions to photograph, just like I did with this image.

A small aperture allowed me to keep all of the elements in the scene in focus.

I used a tripod to keep the camera stable while creating the image.

ISO 100 · 4 sec. · f/16 · 40mm lens

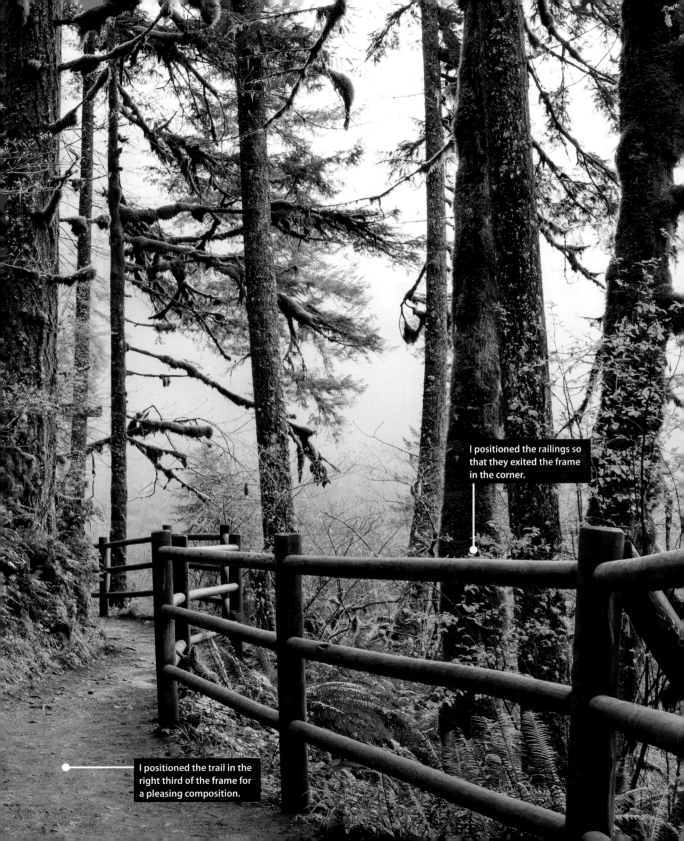

I positioned the railings so that they exited the frame in the corner.

I positioned the trail in the right third of the frame for a pleasing composition.

Sharp and in Focus: Using Tripods

Many features of the 70D will help you create amazing images, but you'll quickly discover that another piece of equipment is crucial when photographing landscapes: the tripod. Tripods are critical to your landscape work for several reasons. One relates to the time of day you will be shooting. To get the best light in your images, you will be shooting at sunrise or sunset, when it's rather dark. When shooting in a dark environment, you need to increase the exposure time, which will result in a slow shutter speed—too slow for handheld photography.

Another reason is that when you are shooting landscapes, you usually want the entire field of view to be in focus (for greater depth of field). In order to achieve this, you will be shooting at very small apertures, which will require you to compensate with a longer, slower shutter speed. Some other reasons that you may need a tripod are if you are creating bracketed exposures for a high dynamic range (HDR) image, then you will need the tripod to keep your scene stable and your images lined up. Also, if you want to do a long exposure for stars or water, then a tripod is a must. The bottom line is if you are serious about landscape photography, then using a tripod is essential to keeping image quality at its peak.

Let's quickly review why using a tripod is so important when you have a slow shutter speed. As you already know, the physical shutter on your camera opens and closes to capture light coming through your lens. The longer this shutter stays open, the more camera shake and blur you could potentially add to your image if the camera or subject is moving. With landscapes, your subject is not moving (for the most part), so by keeping your camera still, you prevent adding blur to your image. Keeping your image sharp and in focus is one of the key ingredients in creating a beautiful landscape photo.

Tripod stability

Most tripods have a center column that allows the user to extend the height of the camera above the point where the tripod legs join together. This might seem like a great idea, but the reality is that the higher you raise that column, the less stable your tripod becomes. Think of a tall building that sways near the top. To get the most solid base for your camera, try to use it with the center column at its lowest point so that your camera is right at the apex of the tripod legs.

So, what type of tripod should you use? There are so many options that it can be difficult to find the right one if you're not sure what you're looking for. I suggest finding a tripod that is light, portable, and very sturdy. These features will add to the expense, but if you plan on photographing a lot of images using a tripod, it's worth the investment. Tripods last for a long time—they don't need upgrades or have hardware failures like other mechanical and electronic equipment. You are also much more likely to use something that is easy to take with you. I have three different tripods: a very large, sturdy tripod that usually stays in my studio because it's so heavy; a very small and light travel tripod that is good for long trips, but also has very skinny and unstable legs so I don't use it too often; and one that's right in between the two—a lightweight, portable, sturdy tripod. If you can afford one, get yourself a tripod made out of carbon fiber. It's an extremely lightweight and strong material, so you'll be more likely to strap it to your camera bag and take it with you.

You'll also need a tripod head so you can attach your camera to the tripod. It's best to get a head with a quick-release plate so you can easily put your camera on and take it off the tripod.

IS lenses and tripods don't mix

If you are using image stabilization (IS) lenses on your camera, remember to turn off this feature when you use a tripod (**Figure 5.1**). The reason is that, while trying to minimize camera movement, the image stabilization can actually create movement when the camera is already stable. To turn off the IS feature, just slide the Stabilizer selector switch on the side of the lens to the Off position.

Figure 5.1 **Be sure to turn off image stabilization when attaching your camera to a tripod.**

Camera Modes and Exposure

When photographing traditional landscapes, you'll most likely want the entire scene to be in focus. To achieve this, you will need to use a small aperture to get great depth of field (**Figure 5.2**). You could always set your camera to Av mode (Aperture Priority) and set your aperture at around f/11 or f/16; this may work well for you, or at least get you to a good starting point.

Just as with all other styles of photography, if you want to be in control of your images, you should select a shooting mode that allows you that control. For full control while photographing landscapes, you may want to consider using Manual mode. Once you are set up and ready to shoot, the light in your scene probably won't change drastically in a short period of time, so your exposure will stay consistent as well. Shooting in Manual mode will ensure that you get the look you want, because you will have full control over both shutter speed and aperture.

Figure 5.2
This image was photographed at a very small aperture to ensure that the details in both the foreground and background were in focus.

ISO 100 · 3 sec. · f/11 · 24mm lens

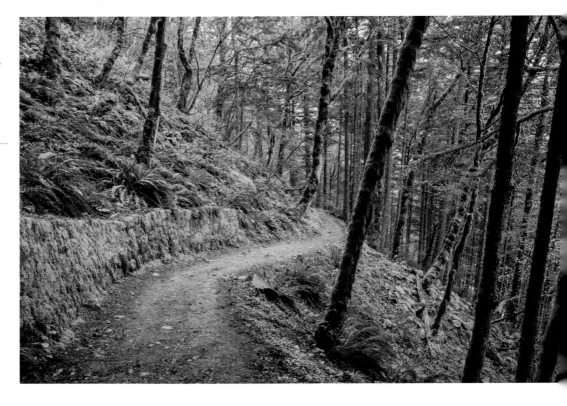

Now, just because most landscapes are photographed with great depth of field doesn't mean you *always* have to photograph your images the same way (**Figure 5.3**). There's no "right way" to do any one thing, so feel free to break the rules and try something new.

Figure 5.3
I created a shallow depth of field by using a long macro lens and focusing on the jellyfish in the background, which blurred the water sparkles in the foreground.

ISO 400 · 1/350 sec. · f/8 · 100mm lens

Selecting the Proper ISO and White Balance

We've already discussed setting your exposure and using a tripod; the next important factor to consider is the ISO. Since you're already shooting with a slow shutter speed, you are free to shoot with a very low ISO, such as 100. By using a low ISO you'll introduce very little digital noise into your images, thereby increasing the detail in your shots (**Figures 5.4** and **5.5**).

Figure 5.4
I used a long exposure to photograph star trails, and there was enough ambient light to capture the image at a low ISO.

ISO 200 · 20 min. · f/2.8 · 14mm lens

Figure 5.5
When zoomed in, there is some noticeable grain in this ISO 200 image, but it's still a small amount when compared with a much higher ISO.

ISO 200 · 20 min. · f/2.8 · 14mm lens

A high ISO will not only add noise to the image; you'll also notice the colorful dots in the shadows. This is something you should generally try to avoid in order to create high-quality photographs. Also, if you are using a tripod and don't mind having a long shutter speed with your image, then you will rarely need to use a high ISO for landscape photographs. Just crank that setting to a low ISO number, such as 100 or 200, and don't touch it—minimal grain and noise is preferred in landscape images, and a low ISO will definitely help get you there.

You're also going to want to capture your image with a proper white balance, and with landscapes, your options (such as the Daylight and Cloudy settings) are more straightforward than with some other types of photography. If you're shooting in RAW, you have some leeway when selecting the white balance in-camera, because it's easy to change it nondestructively after the fact. But my philosophy is that it's always best to get things right in-camera.

Just because there is a "correct" white balance for each scene doesn't necessarily mean that you need to stick with that setting. Try experimenting with different white balance settings to give your landscape images new looks. Changing the white balance in an image can even give the feel of photographing a landscape at different times of day (**Figures 5.6** and **5.7**).

Figure 5.6 (left)
This image was photographed at sunrise with the "proper" white balance—in this case, the Daylight setting.
ISO 100 · 1/40 sec. · f/10 · 70–200mm lens

Figure 5.7 (right)
Switching the white balance to Fluorescent gives the photograph an entirely different look.
ISO 100 · 1/40 sec. · f/10 · 70–200mm lens

Balancing Your Image with the Electronic Level

Sometimes finding the horizon and making sure your camera is level is easier said than done. Photographing a flat landscape is one thing, but when you integrate mountains, rolling hills, and foliage into the image, you might not be able to see where the horizon line is, and you risk tilting your camera in one direction or the other.

Many tripods and tripod heads come with a bubble level, but there will be times when your tripod is propped at a weird angle and you won't be able to rely on it. The 70D has a really cool feature—the *electronic level*—that can help with this. When the electronic level is activated, you can set the horizontal tilt and properly level your camera for landscape photography. You also have the option of viewing this feature through the viewfinder, in Live View, or on the LCD monitor (**Figures 5.8** and **5.9**). When photographing landscapes I prefer using the electronic level in the LCD monitor and in Live View, especially when my camera is on a tripod.

Figure 5.8 **When viewing the electronic level in the LCD monitor, a red line indicates that the scene is not level.**

Figure 5.9 **When the line is straight across and turns green, then your scene is perfectly level.**

Setting the electronic level in the LCD monitor

1. To view the electronic level in the LCD monitor, you may need to change a setting. To do so, press the Menu button and use the Main Dial to select the third setup tab, and then use the Quick Control Dial to scroll down to INFO Button Display Options (**A**). Press the Set button.

2. Make sure that the Electronic Level option is selected (**B**). If it isn't, use the Quick Control Dial to scroll to it, and then press the Set button (a check mark should appear). Use the Quick Control Dial again to scroll down to OK, and then press Set.

3. Press the INFO button until the electronic level appears in the LCD monitor (**C**). You'll know the horizontal tilt is level when the red line turns green and goes straight across. (Note: If you would like to view the electronic level while using Live View, first you will need to disable facial recognition AF tracking (**D**). After doing so, the electronic level will appear in the LCD monitor after pressing the INFO button several times.)

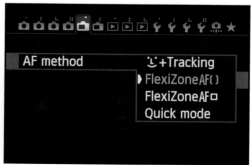

Setting the electronic level in the viewfinder

1. Press the Menu button and use the Main Dial to scroll to the first menu item on the far left. Then scroll down to Viewfinder Level (**A**) and press the Set button.

2. Use the Quick Control Dial to select Show (**B**). Press Set.

3. Look through the viewfinder as if you are going to take a photo and half-press the shutter button to activate the camera. Near the bottom of the frame you will now see a small camera icon with hash marks on the left and right. When the hash marks are straight across, you'll know your camera is level.

Manual callout

For an alternative way to display the electronic level in the viewfinder, please turn to page 61 in the EOS 70D Basic Instruction Manual.

The Golden Hour

In landscape photography, the quality of light is essential to making beautiful photos. Many photographers will tell you that their favorite time of day to take outdoor photographs is during the first and last hour of sunlight, also referred to as the "golden hour" or "magic hour" (**Figure 5.10**). This is because the light is coming from a very low angle to the landscape, creating shadows and providing depth and character. The light also adds color to the earth and the sky—and clouds in the image further add to that color.

If you ask me, the presence of clouds can always improve a landscape image, whether they're cute and fluffy or dark and stormy. During the golden hour, sunlight can reflect off the clouds, producing amazing color combinations that you would not see during the middle of the day. But be prepared—sometimes these color changes take place in a matter of minutes, so be ready to press that shutter button (**Figure 5.11**)!

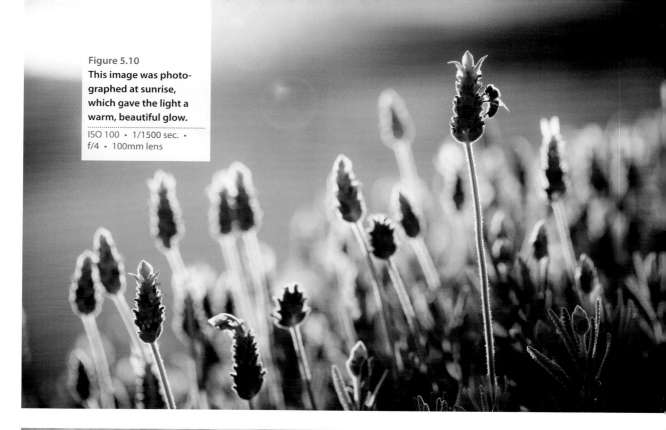

Figure 5.10
This image was photographed at sunrise, which gave the light a warm, beautiful glow.

ISO 100 · 1/1500 sec. ·
f/4 · 100mm lens

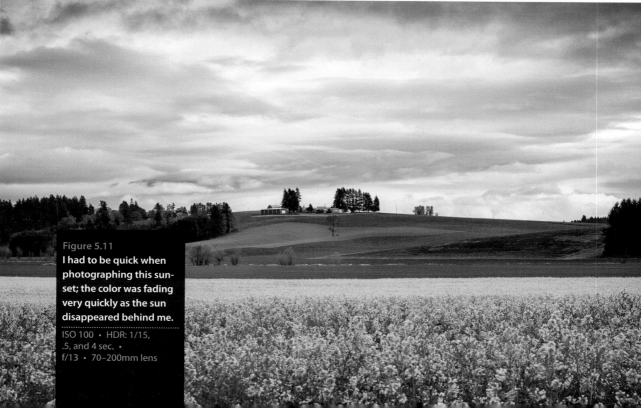

Figure 5.11
I had to be quick when photographing this sunset; the color was fading very quickly as the sun disappeared behind me.

ISO 100 · HDR: 1/15, .5, and 4 sec. ·
f/13 · 70–200mm lens

Focusing Tips for Landscape Photography

We've already established that you will want to use a tripod to minimize camera shake and achieve sharper images, and that you should use a small aperture to get greater depth of field. But shooting at a small aperture doesn't necessarily mean that your entire scene will be in focus. Your goal is to find the spot within the scene that will help you get most of your image in focus.

Hyperfocal distance (HFD) is the closest point of focus to the lens where the remaining distance (out to infinity) is acceptably in focus. Combining HFD with a small aperture will help you achieve a great depth of field, ideal for many landscape photographs. A simple way to achieve this is to focus on an object that is about one-third of the distance into your frame. This is the method used by most working pros and is the easiest to remember and apply while shooting.

When you view the image through the viewfinder, however, you don't always see the correct depth of field, and you might be tricked into thinking that you have more or less depth of field than you actually have. You can address this problem with the 70D's Depth-of-Field Preview feature. This easy-to-use feature works when you look through the viewfinder in Live View. When you have your focus set, just press the Depth-of-Field Preview button located on the front of the camera (**Figure 5.12**), and you'll see a visual representation of what the depth of field in the image will look like when you take the picture.

Figure 5.12 **The Depth-of-Field Preview button will give you a preview of your image and shows how much of the scene will remain in focus.**

Making Water Look Silky

Creating silky-looking images of streams, waterfalls, and even waves adds a beautiful touch to any landscape photo (**Figure 5.13**). Applying this effect to your images is simple—it's just a matter of using a very slow shutter speed to blur the water as it flows through your image. Of course, you'll need to place your camera on a tripod, and it's also a good idea to attach a cable release to prevent any potential camera shake when pressing the shutter button. To achieve a great effect, use a shutter speed of at least 1/15 of a second or longer (I typically try to create water photos with a shutter speed of 3 seconds or more).

Figure 5.13
A long shutter speed will blur your water and make it look silky smooth.

ISO 100 · 8 sec. · f/32 · 100mm lens

Setting up for a flowing water shot

1. Attach the camera to your tripod, and then compose and focus your shot.

2. Make sure the ISO is set to 100.

3. Using Av mode, set your aperture to a smaller opening (such as f/16 or f/22).

4. Press the shutter button halfway so the camera takes a meter reading, and look to see if your shutter speed is relatively slow.

5. Take a photo, and then check the image on the LCD monitor.

When creating flowing water images, be sure to enable the Highlight Alert (see Chapter 1, "The 70D Top Ten List," for more information). Then check the water areas in the image on the LCD monitor; if the water is blinking on the LCD (indicating that the scene is over-exposed), you'll need to adjust the exposure compensation to underexpose the scene slightly and bring back the shadow details in the water.

It's possible that the light in the area in which you want to create this effect is too bright and won't allow you to use a shutter speed that is slow enough to effectively blur the water. In this case, you can use a filter—typically a neutral density (ND) filter—to help reduce the amount of light that is coming through the lens. This filter is basically just a dark piece of glass that serves to darken the scene by several stops, allowing you to use very slow shutter speeds during bright conditions (**Figures 5.14** and **5.15**).

Figure 5.14
This image shows a beach scene without the use of an ND filter.

ISO 100 · 1/10 sec. · f/11 · 70–200mm lens

Figure 5.15
Adding an ND filter to my lens allowed me to blur the water for a very long period of time, making it look like cotton candy.

ISO 100 · 76 sec. · f/11 · 70–200mm lens

Composing Landscape Images

When we look at a photograph, our eyes tend to focus on certain parts of it before we notice the rest. It's usually in those first few seconds of viewing a photograph that we decide if we like it or not. Test this out. Open a magazine and take a quick look at the first photo you see. Your eyes will most likely be drawn to the brightest part of the picture first. Next you'll probably notice the sharpest, most in-focus parts of the image, and then finally you'll start moving your eyes, looking for the most vibrant colors. The placement of these elements helps make up the photograph's overall composition, and your goal should be to keep the viewer's eyes interested and moving among all of the elements of your images.

Rule of Thirds

In Chapter 4, "Say Cheese!," I discussed the importance of the rule of thirds, and you'll read even more about it in the chapters to come. It's one of the most basic rules of composition, and it works with nearly every type of image.

In landscape photography, you will often compose your image so that both the earth and the sky appear in the same shot. Pay attention to the placement of your horizon, as it's generally best to keep the horizon line away from the middle of the frame. Try to compose your shot so that the horizon falls on either the top- or bottom-third line of the frame (**Figure 5.16**).

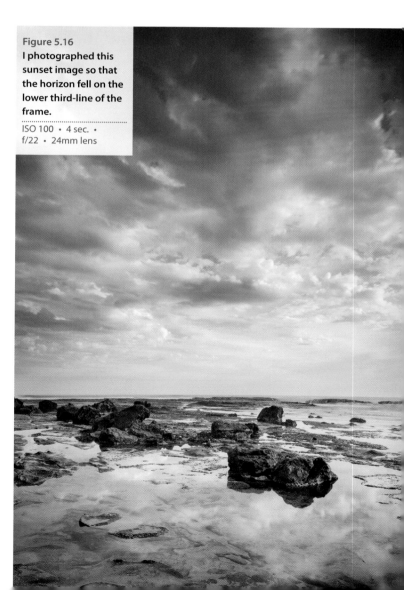

Figure 5.16
I photographed this sunset image so that the horizon fell on the lower third-line of the frame.

ISO 100 · 4 sec. · f/22 · 24mm lens

For a scene with a specific point of interest, such as a building or tree, compose that object on one of the intersecting third-lines within your frame (**Figure 5.17**). If you would like a little extra help, you can enable the grid display to show up in your viewfinder or on the LCD monitor (for Live View); please turn to Chapter 4 for more information.

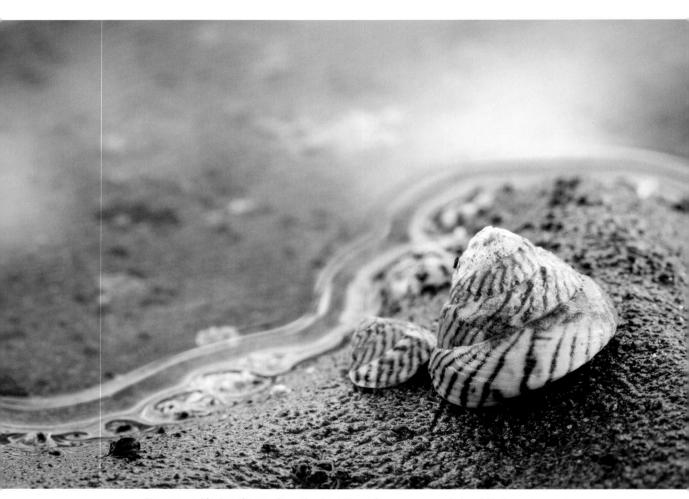

Figure 5.17 **Placing objects along the third-lines of your scene can help add balance to your images.**

ISO 400 • 1/8 sec. • f/16 • 100mm lens

Creating Depth

With landscape photography, finding a scene with a foreground, a middle ground, and a background can add depth to your image (**Figure 5.18**). Using all three of these areas effectively gives the image a three-dimensional feel and offers several distinct spaces for the viewer's eyes to travel.

Figure 5.18 **This image has a distinct foreground (rocks), middle ground (water), and background (mountains/bridge).**

ISO 100 · 52 sec. · f/11 · 24mm lens

Advanced Techniques to Explore

The following two sections, covering panoramas and HDR images, require you to use image-processing software to complete the photograph. However, if you want to shoot for success, it's important that you know how to use these two popular techniques.

Photographing Panoramas

Sometimes you'll be in a location that is simply too big to cover within the typical camera frame. In such cases, you might consider photographing a panorama. You could always take a photo and crop off the top and bottom, making a "fake" panorama, but the

Figure 5.19
This is the making of a panorama, with eight different shots overlapping about 30 percent of the frame.
ISO 100 • 10 sec. • f/5.6 • 70–200mm lens

Figure 5.20
I used Adobe Photoshop to combine all of the exposures into one large panoramic image.

purpose of a panorama image is to photograph an extended view of a scene, with minimal distortion, that can't typically be created with one shot.

If you want to make a true panorama, you either need a special camera that can move on its own to seamlessly photograph a scene, or you can use the following method to achieve similar results (**Figures 5.19** and **5.20**). You'll photograph a series of side-by-side images and stitch them together using editing software to produce one elongated panoramic shot.

I won't get into details on how to edit photographs, but if you have the proper software, such as Adobe Photoshop, the best thing you can do is learn how to photograph the images in a way that will make stitching them together a piece of cake.

Shooting for a multiple-image panorama

1. Mount your camera vertically on your tripod and make sure it is level. (Shooting vertically will give your panorama more height and therefore more image detail.)

2. Choose a focal length for your lens between 35mm and 50mm.

3. In Av mode, use a very small aperture for the greatest depth of field. Take a meter reading of a bright part of the scene and make note of it.

4. Now change your camera to Manual mode (M), and dial in the aperture and shutter speed that you obtained in the previous step.

5. Set your lens to manual focus, and then set your focus by finding a point one-third of the way into the scene. (If you use autofocus, you risk getting different points of focus from image to image, which will make the image stitching more difficult for the software.)

6. While carefully panning your camera, shoot your images to cover the entire area of the scene from one end to the other, leaving about a 30-percent overlap from one frame to the next.

Quick tip: Sorting your panoramic images

Pulling panorama images into your editing software can be confusing, because you're not sure where one series of photographs ends and another begins. Here's a quick tip for sorting your images.

When you're all set up and ready to start shooting your panorama, hold up one finger in front of the lens and take a quick shot. Then start your panorama shots. After you've photographed the last image, hold up two fingers in front of the lens and take another photo. This will help you find where each series begins and ends, and should make it easier to sort and edit your panoramas.

Photographing HDR Images

A fun and popular way to create images is through a technique called high dynamic range (HDR). When you create an image that has a wide range of tones (shadows and highlights), such as a landscape image with a very bright sky, you need to decide which areas you want to emphasize and adjust your exposure to match. We can often find an exposure that is a balance between overexposing the sky and underexposing the ground. HDR photography allows you to photograph several different exposures of the same scene, capturing the shadows, midtones, and highlights, and then to combine them to create a single image in editing software (**Figures 5.21** and **5.22**).

Note that it's absolutely necessary to use a tripod when using this technique, because all the images must be aligned perfectly to combine them during the editing process.

Figure 5.21
To create an HDR image, I shot three consecutive photos at different exposures using AEB (Auto Exposure Bracket) mode.

ISO 100 • 1/20 sec. • f/11 • 24mm lens

ISO 100 • 1/5 sec. • f/11 • 24mm lens

ISO 100 • 0.8 sec. • f/11 • 24mm lens

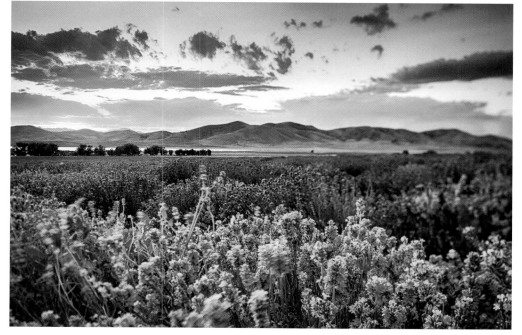

Figure 5.22
Using HDR software, I merged the three exposures in the previous image to create the final HDR photo.

The first step is to set your camera to automatically bracket your exposures. You will want one image that is underexposed, one that is overexposed, and one that is right in the middle. The 70D allows you to set this up so that it automatically photographs a series of three shots with each of those exposures.

Setting up Auto Exposure Bracket (AEB) mode for HDR

1. Press the Menu button and use the Main Dial to get to the third shooting tab, and then use the Quick Control Dial to highlight the Expo. Comp./AEB item at the top (**A**). Press the Set button.

2. Scroll the Main Dial to the right until the exposures are set to two stops between each shot (–2, 0, +2) (**B**), and then press the Set button. (Note that this setting will remain in place until you change it or turn off your camera. To set it back to normal, just scroll the Main Dial to the left until only the center line is highlighted in red.)

3. Press the DRIVE button on the top of your camera.

4. Use the Quick Control Dial to select high-speed continuous shooting mode. (This will allow you to photograph your three bracketed images very quickly. This is important because some things in your image may be moving, such as clouds or leaves.)

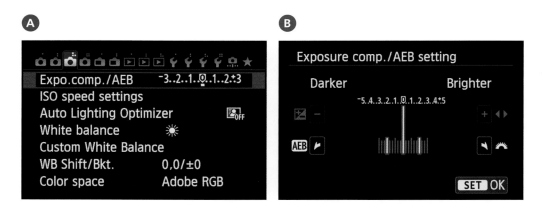

Now that AEB mode is set up, let's go through the steps to create photographs for an HDR image.

Setting up for shooting an HDR image

1. Mount your camera on your tripod, and then set your ISO to 100 to ensure clean, noise-free images.

2. Set your program mode to Av. During the shooting process, you will be taking three shots of the same scene, creating an overexposed image, an underexposed image, and a normal exposure. Since the camera is going to be adjusting the exposure, you want it to make changes to the shutter speed, not the aperture, so that your depth of field is consistent.

3. Set your camera file format to RAW. This is extremely important because the RAW format contains a much larger range of exposure values than a JPEG file, and the HDR software needs all of this information.

4. Focus the camera manually using the hyperfocal focusing method discussed earlier in the chapter, compose your shot, secure the tripod, and hold down the shutter button until the camera has fired three consecutive times.

5. Download the images to your computer, and create the HDR image using specialized editing software.

Bracketing your exposures

In HDR, bracketing is the process of capturing a series of exposures at different stop intervals. You can bracket your exposures even if you aren't going to be using HDR. Sometimes this is helpful when you have a tricky lighting situation and you want to ensure that you have just the right exposure to capture the look you're after. In HDR, you bracket to the plus and minus side of a "normal" exposure, but you can also bracket all of your exposures to the over or under side of normal. It all depends on what you are trying to do. If you aren't sure whether you are getting enough shadow detail, you can bracket a little toward the overexposed side. If you aren't sure you're getting enough detail in your highlights, bracket a little toward the underexposed side. You can bracket in increments as small as a third of a stop. This means that you can capture several images with very subtle exposure variances and then decide later which one is best.

Chapter 5 Assignments

We've covered a lot of ground in this chapter, so it's definitely time to put this knowledge to work in order to become familiar with these new camera settings and techniques.

Experiment with white balance using Live View

Set up your camera and use the Daylight white balance setting. Then turn on the Live View and change the white balance to the other modes, previewing each change in the LCD monitor. Pay attention to the colors of your scene and the different settings, and then pick the white balance that works best for your image.

Level the horizon

Set your camera up on a tripod, and do your best to eyeball the horizon and get it level in your scene. Then turn on the electronic level, either in the viewfinder or on the LCD monitor, and see how close you were to getting your scene level. If you were off, then go ahead and adjust your camera until it's balanced and leveled horizontally. Don't forget to preview your composition before you take the shot—just because the camera thinks it looks good doesn't necessarily mean it will turn out that way!

Apply hyperfocal distance to your landscapes

Pick a scene that contains objects positioned near the camera, as well as something that is clearly defined in the background. Try using a wide to medium-wide focal length (18–35mm). Use a small aperture and focus on the object in the foreground, then recompose and take a shot.

Without moving the camera position, use the object in the background as your point of focus and take another shot.

Finally, find a point that is one-third of the way into the frame from near to far and use that as the focus point.

Compare all of the images to see which method delivered the greatest range of depth of field from near to infinity.

Place your horizons

Find a location with a distinct horizon and, using the grid on the viewfinder or using Live View on the LCD monitor, take three shots: one with the horizon in the top third of the frame, one with it in the middle of the frame, and one along the bottom third of the frame. Compare each shot to see which one is most visually striking.

Share your results with the book's Flickr group!
Join the group here: flickr.com/groups/canon70dfromsnapshotstogreatshots

ISO 100 • 1/1000 sec. •
f/5.6 • 70–200mm lens

6
Moving Target

Techniques and tricks with action photography

Photographing moving subjects is exciting, especially when you catch something you weren't expecting. When I was a kid photographing on the sidelines of my high school's football games, I used to dream of becoming a professional sports photographer—there's just something surreal about capturing a moment in time that only you could see with your camera. Whether you're photographing sports or your child running around the backyard, this chapter will give you the tools you need to get some great action shots.

Poring Over the Picture

The overcast day with diffused light allowed my scene to be exposed evenly, with no overly harsh shadows.

A fast shutter speed allowed me to capture their expressions quickly.

ISO 400 · 1/2500 sec. · f/5.6 · 70–200mm lens

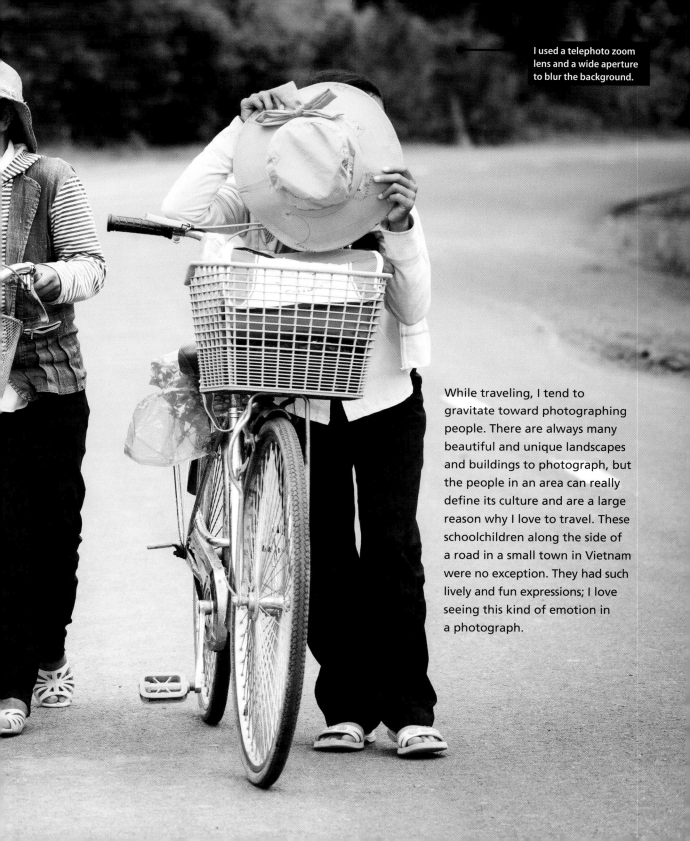

I used a telephoto zoom lens and a wide aperture to blur the background.

While traveling, I tend to gravitate toward photographing people. There are always many beautiful and unique landscapes and buildings to photograph, but the people in an area can really define its culture and are a large reason why I love to travel. These schoolchildren along the side of a road in a small town in Vietnam were no exception. They had such lively and fun expressions; I love seeing this kind of emotion in a photograph.

Stop Right There!

When you are photographing a fast-moving subject, the most important setting to be aware of is your shutter speed. If the shutter speed is fast enough to freeze your subject, then you should see little or no motion blur. If your shutter speed is too slow, your subject will end up being a colorful streak across the frame.

Shutter speed is measured in fractions of a second, so when you are reading the numbers on the top LCD Panel or in the viewfinder, look for a very high number for a fast shutter speed. Even though you are shooting in fractions, the camera won't actually show shutter speeds that way but instead will display whole numbers. There's no single setting you can stick with to be sure you will freeze the action—the shutter speed you use will depend on the subject you are photographing and how fast it is moving. Also keep in mind what direction the subject is traveling and how far away you are from it. Let's take a brief look at each of these factors to see how they might affect your shooting.

Direction of Travel

When determining exposure for action photography, the first thing you might think about is how fast the subject is moving, but you will also want to consider the direction in which it is traveling. The speed of something moving from left to right can be perceived differently from that of something moving toward you. With the subject moving left to right, you'll need to set your camera to a faster shutter speed to freeze it in place; using a shutter speed that is too slow could blur your subject. With a subject moving toward the camera, you can get away with a slower shutter speed, because it appears more stationary (**Figure 6.1**). A subject that is moving in a diagonal direction—both across the frame and toward or away from you—requires a shutter speed in between the two.

Subject Speed

Once you've determined the direction your subject is heading, you'll need to assess the speed at which it is moving. The faster your subject is moving, the faster your shutter speed needs to be in order to "freeze" the action (**Figure 6.2**). A person walking on a sidewalk is moving quite slowly, so you will be able to use a slower shutter speed, such as 1/60 of a second, in order to photograph her with little or no motion blur. Using the same shutter speed to photograph a speeding car would result in the car being blurred across your image, so to compensate, you would need to use a much faster shutter speed.

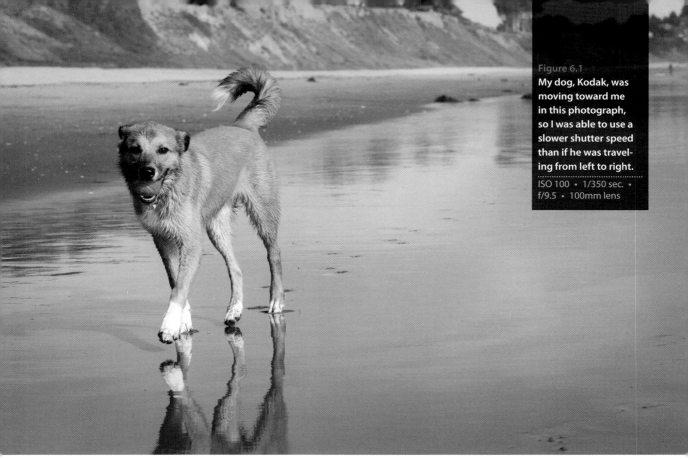

Figure 6.1
My dog, Kodak, was moving toward me in this photograph, so I was able to use a slower shutter speed than if he was traveling from left to right.

ISO 100 · 1/350 sec. · f/9.5 · 100mm lens

Figure 6.2
I was able to freeze the action of this woman throwing a chunk of dirt by using a fast shutter speed.

ISO 400 · 1/3200 sec. · f/5.6 · 70–200mm lens

Subject-to-Camera Distance

One final factor to keep in mind when photographing moving subjects is their distance from you and your camera. Imagine that you are standing on top of a tall building looking down at the street below. You can watch the cars moving with little effort; in other words, your eyes don't have to move very far to see cars travel from one block to another, and you don't have to turn your head much to follow them. Now put yourself on the sidewalk directly next to the street, and try to follow those cars traveling the same speed—you need to move your head from left to right to keep your eyes on one car. Standing on the street requires a lot more movement on your part to keep up with the moving traffic.

Now imagine you are holding your camera and trying to photograph the cars in both of the above scenarios. Although the subjects are traveling at the same speed in both instances, the movement of your camera will affect the shutter speed you'll need to use in order to freeze the action. Photographing a fast-moving subject that is farther from you requires a slower shutter speed than if you were standing a few feet away from it, because the perceived speed is much slower.

This same principle can also be applied to the lens you use. If you are using a wide-angle lens, you can probably get away with a slower shutter speed, whereas using a telephoto lens brings you in closer to the subject and will require a faster shutter speed to compensate for the movement of the lens following your subject (**Figure 6.3**).

Using Shutter Priority (Tv) Mode to Stop Motion

In Chapter 3, "Camera Shooting Modes," you learned about the Canon 70D's different shooting modes. Shutter Priority (Tv) mode gives you full control over the shutter speed—you pick the shutter speed and the camera determines the aperture. In many instances of sports and action photography, you will be working with very fast shutter speeds; using Tv mode will give you the control you need to capture high-speed images (**Figure 6.4**).

To use a fast shutter speed, you need to be in an environment with sufficient light available for the speed you want to use. You might decide to set your aperture at a wide f-stop in order to bring more light into the sensor to balance the fast shutter speed. However, there may be times when your environment is just too dark for what you want to shoot—you'll know this because the aperture value will flash on the top LCD panel and on the viewfinder info screen, and also on the LCD monitor when using Live View. When the light is insufficient for the shutter speed and aperture combination you want to use, you'll need to change your ISO settings.

Figure 6.3
For this image I used a telephoto zoom, which required a much faster shutter speed to compensate for the movement of the lens.

ISO 100 • 1/750 sec. • f/2.8 • 70–200mm lens

Figure 6.4
I used a fast shutter speed to capture the laptop in midair.

ISO 100 • 1/6400 sec. • f/2.8 • 50mm lens

What's great about digital cameras is that they allow the user to change the ISO as often as needed. With film, each individual roll of film had a specific ISO number and couldn't be changed from frame to frame, as can be done with digital cameras today. It can be difficult for new photographers to decide what ISO to use at first, but once you understand how the process works, it's much easier to make that decision.

I like to keep my ISO very low and usually shoot somewhere between ISO 100 and 800. I do this because at low ISO numbers, the digital noise is insignificant and hardly visible. When you start cranking up that number, the camera's sensor becomes more sensitive to light and you can increase your shutter speeds; however, the noise level will be much greater. For my line of work, I tend to keep my images as noise-free as possible, but in a photo in which the subject and activity being photographed are more important than the technical quality of the pixels, being able to change the ISO is a big advantage. It's a good option to have when you're in an environment that you can't control, and depending on the final output (Web, print, and so on), it may or may not make much difference in the overall quality of the image. With the 70D you can quickly adjust the ISO number as needed with just a few simple steps.

Adjusting your ISO on the fly

1. If the shutter speed is too fast for your aperture setting, then you'll see the aperture number blink in the viewfinder (**A**). A blinking aperture is an indication that your image will be underexposed. In this case, the aperture is at its lowest setting, so your only option is to increase the ISO.

2. To change the ISO while looking through the viewfinder, move your right index finger back from the shutter button and press the ISO button (**B**). It's easy to find because it has a raised bump in the middle of the button.

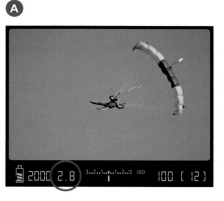

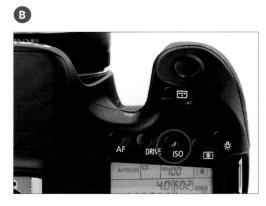

3. Now move your finger forward to the Main Dial and rotate it to the right to raise the ISO to the next highest level.

4. Press the shutter button halfway and check to see if the aperture is still blinking.

5. If it's not blinking, shoot away. If it is, repeat steps 2–4 until the ISO is set correctly.

Get creative

When photographing sports and action images, try to find new and creative ways to capture your subject. In **Figure 6.5**, I knew that I would need a fast shutter speed to catch the basketball player in midair, so I positioned myself facing the sun and silhouetted him as he was jumping up to take a shot. The bright light from the sun not only allowed me to use a shutter speed that was fast enough to catch the action, but also added a unique quality to the scene.

Figure 6.5

By photographing directly into the sun, I was able to silhouette the basketball player and freeze him in place with a fast shutter speed.

ISO 100 · 1/180 sec. · f/16 · 18–50mm lens

Using Aperture Priority (Av) Mode to Isolate Your Subject

When you are shooting in Tv mode at a very fast shutter speed, your camera will often be set at a wide aperture to bring in as much light as possible through the lens. As you learned in Chapters 2 and 3, using a wide aperture will help to reduce the sharpness of the photo's background, narrowing the depth of field (**Figure 6.6**). This is quite effective with sports and action photography, because you move the viewer's attention to the focal point of the image—your subject.

So when will you want to use Aperture Priority (Av) mode for action and sports? You already know that using Tv mode allows you to choose your shutter speed, so if you need a specific or fast shutter speed, Tv mode is a good choice. But if you want to isolate your subject and blur the background by using a large aperture, then you will probably want to set your camera to Av. One benefit to using Av mode with the aperture at its widest setting is that the camera will always use the fastest-possible shutter speed depending on the available light in your environment.

Figure 6.6
Using a wide-open aperture allowed me to blur the trees in the background.
ISO 2000 · 1/350 sec. · f/5.6 · 70–200mm lens

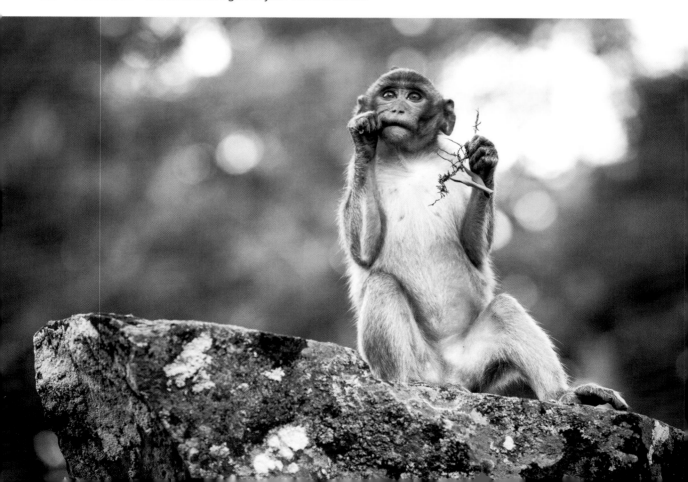

You can also change the ISO quickly when shooting in Av mode, just as you learned in the previous section. Just remember to keep an eye on the shutter speed—if it's too slow, boost the ISO number to increase the sensitivity of the sensor and allow the use of faster shutter speeds.

One challenge you'll face when using a wide-open aperture in action photography is to make sure you maintain proper focus on your subject, because you have less wiggle room with a larger aperture than with a smaller one. You also want to be able to take several continuous photos of your subject ("machine gun" style) to make sure you get the shot. With portrait and landscape photography, you can easily get away with One Shot AF (autofocus) and the single shooting drive mode. But when you are trying to focus on something that is constantly moving, it's much easier to use a focusing system that can track your subject. In the next section, I will discuss the 70D's drive modes, AI Servo AF, and the AF selection points you can use when photographing fast-moving subjects.

Using Manual mode with Auto ISO

If you need the best of both worlds—a specific shutter speed along with a wide aperture—then you may want to consider using Manual mode. By setting the camera to Manual and using Auto ISO, you can control the movement in your image (or lack thereof), as well as the depth of field, while also allowing the camera to keep a balanced exposure by changing the ISO automatically (**Figure 6.7**). This is a great way to set your exposure if you need specific settings and are not concerned with the potential of additional digital noise in the image.

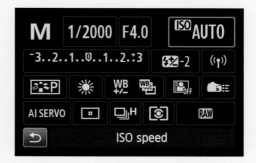

Figure 6.7

Using Manual mode with Auto ISO allows you to maintain specific settings while allowing the camera to determine the ISO, keeping your exposure balanced and your creative settings intact.

Setting Up Your Camera for Continuous Shooting and Autofocus

In order to photograph fast-moving subjects, get several shots at a time, and stay focused on the subject through the entire process, you'll need to make a few changes to your camera settings. The 70D makes the process simple, but it can be a bit confusing when you first start to work with it. Here, I briefly explain the two areas that are addressed in this section: drive modes and AF (autofocus) modes.

Drive Modes

The 70D's drive mode determines how quickly each photo is taken and how many photos it will take continuously. The drive modes available on your camera include the following:

- **Single shooting:** With this setting you will take only one photo each time you press and hold the shutter button.

- **High-speed continuous shooting:** When you press and hold the shutter button, your camera will continuously take photos very quickly—up to seven frames per second—until you release the shutter button.

- **Low-speed continuous shooting:** When you press and hold the shutter button, your camera will continuously take photos at a slower pace—up to three frames per second—until you release the shutter button. You can also easily take just one shot by quickly pressing and releasing the shutter button.

- **Silent single shooting:** This is the same as the single shooting mode, but with less sound.

- **Silent continuous shooting:** This is the same as the low-speed continuous shooting mode, but with less sound.

- **10-sec self-timer:** The camera waits 10 seconds to take a photo once you press the shutter button. You can also use this mode when shooting with a wireless remote control.

- **2-sec self-timer:** The camera waits 2 seconds to take a photo once you press the shutter button. You can also use this mode when shooting with a wireless remote control.

For action and sports photography, the best option will usually be either high-speed or low-speed continuous shooting. In these modes you will take several consecutive photos very quickly and are more likely to capture a good image of your fast-moving subject. Keep in mind that taking this many images at a time will fill up your memory card much more quickly than taking just one image at a time. The speed of your SD (Secure Digital) card also limits how many images you can take in a row.

Within your camera is a *buffer,* a feature that processes the image data before it can be written to the SD card. When you take a photo, you'll see a red light on the back of your camera (the access lamp)—you usually won't notice anything is happening, because the buffer is big enough to hold data from several photos at a time. When you take a lot of photos in a row with the high-speed continuous drive mode, however, the buffer fills up more quickly—and if it fills up completely while you are shooting, your camera will "freeze" momentarily while the images are written to the card, and the word "busy" will appear on the top LCD panel and also through the viewfinder. Shooting in RAW is likely to slow down your buffer and fill it up fast when shooting several images in a row; sports photographers who shoot in JPEG can get more images written to the card much more quickly.

One way to stay on top of this while you are shooting is to look inside the viewfinder. In the lower-right corner you'll see a number that tells you how many photos you can take before the buffer is full (**Figure 6.8**). In general, it's a good idea to do short bursts of photos instead of holding down the shutter button for several seconds. This will help keep the buffer cleared, and the card won't fill up as quickly.

Figure 6.8
The number on the far-right side of the viewfinder shows you how many shots you have left (max bursts) before the buffer is full.

Use continuous mode to capture expressions

Using a fast shutter speed is not just for fast-moving subjects, but also for catching the ever-changing expressions of people, especially small children. **Figure 6.9** shows how an expression can change in a matter of seconds. Taking several consecutive shots allowed me to capture each moment as it happened without missing a thing.

Figure 6.9 These photographs of my nephew, only seconds apart from each other, show the diverse range of expressions you can see in a short period of time.

ISO 100 · 1/250 sec. · f/2.8 · 40mm lens

Selecting and shooting in high-speed continuous drive mode

1. Press the DRIVE button on the top of the camera.

2. Rotate the Main Dial until you see the drive setting that shows an "H."

3. Locate and focus on your subject in the viewfinder, and then press and hold the shutter button to take several continuous images.

Manual callout

The number of frames that you can capture varies depending on the image format that you're using (JPEG, RAW, or RAW+JPEG). To find out the frame rates, as well as the maximum number of frames that you can take in one continuous burst, check out page 99 of the EOS 70D Basic Instruction Manual.

Focus Modes

Now that your drive setting is ready to go, let's move on to focusing. The 70D allows you to shoot in three different focus modes: One Shot, AI Focus, and AI Servo (AI stands for Artificial Intelligence). One Shot mode is designed for photographing subjects that are stationary or don't move around very much; this setting typically is not very useful with action photography. You will be photographing subjects that move often and quickly, so you'll need a focus mode that can keep up with them. AI Servo mode will probably be your best bet. This setting will continue to find focus when you have your shutter button pressed halfway, allowing you to keep the focus on your moving target.

Selecting and shooting in AI Servo focus mode

1. Press the AF button on the top of the camera and make sure that your lens is switched to autofocus (AF).

2. Use your index finger to rotate the Main Dial until AI SERVO appears in the top LCD panel.

3. Locate your subject in the viewfinder, and then press halfway and hold the shutter button to activate the focus mechanism. You'll notice that while in this mode you won't hear a beep when the camera finds focus.

4. The camera will maintain focus on your subject as long as the subject remains within your focus point(s) in the viewfinder or until you take a picture.

AI Focus mode is another setting that can be useful when you have a subject that is stationary at first but then starts to move—it's the "best of both worlds" when it comes to focusing on your subject. Imagine that you are photographing a runner about to sprint in a race—you want to focus on the person's eyes as they take the "ready" position and don't want your camera to change focus. But just as the runner starts running down the

track, the camera will kick into AI Servo mode to track and focus on the runner as they are moving.

You should note that holding down the Shutter button for long periods of time will quickly drain your battery, because the camera is constantly focusing on and metering the subject. You can also activate the focus by pressing the AF-ON button on the back of the camera (**Figure 6.10**). This is a great way to get used to the focusing system without worrying about taking unwanted pictures.

Figure 6.10
The AF-ON button will activate the autofocusing system in your 70D without your having to use the shutter button. Note that this button will not work when shooting in one of the fully automatic modes.

AF points

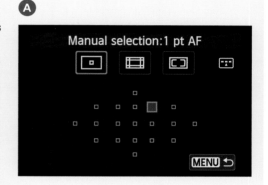

A

The Canon 70D has a total of 19 AF points and three different settings for autofocus: Single-Point AF (manual selection), Zone AF (manual zone selection), and 19-Point automatic selection. Single-Point AF lets you choose one of the 19 focus points within the viewfinder to set your autofocus to (**A**), Zone AF lets you choose one of five zones where you want your focus to be (example **B** shows one of these zones, which is a grouping of four individual focus points), and the 19-Point automatic selection AF allows the camera to decide which autofocus points to focus on for each shot (**C**).

When you are photographing something and are able to set the focus point on the part of the image you want in focus all the time, such as when it's focused on the eyes of a person, then it's best to use one of the manual selection options. If you're photographing something where your subject will be near the center of the screen and moving around quickly, such as children running around on a soccer field, then you might want to give either the Zone or Automatic selection a try. Experiment with each setting to find out which one works best with your shooting style.

For more information and details on setting AF points, please turn to Chapter 1.

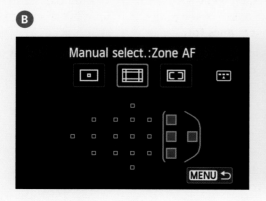

B

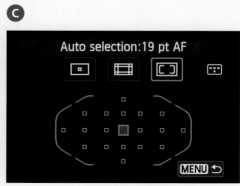

C

Manual Focus for Anticipated Action

I tend to stick with autofocus when photographing moving subjects; however, sometimes when photographing fast-moving subjects, focusing manually can actually make it easier to get the shot. In **Figure 6.11,** I knew where the skateboarder would be jumping, and if I were to rely on autofocus it might try to focus on the wrong part of the scene. In order to ensure that he was in focus, I pre-focused my lens before he jumped. Then when he made his move, I was ready to go and didn't have to worry about my camera finding a new, incorrect focus area.

Figure 6.11
I knew where the skateboarder would be jumping, so I focused my lens manually to be sure that the focus area was accurate.

ISO 200 · 1/200 sec. · f/5.6 · 70–200mm lens

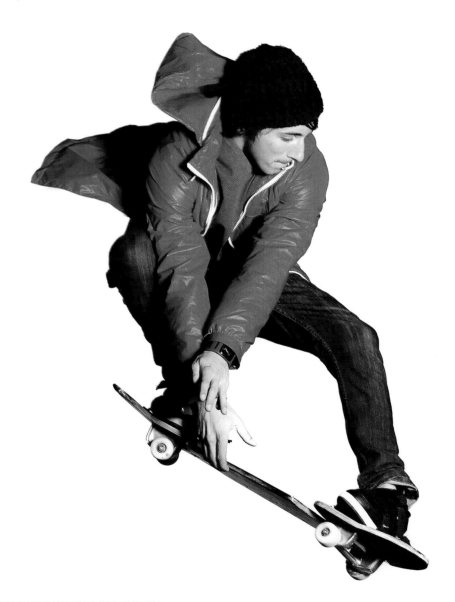

Another example in which manual focus is effective is with panning shots. Because your subject is moving very quickly, you will want to be sure the focus is set on it, since you might otherwise miss the shot as it whizzes past you. If you know where it's heading, as I did with the motorcycle shot in **Figure 6.12**, then you can pre-focus your lens rather than rely on the camera to find focus. (I'll discuss panning photography in more detail in the next section.)

Figure 6.12 **Using manual focus is a good choice when photographing panning images.**

ISO 400 · 1/8 sec. · f/9 · 70–200mm lens

A Sense of Motion

When photographing a moving subject, you might not always want to freeze everything in its tracks—sometimes you'll want to convey to the viewer the sense of movement in the image. Two techniques you can use to achieve this effect are panning and motion blur.

Panning

One of the most common ways to portray motion in an image is by panning. *Panning* is the process of using a slower-than-usual shutter speed while following your subject across the frame, moving your camera along with it. This technique adds motion blur to the background. The key here is a slow shutter speed, but the exact shutter speed you use depends on the speed of the subject. Choose a shutter speed that is slow enough to capture motion in the background but fast enough to allow you to capture your subject with little or no blur. You also want to follow through with your camera until you are sure that your shutter is closed and you've completed the shot. You can further maintain the sharpness of the subject by using a flash source (such as the built-in flash on your 70D or an off-camera flash or strobe) to freeze the subject (**Figure 6.13**).

Panning photography often involves a lot of trial and error until you get the perfect combination of shutter speed and camera movement. The beauty of digital photography is that we get instant feedback and can keep tweaking our settings until we have them set just right for the image we want to create.

Figure 6.13 **Using a separate light source can help to prevent blurring your panning subject. In this photo, I used an off-camera strobe to keep the runner tack-sharp.**

ISO 100 • 1/15 sec. • f/13 • 24–70mm lens

Motion Blur

Another way to let the viewer in on the feel of the action is to include some *motion blur* in the image. This blur is less refined than it is in a panning shot, and there's no specific or correct composition, colors, or way to move your camera to get a desirable effect. The blur doesn't need to be extreme or a major part of the scene in order for it to add impact. In **Figure 6.14,** I photographed a woman at an outdoor market preparing some food. The movement in this scene, even though it is subtle, adds a sense of motion and intrigue to the photograph.

As with a panning shot, there is no set shutter speed and aperture combo that you can use every time for this effect. It may take a lot of trial and error to get the outcome you want, but in my opinion, that challenge makes it all the more fun and is a great reason to give it a try!

Figure 6.14
Adding blur to your images can be a fun and creative way to imply a sense of motion in the scene.

ISO 3200 · 1/60 sec. · f/5.6 · 70–200mm lens

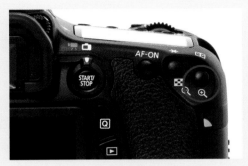
Tips for Shooting Action

Give Them Somewhere to Go

It can be easy to get wrapped up in the moment when photographing fast-moving subjects, but it's important that you remember some basic rules of composition and framing. One of my goals is to keep the elements of the photo within the frame so that the viewers' eyes focus on what I want them to see. With action photography the subject is most likely moving, so you need to make sure that there's room for the subject in the direction it's heading. Do your best to keep from cropping the image too tightly or pushing the subject too close to the left or right edges of the frame (**Figure 6.16**).

Get in Front of the Action

Another technique to keep in mind is to try to photograph the action coming toward you (**Figure 6.17**). When you are photographing people or animals, it's always best to show their faces and expressions, which can convey a sense of urgency and the emotion of the moment.

Figure 6.16
I composed this image so that the biker would appear in the upper-left third of the frame and on his way down from the jump.

ISO 100 · 1/100 sec. · f/9 · 10–20mm lens

Figure 6.17
Always try to capture your subject moving toward you. For this photo, I placed myself so that the rider and her horse would be facing me as they made the turn around the barrel.

ISO 100 · 1/400 sec. · f/2.8 · 24–70mm lens

Figure 6.18

I got down behind some tall grass to shoot this motocross driver as he made the jump; the foreground elements add depth to the photograph.

ISO 100 •
1/2000 sec. • f/3.5 •
70–200mm lens

Put Your Camera in a Different Place

Finding new perspectives and ways to photograph your subject can be a fun way to add interest to an image. Sometimes you are limited in the location you shoot from, but there are still ways to add depth and uniqueness to your images just by finding a different spot to place your camera.

When photographing this motocross driver, I wanted to add some dimension to the image by blurring the foreground elements (**Figure 6.18**). I was in an open field with few other elements in the area, so I ducked down behind some tall grass and shot through it to add it to the foreground. I was still able to capture the driver and his bike exactly how I wanted while adding depth to the image with shallow depth of field.

Think Outside the Box

Any scene with movement can be frozen in time or made intentionally blurry, not just sports and action! If something in a scene is moving, play with your settings to see what results you can get. Oftentimes I use these principles with other types of photography, such as food (**Figure 6.19**) and while traveling (**Figure 6.20**). Creatively displaying movement in a photograph can add depth and emotion to an otherwise simple scene.

Figure 6.19
I used a fast shutter speed to freeze the movement of the pouring sparkling wine and the bubbles in this image.

ISO 100 · 1/500 sec. · f/4 · 100mm lens

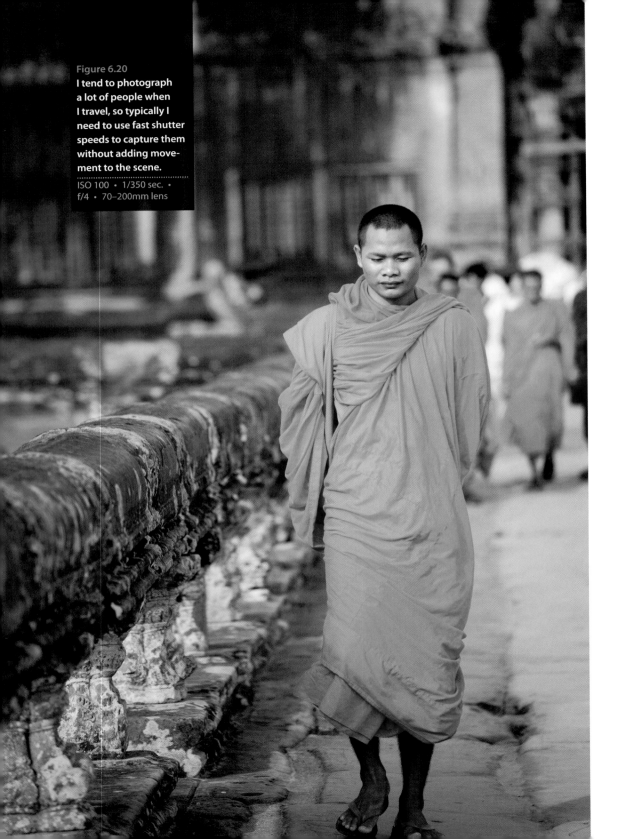

Figure 6.20

I tend to photograph a lot of people when I travel, so typically I need to use fast shutter speeds to capture them without adding movement to the scene.

ISO 100 • 1/350 sec. • f/4 • 70–200mm lens

Chapter 6 Assignments

Practice the mechanics of motion

Find a fast-moving subject, such as cars on a busy street. Set your camera to Tv (Shutter Priority mode) and take some photos using different shutter speeds. Be sure to keep your camera still while you're taking the photos. Start with a slower speed, such as 1/30 of a second, and then gradually increase the speed until you find one that freezes the action of your subject.

Compare wide vs. telephoto

Just as with the first challenge, photograph a subject moving in different directions, but this time use a wide-angle lens and then a telephoto. Check out how the telephoto setting on the zoom lens will require faster shutter speeds than the lens at its wide-angle setting.

Get a feel for focus modes

Set your camera to AI Servo and Manual AF Point selection. Find a moving subject and follow it around with your lens while looking through the viewfinder and pressing the shutter button halfway. Watch how the camera looks for the focus point in the area you have selected.

Now switch to the 19-Point automatic selection. Follow the same subject with your camera and notice the differences in where the camera wants to find focus. Switching between these two different modes will help you determine which mode works best for your shooting situation.

Anticipate the spot using manual focus

For this challenge, you'll need to find a subject that you know will cross a specific line that you can pre-focus on, such as a street with moderate traffic or a person jogging along a path. Set your lens to Manual and focus on a spot that the subject will travel across. It's also a good idea to set your camera to the high-speed continuous shooting mode for this to work well. Now, when your subject approaches the spot, start shooting. Try shooting in three- or four-frame bursts.

Follow the action

Panning is a great way to show motion. To begin, find a subject that will move across your path at a steady speed and practice following it in your viewfinder from side to side. Now, with the camera in Tv mode, set your shutter speed to 1/30 of a second (try to pre-focus on the spot where you think your subject will be traveling, as you did in the previous challenge). Now pan along with the subject and shoot as it moves across your view. Experiment with different shutter speeds and focal lengths. Panning is a skill that takes some time to get a feel for, so try it with different types of subjects moving at different speeds.

Share your results with the book's Flickr group!
Join the group here: flickr.com/groups/canon70dfromsnapshotstogreatshots

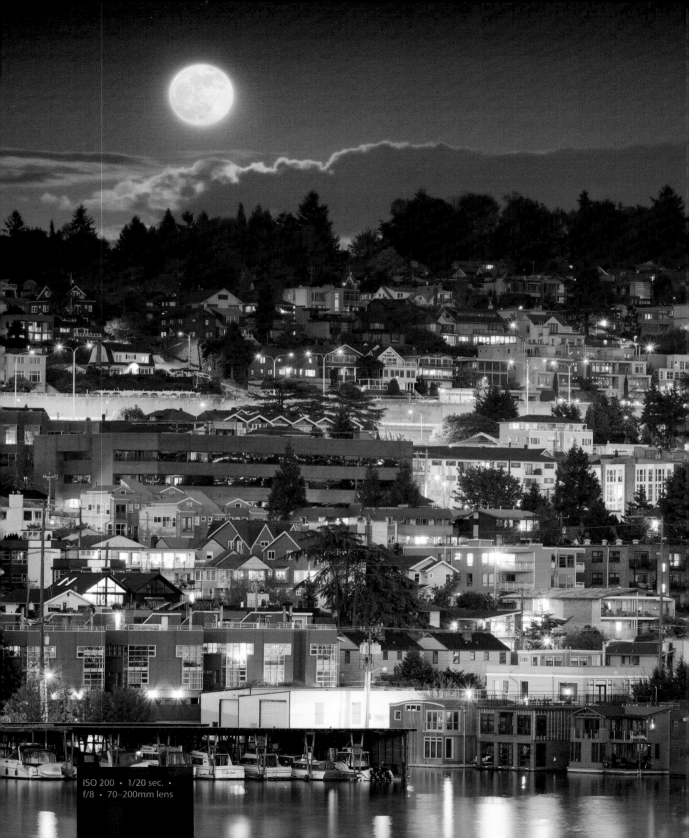

ISO 200 · 1/20 sec. ·
f/8 · 70–200mm lens

7

Mood Lighting

Shooting when the lights get low

The advances in digital camera technology have made it possible to capture images in some of the most challenging lighting situations, and the 70D allows you to keep on shooting even after the sun goes down. In this chapter, we'll explore ways to use your camera with available light and with the 70D's built-in flash, but let's start with the obvious solution to shooting when the light is low: raising the ISO.

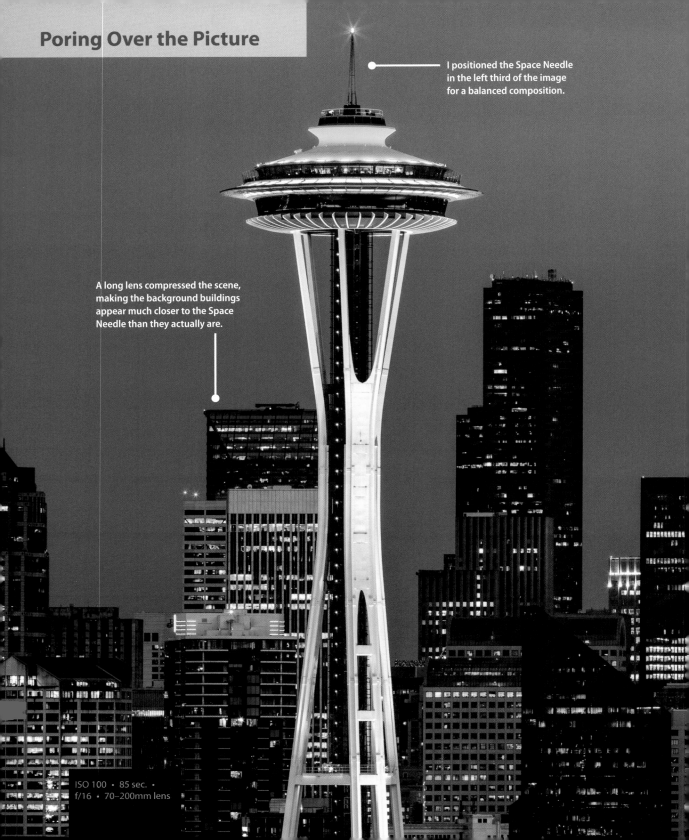

Poring Over the Picture

I positioned the Space Needle in the left third of the image for a balanced composition.

A long lens compressed the scene, making the background buildings appear much closer to the Space Needle than they actually are.

ISO 100 • 85 sec. •
f/16 • 70–200mm lens

I lived in Seattle for a short period of time, but long enough to photograph the Space Needle several times over. I photographed this iconic view from Kerry Park, just a short drive from my apartment. There's something beautiful and magical about cities at night; they change from ordinary buildings to sparkling and colorful structures, all filled with a life of their own.

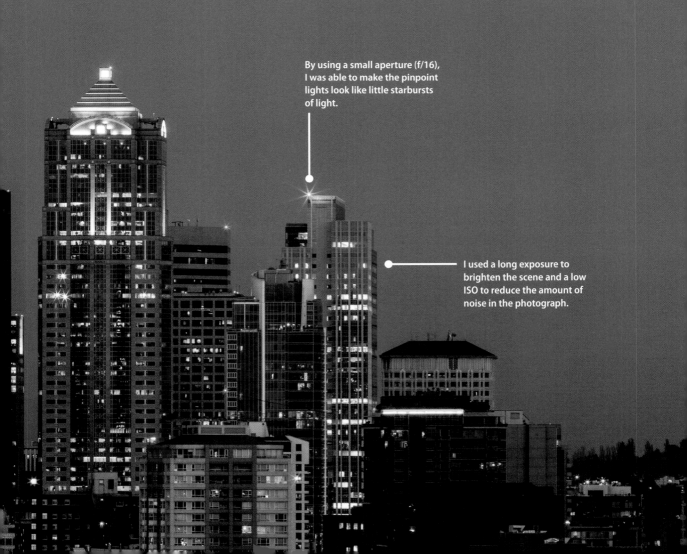

By using a small aperture (f/16), I was able to make the pinpoint lights look like little starbursts of light.

I used a long exposure to brighten the scene and a low ISO to reduce the amount of noise in the photograph.

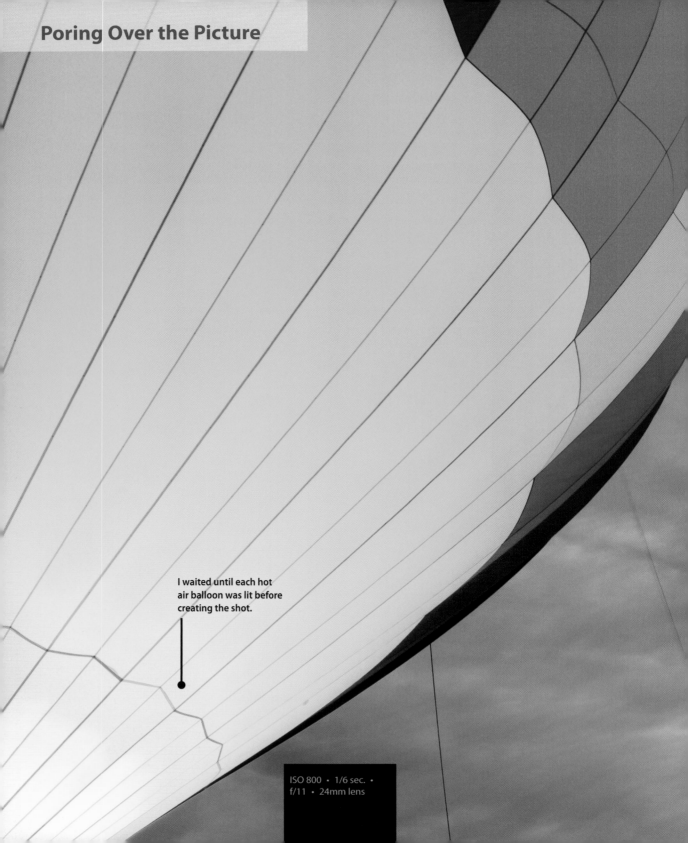

I waited until each hot
air balloon was lit before
creating the shot.

ISO 800 · 1/6 sec. ·
f/11 · 24mm lens

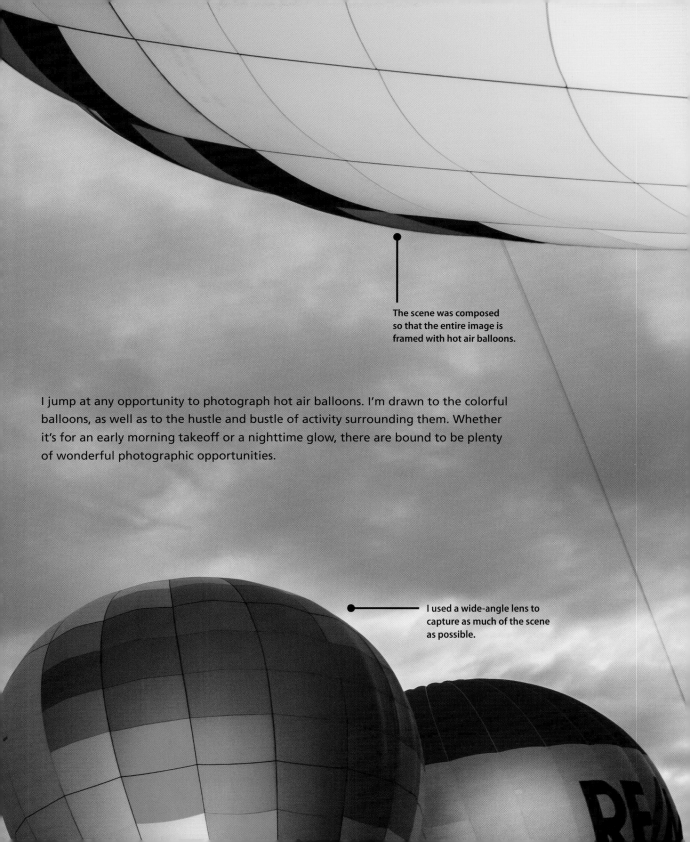

The scene was composed so that the entire image is framed with hot air balloons.

I jump at any opportunity to photograph hot air balloons. I'm drawn to the colorful balloons, as well as to the hustle and bustle of activity surrounding them. Whether it's for an early morning takeoff or a nighttime glow, there are bound to be plenty of wonderful photographic opportunities.

I used a wide-angle lens to capture as much of the scene as possible.

Raising the ISO: The Simple Solution

Capturing moments in low-light situations is easy with digital cameras—just raise the ISO. Adjusting the ISO on the fly is easy; simply press the ISO button on the top of the camera and change the ISO number by using the Main Dial (see Chapter 1, "The 70D Top Ten List," for more information). In most lighting situations, you will probably be working with an ISO range of 100 to 800. But as your available light gets lower, you have the ability to push the ISO to extremely high numbers (**Figure 7.1**).

Using a tripod with a slow shutter speed and low ISO setting is a good option when the lights are low, but if your subject is moving too fast, you won't be able to freeze it in place. Tripods also tend to attract a lot of attention, and they are not allowed in some areas. I find that hauling around a tripod can be cumbersome—if I know that I need one for a specific image, it's not a big deal, but if I'm not sure what I'll be shooting, I prefer other methods that don't require as much gear.

So if you find that raising your ISO level above 800 is your only option, you can reduce the amount of noise in the image by turning on the 70D's High ISO Speed Noise Reduction feature. Keep in mind that you may not always notice noise when viewing your images on the back of your camera, since what you're seeing is a scaled-down version of the original. Using the back-of-camera zoom features to preview your shots close-up will give you a better idea of the amount of noise that higher ISO levels introduce into your images. (See Chapter 6, "Moving Target," for more information on zooming in while reviewing your images.)

Figure 7.1
I increased the ISO in order to use a faster shutter speed to photograph this market scene at night.

ISO 4000 • 1/125 sec. • f/4 • 70–200mm lens

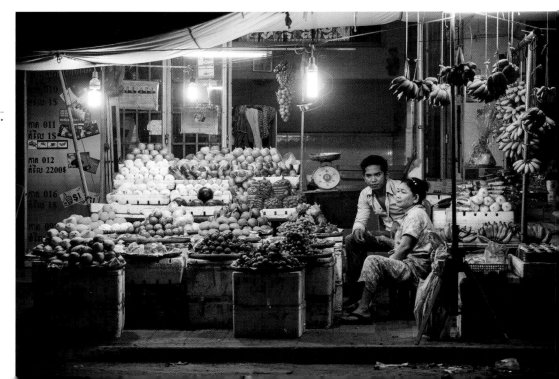

Turning on High ISO Speed Noise Reduction

1. Press the Menu button and scroll to the fourth shooting tab.

2. Scroll down to the High ISO Speed NR option and press Set (**A**).

3. Use the Quick Control Dial to select the level of noise reduction you would like applied to your images (**B**), then press Set again.

4. Press the Menu button twice to exit. This noise reduction will be applied to all high ISO speeds but will be much more noticeable at the highest ISO levels.

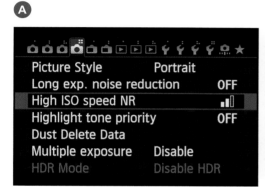

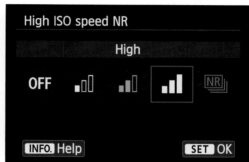

Controlling the Minimum and Maximum ISO

By default, the ISO on the 70D can be set anywhere between 100 and 12800. This is true when selecting the ISO manually, or when using the Auto ISO feature (to have the camera select the ISO automatically). However, there may be some situations in which you would like to control the minimum and maximum ISO speeds, such as if you want to work in low light using auto ISO but don't want the ISO pushed unintentionally to a very high setting. In these situations, you will want to make some adjustments in the camera's menu to control this ISO range.

Setting up minimum and maximum Auto ISO speeds

1. Press the Menu button and scroll to the third shooting tab.

2. Scroll down to the ISO Speed Settings option and press Set (**A**).

3. Use the Quick Control Dial to select the Auto ISO Range option, and then press Set again (**B**).

4. Using the Quick Control Dial, select the Maximum number and press Set. Then use the Multi-Controller to change this number to the highest ISO level in which you are comfortable shooting (**C**). When finished, press Set.

5. Use the Quick Control Dial to scroll to the OK button, and then press Set to lock in your changes.

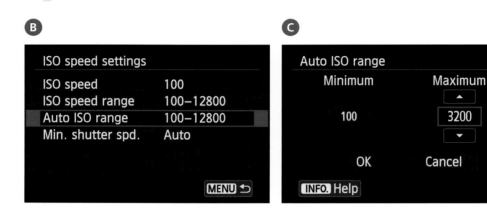

Using a Very High ISO

If you're finding that ISO 12800 just isn't high enough for you, you have the option of increasing it to the highest level, ISO 25600. This setting won't appear as a number, but as an "H" on your top LCD panel and within the viewfinder. Once again, we'll tap into the 70D's custom settings to raise your ISO setting.

Setting up the ISO Expansion feature

1. Press the Menu button and scroll to the third shooting tab.

2. Scroll down to the ISO Speed Settings option and press Set (**A**).

3. Use the Quick Control Dial to select the ISO Speed Range option, and then press Set again (**B**).

4. Using the Quick Control Dial, select the Maximum number and press Set. Then use the Multi-Controller to change this number to the highest ISO level available, which is listed as H(25600) (**C**). When finished, press Set.

5. Use the Quick Control Dial to scroll to the OK button, and then press Set to lock in your changes. Now that you've raised the high end of the ISO range, you can set the camera's ISO to its very highest ISO speed possible.

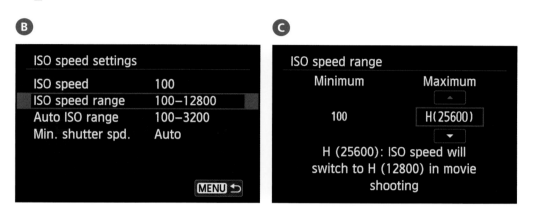

While you are able to capture images in extremely low-light situations, the noise from this setting is highly visible (**Figure 7.2**). My recommendation is to use the H setting sparingly and only as a last resort.

ISO 100 · 1/30 sec. ·
f/5.6 · 100mm lens

ISO 25600 · 1/8000 sec. ·
f/5.6 · 100mm lens

Figure 7.2
It's not difficult to see the difference in quality that extremely high ISO levels can produce. This is a cropped portion of an image photographed at two different ISO settings. The left half shows the photo taken at ISO 100 and has virtually no noise, while the right half was photographed at ISO 25600 (the H setting) and produces an enormous amount of color noise and grain.

Stabilizing the Situation

Many of today's Canon lenses come with a feature called image stabilization (IS). If you happen to have an IS lens, you have a little extra help keeping your lens stable while doing any type of handheld photography. This is extremely useful in situations where the light is low, but to prevent camera shake, you still need to set your shutter speed slower than you normally would when shooting without a tripod (**Figure 7.3**). Most people can hold their camera steady at 1/60 of a second or faster. The longer your focal length, the faster your shutter speed needs to be in order to keep your images sharp and free of camera shake.

Figure 7.3
I used an IS lens to photograph this image with a shutter speed that normally would have been too slow to shoot handheld with the focal length I was using.

ISO 6400 • 1/80 sec. • f/4 • 70–200mm lens

The Canon IS lenses contain small gyro sensors and servo-actuated optical elements that correct for camera shake and stabilize the image. The IS function is so good that it is possible to improve your handheld photography by two or three stops, meaning that if you are pretty stable at a shutter speed of 1/125, the IS feature lets you shoot at 1/60, and possibly even 1/30 of a second (**Figures 7.4** and **7.5**). To use this feature, just flip the stabilizer switch on your IS-enabled camera to the ON position.

Figure 7.4 (left)
This image was photographed without the use of image stabilization.

ISO 100 • 1/25 sec. • f/5.6 • 100mm lens

Figure 7.5 (right)
I took the same shot as Figure 7.4, but this time I turned on the image stabilization to help steady my shot and prevent motion blur.

ISO 100 • 1/25 sec. • f/6.3 • 10000mm lens

Focusing in Low Light

When you are taking photos in low-light situations, you will find that the camera's auto-focus doesn't always work. But before you can properly and consistently find focus in these instances, you need to understand how your camera's focusing system operates.

First, you should know that when you are trying to focus on your subject, the camera utilizes contrast in the viewfinder in order to establish a focus point. If you were to point your camera at a clean, blank wall and try to focus it right in the center, the lens would hunt around and probably not find focus (**Figure 7.6**). By moving the focus point to an area where there is contrast, the camera will be able to set focus much more quickly (**Figure 7.7**).

If your subject doesn't have enough contrast for the camera to read, you can always use the "focus and recompose" method of shooting, if you find an area of contrast that is at the same distance as your subject. To do this, press the shutter button halfway to set focus, and then—with the button still pressed halfway—recompose your shot in the view-finder. When it's composed the way you like it, press the shutter button fully. The focus should stay where you originally set it.

Figure 7.6 This example shows the focus point in a location that might make it difficult for the camera to find focus, since there is not much contrast in the green portion of the apple.

Figure 7.7 It's best to move the focus point or your position with the camera so that the focus point resets over an area with more contrast.

Another option is to use the manual focusing system. If you are photographing something that is difficult to focus on, like fireworks, you should set your camera's focusing manually. If you point the camera into the dark sky, the autofocusing system will just keep searching for—and not finding—a focus point (**Figure 7.8**). To set your focus manually, just flip the switch on the lens from AF to MF and rotate the front of the lens until your focus is set.

Figure 7.8
In order to focus this star photograph properly, I set the camera to manual focus.

ISO 200 • 1219 sec. • f/2.8 • 14mm lens

Autofocus Assist

Another way to ensure good focus is to enable the 70D's autofocus (AF) assist beam. This setting uses the flash to send out short bursts of light on your subject to help the camera locate detail. If you don't want to use the flash, you can disable it while you take your photos; the flash would be used only temporarily to help find focus but wouldn't actually fire when you take your shot. If you are using the Basic Zone shooting modes where the built-in flash is activated, this feature will be enabled automatically.

Turning on the AF assist beam

1. Set your camera to one of the Creative Zone modes, such as Aperture Priority (Av) or Program mode.

2. Press the Menu button, and then use the Main Dial to get to the Custom Function menu tab (the second menu item from the left).

3. Use the Quick Control Dial to select the C.Fn II: Autofocus setting, and then press the Set button (**A**).

4. Use the Quick Control Dial to get to the fifth section, AF-Assist Beam Firing.

5. Press the Set button and select 0:Enable (if it is not already selected), and then press Set again to lock in your choice (**B**). (If you are using an off-camera Speedlite flash, you will want to select either option 2 or 3.)

6. Press the Menu button to exit, and then press the Flash button located on the front of your camera.

7. Now with the flash in the up position, half-press the shutter button to focus and activate AF Assist.

Troubleshooting the AF assist beam

If the AF assist beam is not firing while half-pressing the shutter, you may need to change a setting or two to make sure it will work. Here are some things to check to ensure that things work smoothly:

- Make sure that your autofocus is not set to AI Servo.
- Make sure that your lens is set to AF (it will not work if you are focusing the lens manually).
- The AF assist beam will not fire if your camera is set to the following modes: Disabling Flash, Landscape, or Moving Subjects.
- If the flash option is disabled in any other shooting mode, the AF assist beam will not fire.

Shooting Long Exposures

Sometimes you'll want to shoot in low light and use a long exposure, such as when photographing fireworks, star trails, or streaks of light coming from cars on the street. To capture quality images with long shutter speeds, the first thing you'll need is a sturdy tripod. It's also a good idea to use a cable release or the self-timer to prevent any type of movement in your image when pressing the shutter button.

Because your camera is stabilized on a tripod, you don't need a high ISO. In fact, it's actually better to keep the ISO low (usually between 100 and 400) to reduce the amount of noise in an image (**Figure 7.9**). Often with long exposures you'll introduce a different type of noise in your image because of the amount of time the shutter is open. This noise is referred to as "pattern noise" or "hot pixels," and the 70D has a setting that helps to reduce it.

Now that the noise is under control, you need to determine the camera mode to use when photographing long exposures. When I photograph long exposures, I will use either Av or Manual mode. Sometimes I start in Av so I can choose the aperture and then see what the camera thinks is the best shutter speed. After I take a few test shots to get an idea of what range works well, I switch into Manual mode and continue from there. You will probably find that using manual focus is the best choice as well, since usually it will be too dark for your camera to find focus on its own.

Figure 7.9
I used a very low
ISO and a 30-second
shutter speed to
photograph this
long exposure
of Seattle.

ISO 100 · 30 sec. ·
f/9.5 · 70–200mm lens

Self-time your way to sharper images

Whether you are shooting with a tripod or resting your camera on a counter, you can increase the sharpness of your pictures by taking your hands out of the equation. Whenever you use your finger to press the shutter button, you are increasing the chance that there will be a little bit of shake in your image. If you don't have a cable release to trigger the shutter button, try setting up your camera's self-timer. To do so, just press the Quick Control button and select the Drive mode by pressing it with your finger (**Figure 7.10**). Then choose between either a 2-second or 10-second self-timer (**Figure 7.11**).

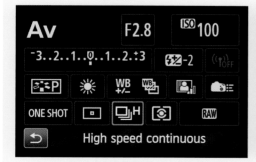

Figure 7.10 You can access self-timer options by clicking the Quick Control button and pressing the Drive mode with your finger.

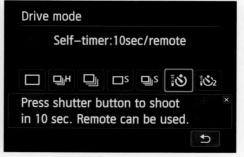

Figure 7.11 The Drive mode has two self-timer options: 10 seconds and 2 seconds.

Turning on the Long Exposure Noise Reduction setting

1. Press the Menu button and scroll to the fourth shooting tab.

2. Scroll down to the Long Exp. Noise Reduction setting and press Set (**A**).

3. Use the Quick Control Dial to select either Auto or On, and then press the Set button (**B**).

4. Press the Menu button to exit. This noise reduction will be applied to all images with exposures that are 1 second or longer.

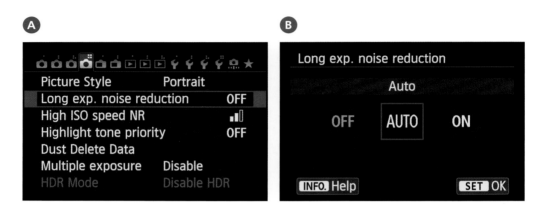

Note: When using the Long Exposure Noise Reduction setting, you'll notice some lag time after taking each photograph. This is because the camera is working and reducing the noise in the most recent shot. You won't be able to take another photo until this process is complete.

Using the Built-in Flash

There are going to be times when you have to turn to your camera's built-in flash to get the shot. The pop-up flash on the 70D is not extremely powerful, but with the camera's advanced metering system, it does a pretty good job of lighting up the night ... or just filling in the shadows.

Manual callout

The light produced from the built-in flash on your 70D can reach only certain distances, but these are dependent on your aperture and ISO speed combination. For a detailed chart that lists the effective range of your built-in flash, please turn to page 118 in the EOS 70D Basic Instruction Manual.

The built-in flash will pop up automatically in most of the Basic Zone shooting modes (Full Auto, Creative Auto, Portrait, etc.) if the camera senses that there isn't sufficient light for your scene. In the Creative Zone modes (P, Av, Tv, and so on), you'll need to push the Flash button, located on the front of your camera, to activate it.

Shutter Speeds

The standard flash synchronization speed for your camera is between 1/60 and 1/250 of a second. If you set the shutter speed faster than 1/250 of a second, it will be too fast to catch all the light produced from the flash. In fact, you'll find that your camera won't let you go beyond 1/250 of a second when the pop-up flash is activated.

The key to great flash photography is controlling the shutter speed. The longer your shutter is open, the more ambient light you let into your image. If you are photographing people during a sunset and drop your shutter speed low enough to capture the light behind them, you can add beautiful colors to the background. Using different shutter speeds with a flash makes it possible to create some fun and creative shots as well (see Chapter 10, "Advanced Techniques"). Let's take a look at how each of the camera modes affects the shutter speed when using your flash.

 Program (P): The shutter speed is set automatically between 1/60 and 1/250 of a second. The only adjustment you can make in this mode is to your exposure compensation by using the Quick Control Dial to change the f-stop.

 Shutter Priority (Tv): You can adjust the shutter speed to as fast as 1/250 of a second all the way down to 30 seconds. The lens aperture will adjust accordingly, but typically at long exposures the lens will be set to its largest aperture.

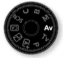 **Aperture Priority (Av):** You will select the aperture, and the shutter speed will be adjusted automatically between 1/250 of a second all the way down to 30 seconds.

Metering Modes

The built-in flash uses a technology called E-TTL II (Evaluative Through the Lens) metering to determine the appropriate amount of flash power to output for a good exposure. When you press the shutter button halfway, the camera adjusts focus quickly while gathering information from the entire scene to measure the amount of ambient light. As you press the shutter button completely, a pre-flash occurs to meter the light off the subject, and a determination is made as to how much power is needed to balance the subject with the ambient light. This applies to the P, Tv, and Av camera modes.

If you have special metering needs, such as a very light or very dark background, you might consider using the Flash Exposure (FE) Lock to meter off your subject and then recompose your image in the viewfinder. This feature works much like the Automatic Exposure (AE) Lock function that was discussed in Chapter 4, "Say Cheese!"

Using the FE Lock feature

1. Press the Flash button on the front of your camera to turn on the built-in flash, then point the camera at the area on which you want to base the flash exposure (normally, this is your subject).

2. Press the FE Lock button, located on the back of the camera (the button with the asterisk above it). You will see "FEL" (Flash Exposure Lock) appear momentarily on the bottom of the viewfinder, and the flash will fire a pre-flash to measure exposure. The AE/FE lock symbol (an asterisk) will also appear in the viewfinder.

3. Recompose the scene as you like, focus, and press the shutter button completely.

The FE Lock will cancel after each exposure, so you have to repeat these steps each time you need to lock the flash exposure.

Compensating for the Flash Exposure

Sometimes your flash will be too bright or too dark for your subject. While the E-TTL II system is highly advanced and will get the flash's output close to where it should be, it doesn't always know what you want the image to look like. What's great about your flash is that it has its own exposure compensation that you can adjust as easily as the aperture and shutter speed exposure compensation that you learned about in Chapter 3, "Camera Shooting Modes."

Like exposure compensation, flash compensation allows you to dial in a change in the flash output in increments of 1/3 of a stop. You will probably use this most often to tone down the effects of your flash, especially when you are using the flash as a subtle fill light.

Using the Flash Exposure Compensation feature to change the flash output

1. Press the Q button on the back of the camera to bring up the Quick Control screen.

2. Use the Multi-Controller to select the Flash Exposure Comp. options box (**A**).

3. Using the Main Dial, scroll right (to increase/brighten) or left (to decrease/darken) the flash output. You can also press the Set button to bring you to a dedicated screen and increase or decrease the flash output from there (**B**).

The Flash Exposure Compensation feature does not reset itself when the camera is turned off, so whatever compensation you have set will remain in effect until you change it. Your only clue to knowing that the flash output is changed will be the presence of the Flash Exposure Compensation symbol in the viewfinder. It will disappear when there is zero compensation set.

Reducing Red-Eye

When photographing people with an on-camera flash, one thing that we've all seen and would like to avoid is red-eye. This effect is the result of the light from the flash entering the pupil and then reflecting back as an eerie red glow. This is especially true when it's dark and the subject's eyes are dilated. It occurs most often when you're using an on-axis flash (a flash that's aligned with the lens of your camera), since most people will be looking at the camera's lens, and thus very near the flash, when their photo is taken.

There are two ways to avoid this problem. The first is to move the flash away from the camera so that it is pointing the light at your subject off-axis from the lens; obviously, this isn't an option if you're using the built-in flash. The second is to turn on the 70D's Red-Eye Reduction feature. This is a simple feature that shines a light from the camera at the subject, causing their pupils to shrink and thus eliminating or reducing the effects of red-eye.

The feature's default setting is Off, so you need to turn it on in the shooting menu.

Turn on the lights!

When shooting indoors, another way to reduce red-eye—or just to shorten the length of time that the reduction lamp needs to be shining into your subject's eyes—is to turn on a lot of lights. The brighter the ambient light levels, the smaller the subject's pupils will be. This will reduce the time necessary for the red-eye reduction lamp to shine, and it will allow you to take more candid pictures, because your subjects won't be required to stare at the red-eye lamp while waiting for their pupils to reduce.

Turning on the Red-Eye Reduction feature

1. Press the Menu button, and then use the Main Dial to scroll to the second shooting menu tab.

2. Use the Quick Control Dial to select Red-Eye Reduc. (**A**), and then press the Set button.

3. Using the Quick Control Dial, select Enable and press the Set button (**B**).

4. Press the Menu button or the shutter button to return to shooting mode.

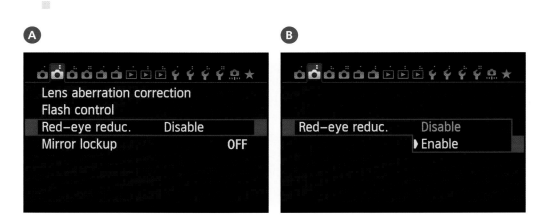

To get the full benefit of the Red-Eye Reduction feature, you should hold the shutter button down halfway, which causes the reduction light to shine into your subject's eyes. A small scale will appear in the viewfinder that shows how long to hold the shutter button before pressing completely. Once the countdown scale has reduced down to nothing, press the shutter button completely to take the picture.

Note: When using the AF-ON button for focusing, the reduction light will shine only once you press the shutter button. In order for the red-eye reduction light to work properly, you will need to half-press the shutter button and wait for the countdown to be completed before taking your photo.

Disabling the flash

You may not want the flash to fire in all situations, or you may want the flash to work only with the AF assist beam (mentioned earlier in this chapter). If this is the case, you will want to disable the flash:

1. Press the Menu button, and then use the Main Dial to scroll to the second shooting menu tab.

2. Using the Quick Control Dial, select Flash Control and press the Set button (A).

3. Select the Flash Firing option (B), press Set, and then select Disable (C).

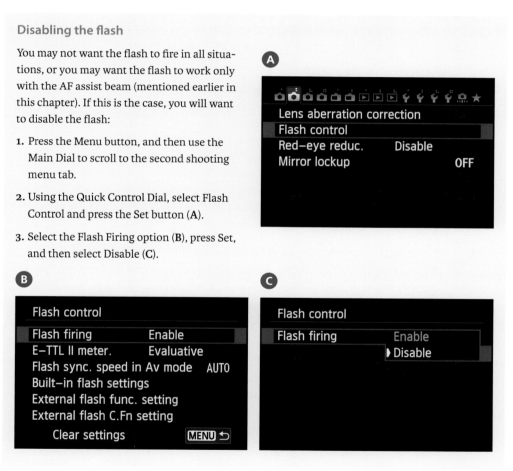

Using Second Curtain Sync

The 70D has two flash synchronization modes: first curtain and second curtain. The term *curtain* relates to the opening and closing of the shutter—the first curtain refers to when the shutter is being opened, and the second curtain describes the point just before the shutter is closed (try to visualize a curtain on a stage opening and closing; the amount of time it's opened is how long your shutter speed is).

The built-in flash on your camera can be synchronized to fire during the first curtain or the second curtain. This applies only to shutter speeds of 1/30 of a second or slower, since a faster shutter speed moves so quickly that the mode wouldn't really matter. But for longer exposures, I find that using the second curtain flash is usually the best option.

Flash sync

The basic idea behind the term flash synchronization (flash sync for short) is that when you take a photograph using the flash, the camera needs to ensure that the shutter is fully open when the flash goes off. This is not an issue if you are using a long shutter speed such as 1/15 of a second, but it becomes more critical for fast shutter speeds. To ensure that the flash and shutter are synchronized so that the flash is going off while the shutter is open, the 70D implements a top sync speed of 1/250 of a second. This means that when you are using the flash, your shutter speed cannot be any faster than 1/250. If you used a faster shutter speed, the shutter would actually start closing before the flash fired, causing a black area to appear in the frame where the light from the flash was blocked.

For example, imagine you are photographing a person running past you in a race. It's somewhat dark outside, maybe at sunset, so you can get away with a slower shutter speed of 1/15 of a second, but you also want to use your flash to freeze the subject in place. If you take the photo in First Curtain Sync mode, the flash will fire right away, and the person will run across the frame during the rest of the exposure. Because you used a slower shutter speed, you will see blur in front of the runner, as the flash froze the subject in place at the beginning of the exposure. If you change your flash setting to Second Curtain Sync and take the same photograph, you'll see some blur across the frame after you press the shutter button, but the flash will fire at the end of the exposure, making the blur appear behind the runner.

Setting Second Curtain Sync

1. Press the Menu button and use the Main Dial to scroll to the second camera setup menu tab.

2. Select Flash Control and press Set.

3. Use the Quick Control Dial to select the Built-in Flash Settings option, and then press the Set button (**A**).

4. Use the Quick Control Dial to select Shutter Sync and press Set (**B**).

5. Change the setting to 2nd Curtain and press the Set button to lock in your changes (**C**).

Now, when you are using a slow shutter speed (slower than 1/30 of a second), once you press the shutter button, you'll notice a quick burst of light from the flash to measure exposure, then the full burst at the end of the exposure to light your subject.

A Few Words about External Flashes

As you've learned in this chapter, the built-in pop-up flash on the 70D is a convenient addition to the camera and can be useful, but as far as quality of light goes, it's average. I don't use this flash very frequently in my photography, since I find that there are other, more flattering ways to light my subjects.

Many photographers use external flashes (also referred to as Speedlites) or strobe lights in their photography when they need an additional and portable light source (**Figure 7.12**). Speedlites are extremely sophisticated for their size and can produce an amazing quality of light with customizable settings. Their size allows you to place them almost anywhere in a scene to light your subject. Strobes, on the other hand, require an external light source to power them, but they can be very powerful and are a popular choice for studio photographers.

One feature on the Canon 70D is its ability to fire wirelessly any of the Canon Speedlites by using the pop-up flash as a trigger. This powerful feature opens up a lot of photographic opportunities when it comes to using off-camera flash. I won't go into the details of how to use this feature (or any other off-camera flash photography methods) in this book, but many resources are available if you're interested in trying it out. The 70D instruction manual is a good place to start, but a Web site like Strobist™ (http://strobist.blogspot.com) will offer more advanced information about creating great images using small flashes.

Figure 7.12
Off-camera lights can be very useful for many types of photography, including still life and food.

ISO 100 • 1/125 sec. • f/5.6 • 28mm lens

Chapter 7 Assignments

Now that we have looked at the possibilities of shooting after dark, it's time to put it all to the test. These assignments cover the full range of shooting possibilities, both with flash and without.

Steady your shots with IS

It's important to understand just how powerful your IS lens can be in steadying your shots. Using your IS lens, find a subject and set your camera to Tv mode. With the IS button turned to On, take a few photos at 1/30, 1/15, and 1/8 of a second. Then turn the IS feature to Off and take the same shots with the same settings. Compare your images to see how much more camera shake you are creating in each shot.

Push your ISO to the extreme

Turn on the ISO Expansion feature. Now find a place to shoot where the ambient light level is low. This could be at night or indoors in a darkened room. Using the mode of your choice, start increasing the ISO from 100 until you get to 25600. Make sure you evaluate the level of noise in your image, especially in the shadow areas. Only you can decide how much noise is acceptable in your pictures.

Get rid of the noise

Turn on the High ISO Speed Noise Reduction feature and repeat the previous assignment. Find your acceptable limits with the noise reduction turned on. Also pay attention to how much detail is lost in the shadows with this function enabled.

Take long exposures in the dark

If you don't have a tripod, find a stable place to set your camera outside and try some long exposures. Set your camera to Av mode and then use the self-timer to activate the camera (this will keep you from shaking the camera while pressing the shutter button), or use a cable release if you have one.

Shoot in an area that has some level of ambient light, be it a streetlight or traffic lights, or even a full moon. The idea is to get some late-night, low-light exposures. For best results, perform this assignment and the next assignment in the same shooting session using the same subject.

Reduce the noise in your long exposures

Now repeat the last assignment with Long Exposure Noise Reduction set to On. Look at the difference in the images that were taken before and after the noise reduction was enabled.

Test the limits of the pop-up flash

Wait for the lights to get low and then press the pop-up flash button to start using the built-in flash. Try using the different shooting modes to see how they affect your exposures. Use the Flash Exposure Compensation feature to take a series of pictures while adjusting from −3 stops all the way to +3 stops so that you become familiar with how much latitude you will get from this feature.

Get the red out

Find a friend with some patience and a tolerance for bright lights. Have them sit in a darkened room or outside at night, and then take their picture with the flash. Now turn on Red-Eye Reduction to see if you get better results. Don't forget to wait for the red-eye timer to extinguish completely before taking the picture.

Get creative with 2nd Curtain Sync

Now it's time for a little creativity. Set up your camera for 2nd Curtain Sync and start shooting. Moving targets are best. Experiment with Tv and Av modes to lower the shutter speeds and exaggerate the effect. Try using a low ISO so the camera is forced to use longer shutter speeds. Be creative and have some fun!

Share your results with the book's Flickr group!
Join the group here: flickr.com/groups/canon70dfromsnapshotstogreatshots

ISO 400 • 1/750 sec. •
f/4 • 100mm lens

8
Creative Compositions

Improve your pictures with sound compositional elements

To make a beautiful photograph, you need more than just knowledge about your camera and its settings—you should also have a good understanding of how to compose your images. Being able to create beautiful compositions is an extremely useful skill and sometimes is more important than the nitty-gritty technical aspects of photography. Just knowing one or two tricks isn't enough, but learning several methods and piecing them together will help you to create great images. In this chapter, we will examine how you can add interest to your photos by utilizing common compositional techniques.

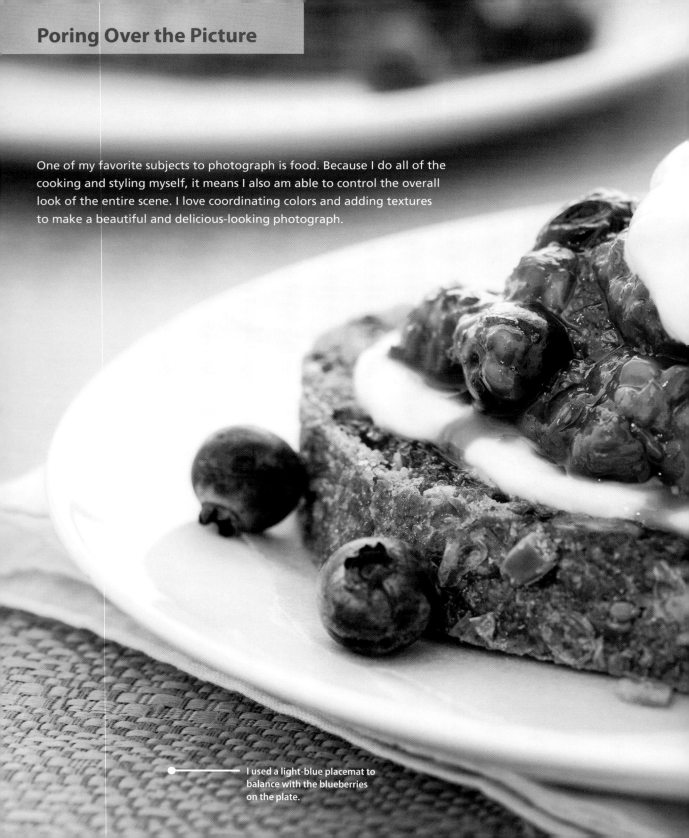

Poring Over the Picture

One of my favorite subjects to photograph is food. Because I do all of the cooking and styling myself, it means I also am able to control the overall look of the entire scene. I love coordinating colors and adding textures to make a beautiful and delicious-looking photograph.

I used a light-blue placemat to balance with the blueberries on the plate.

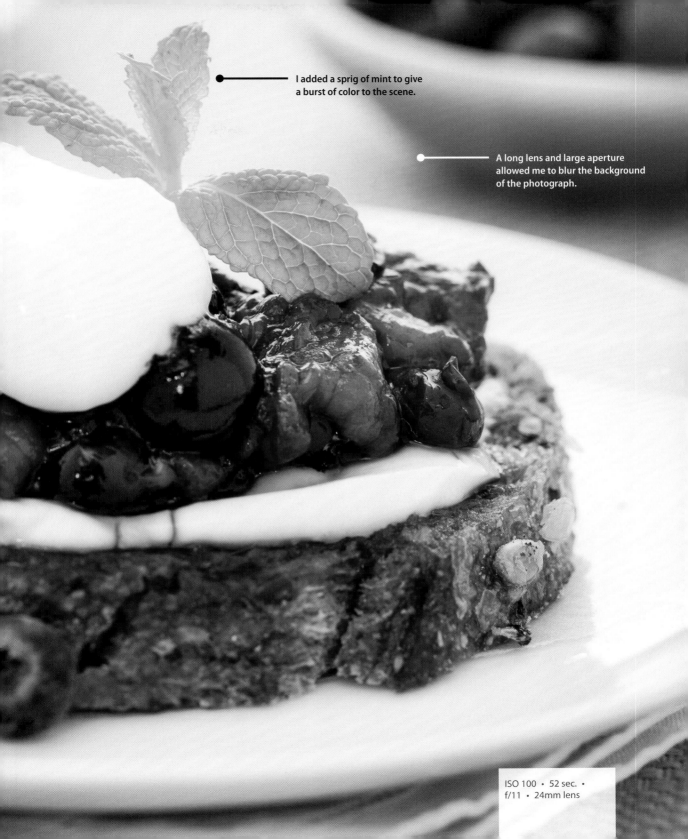

I added a sprig of mint to give a burst of color to the scene.

A long lens and large aperture allowed me to blur the background of the photograph.

ISO 100 • 52 sec. • f/11 • 24mm lens

Depth of Field

Selective focusing with a wide aperture can add a lot of creativity to your images. You are telling the viewer where you want the focus of the image to be, and the meaning and story change depending on what is in focus. Using a telephoto lens can compress your background even more, decreasing the depth of field and making the background or foreground even blurrier. But take into consideration that just because your background or foreground is blurry, it doesn't mean you can't show detail in those areas (**Figures 8.1 and 8.2**).

If you want the entire image to be in focus, you would use a smaller aperture. Images with great depth of field, such as a landscape or an image with a lot of detail, direct the viewer to look at the entire scene (**Figure 8.3**).

Figure 8.1 **I used a wide aperture to blur the background, but you can still see a woman making coffee, which helps tell a story in the photograph.**

ISO 10,000 • 1/125 sec. • f/3.5 • 100mm lens

Figure 8.2
The squid is the focus for this image, but the blurry man in the background is still visible in the shot.

ISO 400 · 1/6000 sec. ·
f/3.5 · 100mm lens

Figure 8.3
I wanted to capture all the details in this image, so I used a small aperture so that the entire scene was in focus.

ISO 1250 · 1/250 sec. ·
f/11 · 100mm lens

Backgrounds

When taking pictures, we usually pay close attention to our subject. This, of course, is a wise thing to do when using your camera, but it's also very important (and sometimes even more important) to pay attention to the background or backdrop *behind* your subject (**Figure 8.4**). The background can make or break your photograph. You should be careful of anything behind your subjects that could appear to be sticking out of their heads (trees are a common culprit) or of busy backgrounds that could compete with whatever or whoever you are photographing.

Figure 8.4
I positioned the objects in the background so that they did not intersect with the main subject in this photograph.
ISO 100 · 1/4 sec. · f/6.7 · 100mm lens

Angles

Strong angles in an image can add a lot to the composition, especially when you have both straight lines and curves at different angles in the same scene (**Figure 8.5**). This can create a tension that is different from the standard horizontal and vertical lines that we are so accustomed to seeing in photos.

You can accentuate the angles in your images by tilting the camera, thus adding an unfamiliar angle to the subject, which draws the viewer's attention (**Figure 8.6**).

Figure 8.5
The assortment of angles and curves on this building added visual interest to the image.

ISO 200 · 1/70 sec. · f/11 · 35mm lens

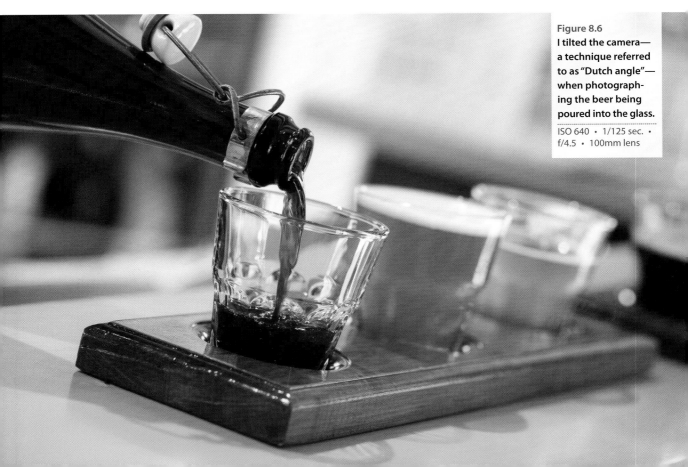

Figure 8.6
I tilted the camera— a technique referred to as "Dutch angle"— when photograph- ing the beer being poured into the glass.

ISO 640 · 1/125 sec. · f/4.5 · 100mm lens

Creative and specialty lenses

You can create shallow and great depth-of-field effects with any lens you own, but some specialty lenses create unusual and uniquely shaped *bokeh* (the area that is out of focus in your image) and also offer an enormous range of creative photographic possibilities.

Tilt-Shift Lens

The tilt-shift lens was created to correct lens distortion in images. It's a popular lens for architectural photography, because it keeps the lines of structures straight, not curved like you would see with wide-angle lens distortion (**Figures 8.7** and **8.8**). You can also tilt the lens to give your photos a unique blur effect in-camera, which can be fun to use to create a miniaturized look to an image.

Note: The 70D has a Creative filter you can apply to your images in-camera that mimics the tilt-shift effect. Please turn to Chapter 10, "Advanced Techniques," for more information.

Figure 8.7 Tilt-shift lenses are helpful in preventing distortion with architectural images.

ISO 400 • 1/15 sec. • f/5.6 • TS–E 17mm lens

Figure 8.8 I use a tilt-shift lens for a large portion of my landscape images; I "shift" the lens to keep trees straight up and down.

ISO 100 • 40 sec. • f/11 • TS–E 24mm lens

Lensbaby

The Lensbaby creates a similar bokeh effect to the tilt-shift lens, but instead of a focus area that is straight across, it has a "sweet spot" within the frame that can be moved around to give the image a different look, depending on the subject (**Figure 8.9**). The moveable lens comes with an array of accessories that can change the look of the image. One of my favorite accessories for this lens is the Creative Aperture kit. It allows you to change the shape of the aperture, which will affect the shape of the bokeh. The bokeh shapes of apertures in traditional lenses and the normal Lensbaby are usually circular or octagonal, but with the Creative Aperture kit you can change the shape to hearts, stars, or virtually anything you can imagine (**Figure 8.10**).

Figure 8.9
In this photo, the boy's face is in focus and the rest of the image is blurred. The area that is in focus is sometimes referred to as the "sweet spot."

ISO 200 · 1/2000 sec. · f/2.8 · Lensbaby Composer lens

Figure 8.10
I photographed this image with a heart-shaped aperture to change the shape of the background bokeh.

ISO 200 · 1/60 sec. · Heart-shaped aperture · Lensbaby Composer lens

Point of View

One thing I love about photography is that I get to show the world what I see, and it's always fun to try photographing a subject from a different point of view to see what I can create. You don't have to change your perspective drastically to get results—sometimes you can capture a great image simply by moving yourself up or down a few feet (**Figure 8.11**). Not only will you be looking at the subject from a different perspective, but your surroundings will also change, sometimes for the better. Try moving up and down when taking photos to see what kind of results you can get.

Figure 8.11
I got low to the ground and positioned myself behind a patch of flowers to photograph the building off in the distance.
ISO 200 • 25 sec. • f/32 • 70–200mm lens

Giving your images a different perspective can also change the dynamics of the image (**Figure 8.12**). By getting in close, you bring viewers into the scene so they feel as if they're experiencing the moment along with you.

Figure 8.12
I was practically inside of this hot air balloon when it was being inflated, a view you don't typically get to see.

ISO 100 · 1/40 sec. · f/5.6 · 14mm lens

Patterns, Textures, and Shapes

Geometric patterns and shapes are visually appealing and can be found almost anywhere you look (**Figure 8.13**). You see patterns not only in fabricated objects but also in nature, where some of the most beautiful and balanced patterns appear.

Another thing to watch for is textures (**Figure 8.14**). Textures make great images, whether you're placing your subject in front of a grungy and textured wall (such as for a wedding or portrait image), photographing a decomposing building, or just photographing the texture on its own. I like to photograph lots of textured surfaces and keep a catalog of them on my computer to composite into images using software such as Adobe Photoshop.

Figure 8.13
The assortment of shapes reflected on this building added visual interest to the image.

ISO 100 • 1/2000 sec. • f/1.8 • 50mm lens

Figure 8.14
I photograph textures, like this one, to use in my photographs when doing composite work in Adobe Photoshop.

ISO 400 • 1/45 sec. • f/2.8 • 40mm lens

Color

Color can play an extremely important part in composition, and understanding how color works will only help your images. In color theory, every color has an "opposite" color that is complementary. On a color wheel the main colors are red, yellow, and blue, and their opposite colors are green, purple, and orange, respectively. Using these colors correctly can add balance and symmetry to your images (**Figures 8.15 and 8.16**).

Figure 8.15
The yellow and blue colors in this image are complementary and help to balance the composition of the shot.

ISO 200 • 1/200 sec. • f/4 • 70–200mm lens

Figure 8.16
The turquoise wall in this photo is a nice contrast to the orange-brown broom up against it.

ISO 800 • 1/50 sec. • f/4 • 70–200mm lens

You can also use color as a theme in your photographs. Oftentimes I will match the background of my scene with a similar color in the subject to keep continuity throughout the photograph (**Figures 8.17 and 8.18**).

Figure 8.17 **Try to create color themes in your photos. In this image, the yellow in the woman's scarf matches the yellow paint on the wall directly behind her.**

ISO 100 • 1/200 sec. • f/5.6 • 10–20mm lens

Figure 8.18 **I used a shade of blue for the placemat to balance with the color of the blueberries.**

ISO 100 • 0.5 sec. • f/8 • 70–200mm lens

Leading Lines

Finding ways to draw your viewer's eyes toward the subject of your photo is important in photographic composition, and one way to do this is to incorporate leading lines in the image (**Figure 8.19**). You can also use this technique to create a vanishing point when the subject you're photographing is creating the lines— for example, a winding road twirling toward the corner of your frame or a row of trees going off into nowhere (**Figure 8.20**).

Figure 8.19
The leading lines of the walkway draw the viewer's eyes to the lighthouse in this photograph.

ISO 100 • 1/250 sec. • f/11 • 70–200mm lens

Figure 8.20
The pathway creates a vanishing point, which leads your eyes toward the center of the frame and makes you wonder where it might be going.

ISO 100 • 4 sec. • f/16 • 40mm lens

Rule of Thirds

As mentioned in previous chapters, it's usually a good idea to avoid placing your subject directly in the center of the frame. Typically, sticking to the "rule of thirds" principle—placing the subject or horizon line one-third of the way from the edge of the frame—results in a pleasing composition (**Figures 8.21 and 8.22**).

Figure 8.21
I used the rule of thirds to place my subject in the lower-right third-line of this image.

ISO 800 · 1/750 sec. · f/4.5 · 100mm lens

Figure 8.22
Placing the car in the left-third portion of the frame helps balance the scene as well as draw attention to the beautiful vineyards and fields off in the distance.

ISO 100 · 1/350 sec. · f/4.5 · 100mm lens

Frames within Frames

The image you are photographing is already framed inside the confines of the viewfinder. Placing your subject within another frame can be a good way to draw the viewer's eyes toward the part of the image you'd like to emphasize (**Figures 8.23 and 8.24**). Framing doesn't need to be on all four sides of your image; you can frame your scene creatively in many other ways, just like I did with the hot air balloons in **Figure 8.25**.

Figure 8.23 I used the archway as a frame for the hallway in this scene.

ISO 400 • 1/50 sec. • f/8 • 70–200mm lens

Figure 8.24 The man is framed by the window in this scene, and is a much more interesting composition than if he were standing outside of the building.

ISO 800 • 1/320 sec. • f/5.6 • 70–200mm lens

Figure 8.25 I used the hot air balloons on the top portion of this image to add a unique frame to the scene.

ISO 800 • 1/6 sec. • f/11 • 24mm lens

Chapter 8 Assignments

Apply the shooting techniques and tools that you've learned in the previous chapters to these assignments and you'll improve your ability to incorporate good composition into your photos. Make sure you experiment with all the different elements of composition and see how you can combine them to add interest to your images.

Learn to see lines and patterns

Take your camera for a walk around your neighborhood and look for patterns and angles. Don't worry as much about getting great shots as about developing an eye for details.

Photograph a theme

Go on a photowalk and give yourself a theme to photograph, such as a specific color or shape. Try to stick to this theme, and take photos and look for images that contain it. Doing this will help open your eyes to your environment in a new way and perhaps discover things you may not have seen otherwise.

Change your perspective

Take a photo from a standing position, then move down lower to the ground and photograph the same thing. Try to get up higher—use a stepladder or just inch up on your toes. Compare your images and see how different your subject looks from each point of view.

Use the aperture to focus attention

Depth of field plays an important role in defining your images and establishing depth and dimension. Practice shooting wide open, using your largest aperture, for the narrowest depth of field. Then find a scene that would benefit from extended depth of field, using very small apertures to give sharpness throughout the scene.

Lead viewers into a frame

Look for scenes where you can use elements as leading lines, and then look for framing elements that you can use to isolate your subject and add both depth and dimension to your images.

Share your results with the book's Flickr group!
Join the group here: flickr.com/groups/canon70dfromsnapshotstogreatshots

ISO 2500 • 1/180 sec. •
f/6.7 • 100mm lens

9

Lights, Camera, Action!

Making movies with the Canon 70D

The ability to shoot still images and movies side by side is a huge advantage with today's digital SLR cameras, and it opens up a world of creative possibilities. Many still photographers are reinventing themselves and finding new ways to express their creativity and art through making videos. Your Canon 70D makes this all possible for you, too.

Poring Over the Video Camera

Camera Back

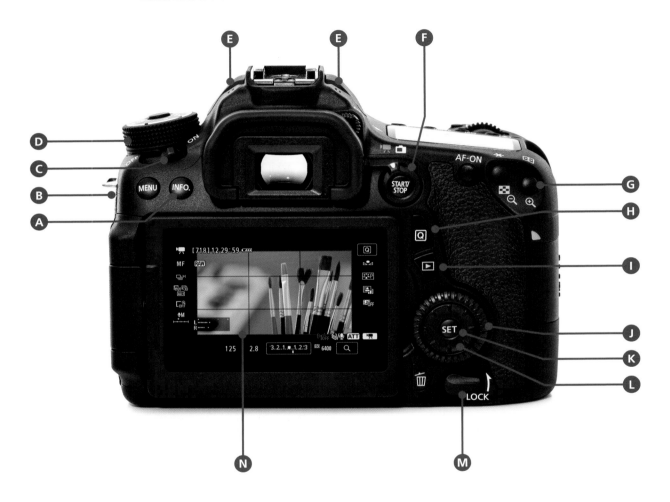

A Info Button (Electronic Level)

B Terminal Cover

C Power Switch

D Mode Dial

E Microphone

F Movie Shooting Switch

G Magnify Button

H Quick Control Button

I Playback Button

J Quick Control Dial

K Multi-Controller

L Setting Button

M Multi-Function Lock Switch

N LCD Monitor

LCD Monitor

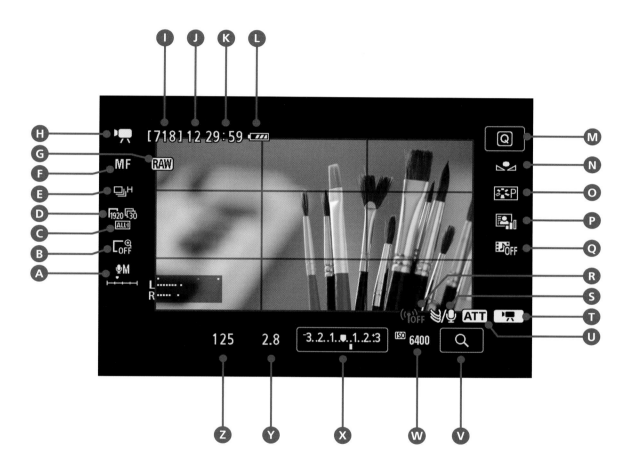

A Recording Level: Manual

B Digital Zoom

C Movie-Recording Size

D Compression Method

E Drive Mode

F Focus Method

G Still Image Quality

H Movie Shooting Mode

I Possible Shots

J Maximum Burst

K Movie Shooting Remaining Time/Elapsed Time

L Battery Check

M Quick Control

N White Balance

O Picture Style

P Auto Lighting Optimizer

Q Video Snapshot

R Wi-Fi Function

S Wind Filter

T Exposure Mode

U Attenuator

V Magnify/Digital Zoom

W ISO Speed

X Exposure Level Indicator

Y Aperture

Z Shutter Speed

Getting Started

The Canon 70D has a separate shooting mode specifically for videos. To get to this mode, just flip the Movie Shooting switch, on the back of the camera, to Movie Shooting (**Figure 9.1**). Once you do this, your camera will go into Video mode and the LCD monitor will light up, ready to start shooting. But before jumping into making movies, you'll need to make a few decisions. To get started, let's go over some of the basic settings you'll use to ensure that you're getting the quality you want.

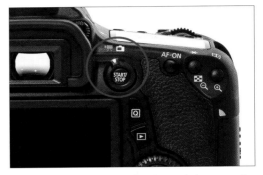

Figure 9.1 **Use the Movie Shooting switch to record video on your 70D.**

Video Quality

The first setting that's important to understand is resolution. You'll need to know which movie-recording size you want to use, along with the frame rate, or frames per second (fps). The files are recorded as .mov files, and the quality and the resolution (size) of each file is measured in pixels. The fps rate is defined as the number of frames (images) the camera records in a 1-second timeframe.

Frame rates

The frame rate numbers listed on your camera are an approximate number of what the camera actually records. The true frame rates are as follows: 24: 23.976; 25: 25.00; 30: 29.97; 50: 50.00; and 60: 59.94.

The 70D has three different sizes you can choose from:

- 1920x1080: This is the full High Definition (HD) setting (16:9 aspect ratio). You have the option to record in 30, 25, or 24 fps. Using this setting at 24 fps is the standard for recording motion pictures. In the Movie Rec. Size menu, this setting is listed as "1920."

- 280x720: This is another HD setting with an aspect ratio of 16:9, but in a smaller resolution. It records movies at 50 or 60 fps and is listed as "1280" in the Movie Rec. Size menu. This is good for shooting Web-sized videos or creating a high-quality, slow-motion effect using editing software. Using this setting will take up the same amount of space on your SD card as the 1920x1080 setting, since it records twice as many fps.

- 640x480: This setting is for Standard Definition (SD) recording and records at a 4:3 aspect ratio. It is listed as "640" in the Movie Rec. Size menu.

In addition to video size, you also have two compression settings to choose from. The compression method you select will affect the file size of your videos. You'll also want to consider how much editing you'll be doing in post-production when choosing a compression setting:

- IPB: This setting will add the most amount of compression to your videos, as it will compress multiple frames at a time, resulting in smaller file sizes. This, in turn, will allow you to store more video on your Secure Digital (SD) card. If you do not plan on editing your video, or plan to do very little editing or post-production, then this compression method is a good choice.

- ALL-I: This setting compresses only one frame at a time, which results in larger file sizes and will fill up your SD card much more quickly. However, if you plan on heavily editing your video in post-production, then choose this setting.

Slow motion

If you want to slow down your videos and create high-quality, slow-motion videos, then you'll want to start by shooting in 720p. This setting records the video at 60 fps so that when you bring it into an editing program, you can set it to play back at 50 percent speed, or 30 fps. Your video will now play back half as quickly as you originally recorded it without sacrificing image quality.

NTSC and PAL

You can set your 70D to record video in one of two formats: NTSC (National Television Standards Committee) or PAL (Phase Alternate Line) (**Figure 9.2**). NTSC is the standard format for broadcasting in North America, South America, and Asia; PAL is the standard format for most European countries and other parts of the world. The main difference between the two formats when shooting with the 70D is their frame rates: 25/50 fps for PAL and 30/60 fps for NTSC. It's recommended that you set your video format to the broadcasting standard for whatever country you're located in.

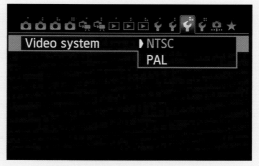

Figure 9.2 **The 70D can record video in one of two formats: NTSC or PAL.**

Setting the movie-recording size and compression

1. On the back of the camera, set the Movie Shooting switch to Video mode.

2. Press the Menu button and use the Main Dial to get to the second movie menu tab.

3. Using the Quick Control Dial, scroll to Movie Rec. Size and press the Set button (**A**).

4. Use the Quick Control Dial to select your preferred setting, and press the Set button to lock in your changes (**B**).

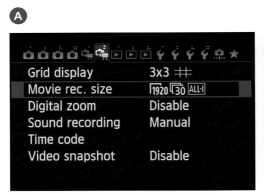

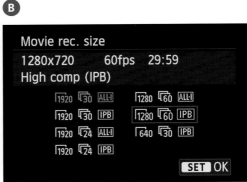

The 70D is also limited in regard to the length of each individual movie file. The longest movie file you can record at a time is 4 GB, which is anywhere from 5 to 18 minutes of recording time at one of the HD settings (the amount of recording time depends greatly on the compression setting you have selected). Typically, this should not be much of an issue, since most videos are recorded in small segments and pieced together during the editing process, but it is good information to know, since there may be times when you'll want to have a movie file that is longer than usual.

However, if you do plan on shooting continually for longer than the permitted time limit, once the 4 GB file has been created, the camera will immediately continue to record a new file. Then you can piece together the files using video-editing software. Also, because video can take up a lot more space than still photos, it's a good idea to use a large memory card, such as a 16- or 32-GB SD card.

Manual callout

The 70D manual gives a detailed description of each file setting (file size, frame rate, and compression setting) and how much recording time you can shoot with a 4 GB, 8 GB, or a 16 GB card. To view this information, please turn to page 138 in the EOS 70D Basic Instruction Manual.

When shooting video with the 70D, it's a good idea to turn off the camera between shots, especially if you're outdoors on a warm or sunny day. The camera's internal temperature is more likely to increase when using Video mode, and shooting for a prolonged period of time could degrade the image quality of your still photos and videos. So when you're not recording, be sure to turn off the camera.

Image Quality: Why Does It Matter?

You might have noticed that an image-quality setting (RAW/JPEG) appears when your camera is in Video mode. Whatever your image quality is usually set to, you'll see that this setting stays the same on the Info screen between recordings. In other words, if you typically shoot in the RAW format, the RAW setting will appear on your screen before you start recording movies (**Figure 9.3**). Just to clarify, the camera does not have the capability to shoot each video frame in the RAW format, but this setting does have a purpose ... trust me!

Let's say you're in the middle of recording a video and you want to take a quick still photo. You don't want to stop the recording, go back to a still shooting mode, change your exposure settings, and so on. Instead of going through all of that trouble just to get one image, all you need to do is press the Shutter button, even if you are still recording your movie. You'll notice a pause in the recording, but after the camera takes the photo, it will return automatically to recording your video. The drawback to this feature is that it creates 1 second of a still image in your movie, but it's a nice feature to have if you need to take still photos temporarily.

Figure 9.3 **The image-quality setting will be visible on the LCD monitor while shooting video.**

Wi-Fi and shooting movies

One important thing to note is that you must have the Wi-Fi option disabled before attempting to shoot movies on the 70D. For more information on changing the Wi-Fi setting, please refer to Chapter 1, "The 70D Top Ten List."

Shooting and Playback

So now that we've gone over some of the basics of getting started with video recording, I'm going to show you how to record video and review it in the Playback mode. There are still a few other things to discuss to ensure that your videos are top-notch quality, but before we get to that, let's put everything to the test—and the only way to do that is to actually shoot some video.

Recording a movie

1. On the back of the camera, set the Movie Shooting switch to Video mode.

2. Compose and focus your scene, and then press the Start/Stop button to begin your recording (**A**). You'll notice a red dot appears in the LCD monitor's upper-right corner, and a countdown timer appears on the top of the screen, indicating your movie length (**B**). This indicates that video recording is in progress.

3. When you are finished recording, press the Start/Stop button again. The red dot will disappear and the timer will stop, indicating that you are no longer recording video.

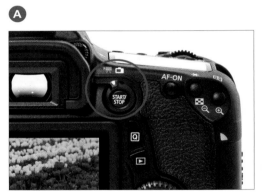

Playing movies

1. On the back of the camera, press the Playback button.

2. Turn the Quick Control Dial until you reach one of your videos. You'll know it's a movie when you see the video camera icon in the LCD monitor's upper-left corner and a large play button in the middle of the screen (**A**). Then press the Set button.

3. To begin playback, press the Set button again (the Play option on the bottom of the LCD monitor will be highlighted by default). You will see the video play, and a countdown timer will appear at the top left of the LCD monitor (press the Info button on the back of your camera if you do not see it) (**B**).

4. To stop or pause playback, press the Set button again. To exit the playback screen, press the Menu button.

The 70D gives you several other options while in the playback screen. **Figure 9.4** shows all of the options you have when viewing movies on your camera.

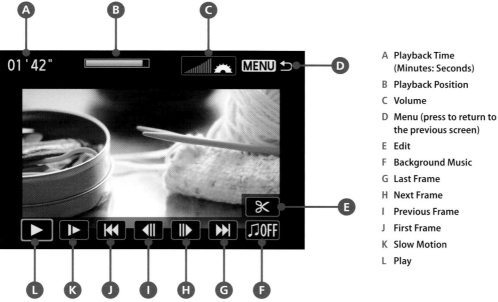

A Playback Time (Minutes: Seconds)
B Playback Position
C Volume
D Menu (press to return to the previous screen)
E Edit
F Background Music
G Last Frame
H Next Frame
I Previous Frame
J First Frame
K Slow Motion
L Play

Figure 9.4 Use the Quick Control Dial to select the other options in the Playback mode. If you recorded sound with your movie, you can also use the Main Dial to adjust the volume during playback.

Video playback on your computer

Viewing movies on your computer that were recorded with your 70D is simple. Just download the .mov files to your computer from the memory card (you can also connect the camera to your computer using a USB cable). If you have a Mac, the movies will play automatically in QuickTime when you open the files; PC users can download this software for free. The Canon Utility software that was included with your camera also has a program, ImageBrowser, that allows you to view still photos and play .mov files on your computer.

Exposure Settings for Video

Setting the exposure for video is similar to setting exposure for still photographs, but you will notice a few differences that will apply only when recording movies. One obvious difference is that you can view your scene only in Live View, and the LCD monitor will display a simulated exposure for what your video will look like during the recording process. There are also some limitations on shutter speed and exposure—keep on reading to learn more about them.

Auto Exposure vs. Manual Exposure

When shooting movies on the 70D, you have two options for exposure: Auto and Manual. Auto is a simple setting to use if you want to get a quick video and don't have time to change the settings manually. One way to shoot in Auto is to select one of the Basic Zone modes, which will be the same as setting the camera to full Auto mode, regardless of the mode you select. Or, if you typically work in one of the Creative Zone modes, you can select from the Shutter Priority (Tv), Aperture Priority (Av), Program (P), or Bulb (B) modes, and they will all function as if you had your camera set to Program mode.

When shooting in either of these zones (Basic or Creative), the camera determines all exposure settings, such as aperture, shutter speed, and ISO. However, if you want to maintain a little bit more control when using Auto, I suggest the Creative Zone. This zone will allow you to change a few settings that normally you would be unable to modify when using the Basic Zone modes, such as exposure compensation and some menu items (the menu options will be different between the Basic Zone and Creative Zone when shooting videos). Overall, with autoexposure you have limited control, so if you want to take full advantage of your DSLR and lenses when shooting video, you'll probably want to give Manual mode a try.

Manual mode for video functions in the same way as it does for still photography: You pick the aperture, shutter speed, and ISO. You can even change your settings while you are recording (although the microphone might pick up camera noises; read more about audio later in this chapter). Manual mode is a great option when shooting video because you have control over all of your settings, particularly the aperture, which controls depth of field in the scene.

One important thing to note when shooting video is that you have some shutter-speed limitations, depending on your fps setting. When shooting with a frame rate of 50 or 60 fps, the slowest shutter speed is 1/60 of a second; for 24, 25, or 30 fps, you can go down to 1/30 of a second. You can't go any faster than 1/4000 of a second, but it's recommended that you keep your shutter speed between 1/30 and 1/125 of a second, especially when photographing a moving subject. The slower your shutter speed, the smoother and less choppy the movement in your video will be.

Setting the Lock switch for exposure compensation

When shooting video in any of the Creative Zone modes (such as Tv, Av, P, or B), one thing you can do to control the exposure is to adjust the exposure compensation. You can do this by turning the Quick Control Dial to the left (to underexpose your scene) or to the right (to overexpose your scene). However, if you want to prevent yourself from changing this setting unintentionally, you will want to make sure that the Lock switch is flipped up, which will prevent the Quick Control Dial from changing your exposure. To ensure that you can make changes, just unlock the switch by moving it all the way down (**Figure 9.5**).

Figure 9.5 **To make changes to the exposure compensation, be sure to keep the Lock switch in the unlocked position (down).**

White Balance and Picture Styles

When shooting video, you want to be sure to get the white balance right. Remember the difference between RAW and JPEG, which you learned about in Chapter 2, "First Things First"? Well, think of a video file as a JPEG. If you were to edit the video file on your computer, it would be difficult to change the white balance without damaging the pixels, and if the white balance is completely off, you might not even be able to salvage the video's original colors.

What's neat about shooting video is that you can see what the video quality will be like before you start recording. This means that you can set the white balance and see it changing right in front of you (this works in the same way as changing your white balance in Live View mode, just like we did in Chapter 1, "The 70D Top Ten List").

Picture styles are also a very useful tool when shooting video. They work the same way as with still photography (see Chapter 10, "Advanced Techniques," for more information), and you can preview your scene with the changes while in the video Live View mode. Just remember that once you record in one of these settings, you can't change this quality of the video. For example, when using the Monochrome (black and white) Picture Style, once you've recorded a movie, there is no way to go back and retrieve the color information.

Composition

When creating movies, most of the same rules of composition you use with still photography apply (see Chapter 8, "Creative Compositions"). The rule of thirds is important to keep in mind when shooting video. The 70D's grid overlay feature places a grid over the LCD monitor to help you frame your shot properly. Changes to this menu item will apply to both Live View (for still images) and video-recording modes.

Setting the Grid display for video recording

1. On the back of the camera, set the Movie Shooting switch to Video mode.

2. Press the Menu button and use the Main Dial to get to the second movie-shooting tab.

3. Using the Quick Control Dial, scroll to Grid Display and press Set (**A**).

4. Using the Quick Control Dial, select your preferred grid again (**B**), and press Set to lock in your change.

5. Press the Menu button to go back into Movie Shooting mode. Now you will see a semitransparent grid over the LCD monitor (**C**).

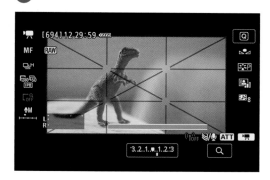

If you place your camera on a tripod to record movies, one very useful feature is the electronic level, which you learned about in Chapter 5, "Landscape & Nature Photography" (**Figure 9.6**). Sometimes it can be difficult to see the horizon line in your scene; the electronic level will help you keep your camera leveled horizontally. With still photography you can always go in and straighten the photo in editing software, but with video you don't have as much wiggle room, so it's always best to get it correct in-camera. Note that if you set the AF method to Face Detection Live Mode, the electronic level won't appear. Be sure to set it to either Live Mode or Quick Mode for it to appear (read the next section for more information on focus settings for video recording).

Another thing you can do to change up the composition is to use the digital zoom, which is available when shooting movies in Full HD mode (1920 by 1080). This will allow you to zoom in three to ten times the focal length of your lens.

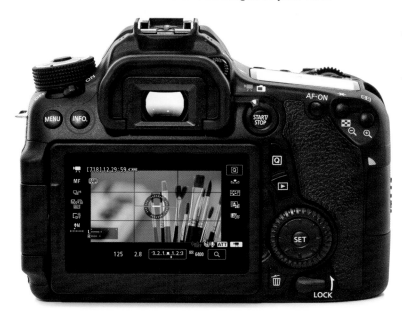

Figure 9.6
To access the electronic level, press the Info button on the back of your camera until the level appears on the LCD monitor.

Using a tripod

To get the best-possible image quality when recording video with your camera, it's a good idea to have a sturdy tripod and a fluid video head. There are also other options for stabilizing your camera, including handheld rigs and additional equipment.

Setting the digital zoom for video

1. In Video mode, press the Menu button on the back of the camera and scroll to the second movie-shooting tab. (For this to work properly, make sure you are shooting in 1920 by 1080.)

2. Scroll down to the Digital Zoom menu item and press the Set button (**A**).

3. Select the Approx. 3–10 Zoom option (which will set your camera to zoom between x3 and x10) and press the Set button (**B**).

4. Press the Menu button to return to movie shooting, and then press the Up and Down buttons on the Multi-Controller to zoom in and out of your scene.

5. To disable the digital zoom and return to your normal focal length, return to the Digital Zoom menu item (steps 1–3) and select Off/Disable.

Note: When using digital zoom, it's best to stabilize your camera with a tripod to prevent a shaky movie.

Focusing

Focusing for video is a bit different than still-image focusing, since you can't look through the viewfinder to set focus—all of it is done on the Live View screen. However, some things are the same: Just like with still photography, you can either focus your lens manually or autofocus it. And one of the best things about the 70D is that it can autofocus the lens during video recording, making it a great video camera for everyday shooting.

The 70D makes it easy to autofocus and gives you three different AF methods to choose from:

- **Face Detection + Tracking:** With this setting enabled, the camera will seek out faces and focus on them automatically. This is a great choice when recording movies of people.

- **FlexiZone - Multi:** This setting allows the camera to choose the focus point in your scene. This is a good option to use if you are recording a movie with a lot of different subjects, or scenes where you are using a wider lens.

- **FlexiZone - Single:** With this setting, you select the area of focus and the camera will focus on that spot automatically. This is good when the camera is stable (on a tripod) and you want to keep one specific area or item in focus at all times.

Selecting the AF method for movie shooting

1. In Video mode, click the Menu button on the back of the camera and scroll to the first movie-shooting tab. (Be sure to disable digital zoom before making changes to this setting.)

2. Use the Quick Control Dial to select the first menu item, AF Method, and then press the Set button (**A**).

3. Choose the AF Method you would like to use and press Set to apply that selection (**B**).

4. Press the Menu button to exit the menu and return to movie shooting.

If you are recording a scene that requires a stable focus point or just needs more refined focusing, you may want to consider using manual focus. The great thing about setting focus manually using the LCD monitor on the back of the camera is the ability to zoom in to your subject temporarily to focus your scene precisely. This feature allows you to compose your shot and use the same buttons you would use to preview your images at 100 percent in Playback mode (See Chapter 6, "Moving Target"), but in Live View you are viewing the subject that you are about to photograph or record.

Focusing your videos manually

1. On the back of the camera, set the Movie Shooting switch to Video mode. Be sure that the focusing switch on your lens is set to MF (manual focus).
2. Press the Magnify button once to activate the zoom (**A**).
3. Use the Multi-Controller to move the white rectangular box to the area you want to focus on.
4. Press the Magnify button again to magnify your image by a factor of 5 (x5) (**B**), and press it twice to magnify by a factor of 10 (x10).
5. Turn the front part of the lens until your image is in focus.
6. Press the Magnify button until the image on the LCD monitor is back to Normal view.

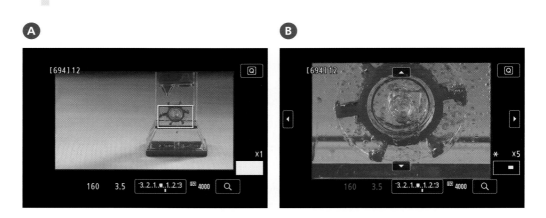

Live View

As you may have already guessed, many of the techniques used in this chapter to set focus and exposure for recording videos can also be applied to shooting still images in Live View mode. Chapter 10 lists some techniques for using Live View. For even more information, please turn to page 119 in the EOS 70D Basic Instruction Manual.

Audio

The Canon 70D records audio by utilizing the microphones located on the top of the camera (**Figure 9.7**). It records in stereo and allows you to make changes to the settings, depending on what equipment you are using or the type of scene you are shooting. This audio is not top-notch, but it gets the job done: If you are making quick, simple movies and don't need high-quality sound, then this microphone will work quite well for you.

One huge drawback to using the built-in microphone is that it will pick up operational noises made by your camera. Changing the ISO or refocusing your lens manually during the recording process might not sound loud to your ears, but when you play back the video you'll hear every click, bump, and swish your camera made during those changes.

If you're serious about shooting videos and want to ensure that you have the best audio possible to go along with them, your best option is to invest in additional audio gear instead of using the built-in microphone. You can plug in this equipment by using the external microphone (MIC) terminal located on the side of your camera, beneath the terminal cover. The advantages to using an external microphone and other equipment are that you can record your sound in stereo and you can regain control over the sound recording level. When you have a microphone plugged in, your camera sound will be recorded through that microphone automatically.

Figure 9.7
The built-in microphones are located on the top of your camera.

There are a few settings you will want to be aware of when selecting the audio settings for your movies. All of these are accessed by going to the second movie shooting tab in the camera's menu and selecting the Sound Recording option (**Figure 9.8**). Here are the audio settings you can choose from:

Figure 9.8 **You can access and change the sound recording settings in the camera's menu.**

- **Sound Recording/Sound-Recording Level:** In this option you have three choices: Auto, Manual, or Disable. Auto is just how it sounds—the camera will set the sound level automatically, responding to the sounds coming in through the microphone. Manual is for advanced users, and allows you to set the recording level manually. And if you don't want any sound to record on your video, select Disable.

- **Wind Filter:** Enabling this option will reduce the wind noise when recording outdoors. (This option is available only when using the built-in microphones.)

- **Attenuator:** When enabled, this setting will help reduce sound distortion if there is a very loud sound in your movie.

Tips for Shooting Video

Transitioning from being a still photographer to making movies might seem like a piece of cake, but there are a few things to keep in mind to make those videos shine.

See Differently

When I first started creating videos with my DSLR, I really started to pay attention to the cinematography of TV and movies. I noticed that the camera was usually still while the world around it moved. Subjects moved into and out of the frame, and the camera didn't always try to follow them. It can be tempting to move the camera to follow your subject, but sometimes keeping still can add more impact and drama to your scene (plus a lot of movement might make your viewers dizzy!). So let your subjects move through the frame while you take a deep breath, relax, and keep your camera pointed in the same, unchanging direction.

Don't Rush

As still photographers, we tend to see things "in the moment." When recording videos those moments last longer, and they need to flow through from one scene to the next. A common mistake that new video photographers tend to make is that they cut their videos short, meaning they stop the recordings too soon. It's important that you have extra time before and after each scene not only to allow for smooth transitions in and out of the video, but also for editing purposes. It's always good to have more than you need when piecing together video clips in post-production.

So, when you think you are done with your video clip and you want to turn it off… don't! Count to three, or four or five, and then stop your recording. It will feel odd at first, but don't worry; you'll get the hang of it. Those few extra seconds can make a world of difference.

Short but Sweet

While you will want to give your videos a little bit of time before and after each scene for editing purposes, you may still want to consider limiting the overall recording time of each individual movie file. Think of the TV shows and movies you watch at home; each individual video clip tends to last for only a few seconds, and the entire show or movie is a compilation of many short videos. Video clips that drag on for several minutes can lose their overall appeal. Instead, try recording shorter videos, but make several of them from different angles and perspectives. You can even try using the video snapshots feature (discussed in the "Video Snapshots" sidebar) to get used to this technique.

Video editing

Once you have recorded your movies, you might want to do a little bit more with them, such as assemble several video clips into one movie, or add sound or additional graphics and text. If so, you'll probably want to learn a thing or two about how to edit your videos using video-editing software. Many different software programs are available to choose from. With some of the free or inexpensive programs, like iMovie (for Mac) or QuickTime Pro, you can do basic editing on your video clips. Other programs, such as Final Cut Pro or Adobe Premiere Pro, will allow you to do even more advanced editing and to add creative effects to your movies. Using editing software is not required to play back and share movies created with your 70D, but it is a fun way to take your movies to the next level.

Video snapshots

Video snapshots are a feature you can use to highlight short moments of certain events. These snapshots allow you to record small clips of video, combine them together quickly using folders, and then play them back as one movie with all of the snapshots stitched together. It's a great way to create a quick video featuring some of the best moments of your vacation, or whatever type of event you are recording.

To enable video snapshots, locate the second movie-shooting tab in the menu and select the Video Snapshot menu item (**A**). Press Set to get to the next menu screen, where you can enable or disable the video snapshots, select the album you would like the videos to save to, and select the length of each snapshot (2, 4, or 8 seconds) (**B**). Also, when recording you will know that the video snapshots are enabled on the LCD monitor by the appearance of the blue countdown bar near the bottom of your frame (**C**).

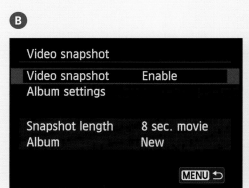

Chapter 9 Assignments

Now that we've covered most of the basics behind shooting video with your 70D, take some time to familiarize yourself with all of the features listed in this chapter. Here are a few exercises to get you started.

Play with movie-recording sizes

Take some time to discover the different movie-recording sizes on your 70D. Set the camera to one of the HD settings (1920x1080 or 1280x720), and then change the setting to SD (480x640). Note the different aspect ratios (16:9 versus 4:3) and areas that are covered with the semitransparent mask. Shoot a few short videos in each recording size, and then play them back on your computer.

Adjust white balance and picture styles

Set your camera on a tripod and set it to Movie Shooting mode. Set the exposure so you can see your scene properly, and then change the white balance, scrolling through all the different options, and watch the screen as you try each setting. Do the same with the picture styles and pay attention to the colors in your scene as you make the changes.

Set your focus

Familiarize yourself with the different autofocus modes by going into the menu and trying each of them. Once you've got the hang of it, set the lens to MF and zoom in using the Magnify button on the back of your camera to focus on a specific area of your scene.

Understand the built-in microphone's limitations

Make sure the Sound Recording feature is set to Auto and your movie exposure is set to Manual, and then start to record a short video clip. During the recording process, change the shutter speed by turning the Main Dial to the right or left. Then, while still recording, set the lens to MF and set your focus manually by turning the front part of the lens. Stop the recording, and then go into Playback mode. Pay attention to the sounds you heard while you were changing the exposure and focus—it's a lot louder than it seemed, right?

Share your results with the book's Flickr group!
Join the group here: flickr.com/groups/canon70dfromsnapshotstogreatshots

ISO 100 · 1/250 sec. ·
f/11 · 70–200mm lens

10
Advanced Techniques

Customizing your camera and your creativity

We've covered a lot of topics in the previous chapters, including the functions of many of the menu items and how to change your camera's internal settings. But there are even more ways you can customize these settings to your liking. Here are a few additional photo techniques that I really enjoy playing around with—and I think you will too!

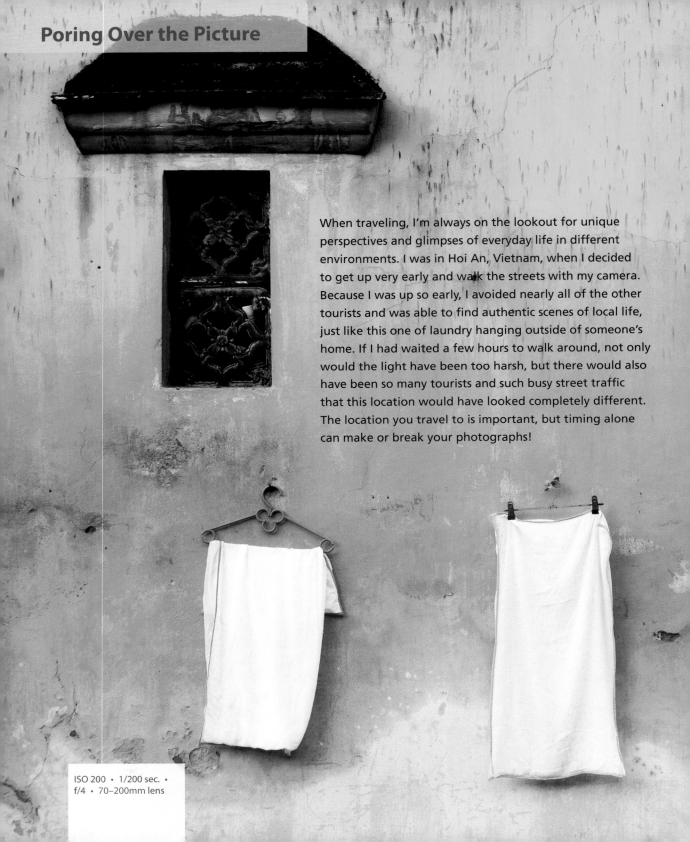

Poring Over the Picture

When traveling, I'm always on the lookout for unique perspectives and glimpses of everyday life in different environments. I was in Hoi An, Vietnam, when I decided to get up very early and walk the streets with my camera. Because I was up so early, I avoided nearly all of the other tourists and was able to find authentic scenes of local life, just like this one of laundry hanging outside of someone's home. If I had waited a few hours to walk around, not only would the light have been too harsh, but there would also have been so many tourists and such busy street traffic that this location would have looked completely different. The location you travel to is important, but timing alone can make or break your photographs!

ISO 200 · 1/200 sec. · f/4 · 70–200mm lens

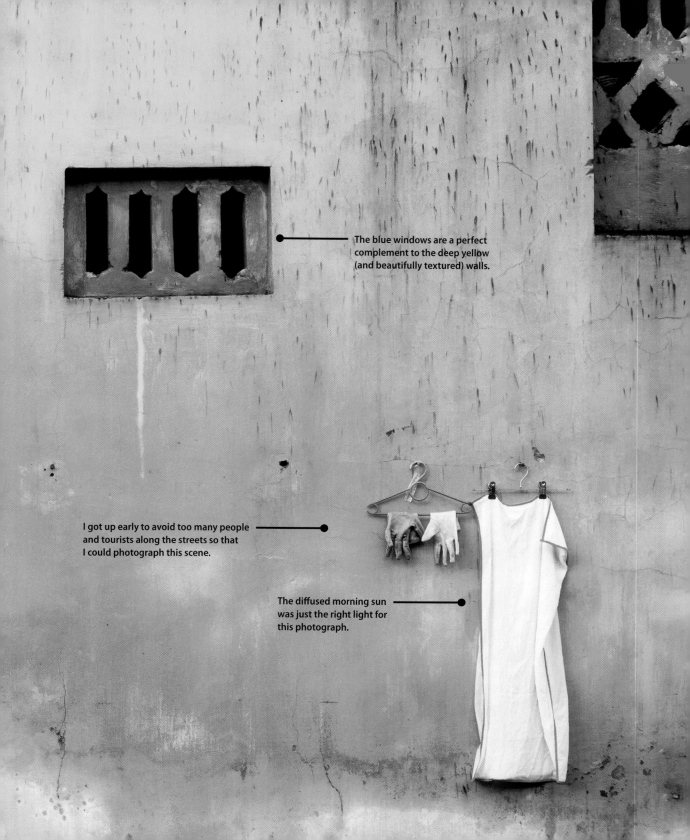

The blue windows are a perfect complement to the deep yellow (and beautifully textured) walls.

I got up early to avoid too many people and tourists along the streets so that I could photograph this scene.

The diffused morning sun was just the right light for this photograph.

Using a Custom White Balance

Throughout this book, I've discussed several of the white balance settings and when to use them. One white balance setting I haven't covered in detail is the Custom setting. Sometimes the presets on your camera won't be 100 percent accurate. For example, you might use the Daylight setting outside on a sunny day, but the color and quality of the light will be different at noon than at 7 p.m. The Daylight white balance setting will get you to a good starting point, but you'll need to go through a few simple steps to achieve as much accuracy as possible.

The only piece of equipment you need to do this, other than your camera, is something you can point your camera at to measure the temperature of the light. These devices come in many shapes, sizes, and prices; one inexpensive option is a basic 8-by-10-inch, 18 percent gray card. You can find these at most camera stores and they don't cost very much—plus they do the job well. You can also use something a little more portable, such as an X-Rite ColorChecker Passport, which has a section with a gray card to use for custom white balance. But you don't need to purchase anything to set this up—you can always use a plain white piece of paper, or anything with a plain white surface. The color won't be as accurate, but it should get you really close.

Note: The Custom white balance setting will not work with an image photographed with the Monochrome picture style.

Setting up a custom white balance using a gray card

1. Place the white or gray card in the light in which you will be photographing your subject (I am using an X-Rite ColorChecker Passport for this step).

2. Position the card in front of the camera so that it fills the majority of the frame, focus manually, and use a balanced exposure. Then press the shutter button to take a picture.

3. Press the Menu button and use the Main Dial to scroll to the third shooting tab.

4. Use the Quick Control Dial to scroll down to the Custom White Balance option (**A**), and then press the Set button.

5. Use the Quick Control Dial to scroll to the photo of the gray card you just took, and then press the Set button and select OK (**B**).

6. If your white balance is not already set to Custom, you will get a reminder on the next screen. Press OK to continue. Then scroll up to the White Balance option and press the Set button (**C**).

7. Change the White Balance setting to Custom and press the Set button to lock in your changes (**D**).

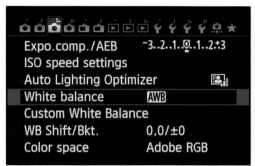

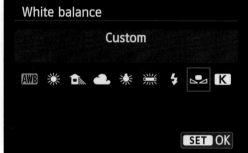

Now your camera should have the proper white balance for the light in which you are currently working. Don't forget to repeat the process when you move to a location with different lighting!

The My Menu Settings

You may find that you are constantly going back and forth in the menu to change some of the same settings over and over again. Instead of going into the menu to hunt for the one item that you need to change but that you have misplaced (this happens to me all the time), take advantage of the My Menu tab, the 70D's simple solution to help you keep a few of those settings in one place and make them easier to find.

Under the My Menu tab, you have the option to register up to six different menu options and custom functions. I usually select menu items that I use frequently so that I can quickly make changes to those settings. Some of the items I tend to keep in the My Menu settings are Custom White Balance, Format Card, Creative Filters, Expo. Comp./AEB, and Wi-Fi (**Figure 10.1**).

Figure 10.1 **This is what the My Menu tab looks like on my 70D.**

Customizing the My Menu tab

1. Press the Menu button and use the Main Dial to select the tab on the far right (the star). Select My Menu Settings and press Set (**A**).

2. Highlight the Register To My Menu option and press Set (**B**).

3. Use the Quick Control Dial or the touch screen to scroll through the available menu items (**C**); when you see one that you want to add, press the Set button and confirm that you want to add it by selecting OK (**D**).

4. Continue adding the items that you want until you have selected your favorites (up to six of them).

5. When you are finished, press the Menu button until you are back in the My Menu settings screen. From here you can sort your menu items as you see fit or, if you change your mind, you can delete them individually or all at once.

6. If you want the My Menu tab to be the first menu tab that appears each time you go into the menu on your LCD monitor, enable the Display From My Menu option (**E**).

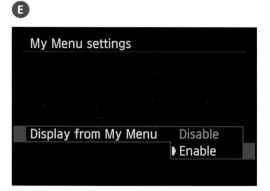

Vari-angle LCD monitor

One really cool feature of the 70D is its Vari-angle LCD monitor (commonly called an "articulating screen"), which can be really handy in certain situations. Benefits of this feature are very apparent when shooting in Live View or Video mode, since you can angle the display so that it's shaded from the sun. You can also angle the display when you want to lower or raise the camera beyond your field of view by moving the LCD monitor so that it's always facing in your direction (**A**). You can also swivel the display so that it's flipped completely around, making it possible to do self-portraits or videos of yourself.

Another nice benefit of the Vari-angle LCD monitor is that you can turn the display so that it's flush against the camera, protecting the monitor from scratches while not in use (**B**). This is a good option when packing the camera in a camera bag or while using it in a harsh environment where damage to the monitor can easily occur.

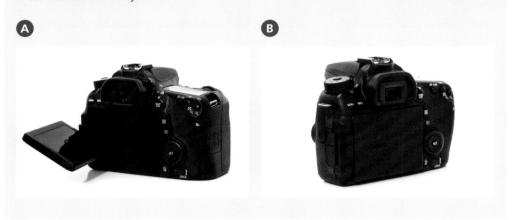

In-Camera Image Editing

The 70D has image-editing features that allow you to process images in-camera quickly and save those files as JPEGs on your Secure Digital (SD) card. This feature is not a replacement for editing images on your computer, but it is a useful and fun way to create quick, ready-to-use images directly from your memory card.

Creative Filters

The Creative filters are a fun way to add different effects to your images. The 70D comes with seven different filters, each with settings you can change to customize the look of your original image (**Figure 10.2**).

Note: You cannot apply these effects to images photographed in the mRAW or sRAW quality settings.

- **Grainy B/W:** This will make the image black and white and also add grain to the image. You can control the amount of contrast in the image—the contrast setting in **Figure 10.3** was set to "low."

- **Soft Focus:** This adds a classic "soft glow" to an image by adding blur (**Figure 10.4**). You have control over the amount of blur you would like to add to your image.

- **Fish-Eye:** This filter mimics the effect of a very wide fish-eye lens. It will add a lot of distortion to the image and also will crop the image slightly, depending on the intensity of the effect (**Figure 10.5**).

- **Art Bold:** This adds a lot of color and saturation, somewhat mimicking the look of an oil painting (**Figure 10.6**).

- **Water Painting:** This filter softens the colors, brightens it up, and makes it look similar to a watercolor painting (**Figure 10.7**).

- **Toy Camera:** This effect adds a color cast and also vignettes the corners of the image to make it look as though it was photographed with a toy camera (**Figure 10.8**).

- **Miniature:** If you want to mimic the look of a tilt-shift lens, then this filter is really fun to use. It adds contrast and blur to the image to make your scene look like a diorama, and it allows you to select the area of focus (**Figure 10.9**).

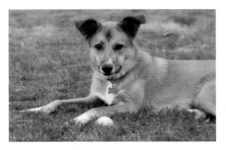

Figure 10.2 **Original**
ISO 100 • 1/400 sec. • f/4 • 100mm lens

Figure 10.3 **Grainy B/W**
ISO 100 • 1/400 sec. • f/4 • 100mm lens

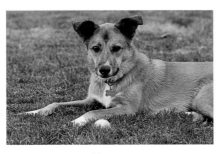

Figure 10.4 **Soft Focus**
ISO 100 • 1/400 sec. • f/4 • 100mm lens

Figure 10.5 **Fish-Eye**
ISO 100 • 1/400 sec. • f/4 • 100mm lens

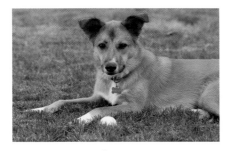

Figure 10.6 **Art Bold**
ISO 100 • 1/400 sec. • f/4 • 100mm lens

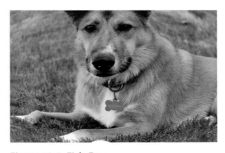

Figure 10.7 **Watercolor Painting**
ISO 100 • 1/400 sec. • f/4 • 100mm lens

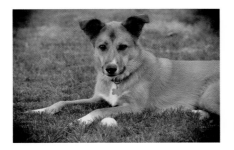

Figure 10.8 **Toy Camera**
ISO 100 • 1/400 sec. • f/4 • 100mm lens

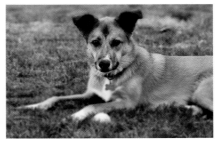

Figure 10.9 **Miniature**
ISO 100 • 1/400 sec. • f/4 • 100mm lens

Applying a Creative filter to an image

1. Press the Menu button and use the Main Dial to scroll to the first playback tab.

2. Using the Quick Control Dial, scroll down to the Creative Filters option and press Set (**A**).

3. Use the Quick Control Dial to select an image to edit (your camera will display only compatible images at this point), and then press Set (**B**).

4. Use the Quick Control Dial to select the Creative filter you would like to apply, and then press Set (**C**). On the next screen you will see creative settings for the filter you selected.

5. Use the Quick Control Dial to adjust the filter's settings (the options are different for each filter) (**D**). When you are finished, press the Set button. (You can also exit out of any of the filters at any time by pressing the Menu button to go to the previous screen.)

6. On the next screen select OK; your image is now saved as a JPEG on your memory card.

7. Press OK to confirm, and press the Menu button to exit.

RAW Processing

Along with the Creative filters, you can also do basic adjustments to RAW files on your 70D. This feature is helpful if you need to edit a file quickly and save it as a JPEG, and you don't have access or time to do so on a computer. Just like with the Creative filters, you cannot process images photographed in the mRAW and sRAW quality settings.

Processing RAW images

1. Press the Menu button and use the Main Dial to scroll to the first playback tab.

2. Use the Quick Control Dial to scroll to the RAW Image Processing option, and then press Set (**A**).

3. Use the Quick Control Dial to select an image to edit (your camera will display only compatible images at this point), and then press Set (**B**).

4. Use the Multi-Controller to select an option to edit, and then use the Quick Control Dial or Main Dial to make changes.

5. Continue changing each setting as necessary, and when you are finished processing the image, scroll down to the Save option and press Set (**C**).

6. On the next screen, select OK to save it as a new file; your image is now saved as a JPEG on your memory card.

7. Press OK to confirm, and press the Menu button to exit.

Resizing Images

Sometimes you might want to resize an image quickly, and the 70D has a feature that makes this very easy. You can resize JPEG L/M/S1 and S2 images, but not RAW and JPEG S3 files. This feature is perfect if you edited an image using a Creative filter (discussed earlier in this section) and need to use the image on the Web or send it as an email attachment.

Resizing images

1. Press the Menu button and use the Main Dial to scroll to the second playback tab.

2. Use the Quick Control Dial to scroll down to the Resize option, and then press Set (**A**).

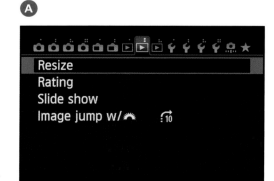

3. Use the Quick Control Dial to select an image to resize (your camera will display only compatible images at this point), and then press Set (**B**).

4. Use the Quick Control Dial to select the size you would like your image to be, and then press Set (**C**).

5. Select OK on the next screen; your image is now saved as a JPEG on your memory card.

6. Press OK to confirm, and press the Menu button to exit.

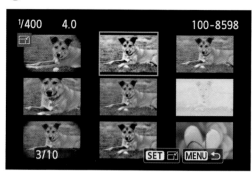

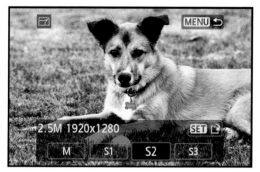

Picture Styles

Picture styles on the 70D will allow you to enhance your images in-camera depending on the type of photo you are taking. The style is selected automatically when you are using any of the Basic Zone modes. When using a Creative Zone shooting mode, you decide which style to use.

There are a few things to keep in mind when using picture styles. The first is that when you are shooting in RAW, the picture style doesn't really "stick." When previewing your images on the LCD monitor, you'll see it applied to the image, but once you bring it into your RAW editing software, you can change it to any of the other styles. Shooting JPEG images or video, however, will embed the picture style permanently to the image or movie and can't be changed. This is extremely important to keep in mind when using picture styles such as Monochrome, since you will be discarding all color from your image.

Picture styles can be applied in the menu, while shooting in Live View, or while editing your RAW images in-camera. (I prefer selecting them using Live View so I can see the effect they have on my scene.) There are six styles to choose from, along with an Auto setting and three additional user-defined styles:

- **Standard:** This general-purpose style is used to create crisp images with bold, vibrant colors. It is suitable for most scenes.

- **Portrait:** This style enhances the colors in skin tone and is used for a softer-looking image.

- **Landscape:** This style enhances blues and greens, two colors that are typically visible in a landscape image.

- **Neutral:** This style creates natural colors and subdued images. It's a good choice if you want to do a lot of editing to your photos on the computer.

- **Faithful:** This picture style is similar to the neutral style but creates better color when shooting in daylight-balanced light (color temperature of 5200K). It's also a good option if you prefer to edit your photos on the computer.

- **Monochrome:** This style creates black-and-white images. It's important to note that if you use Monochrome style and shoot in JPEG, you cannot revert the image to color.

Setting the Picture Style on the Quick Control screen

1. Press the Quick Control button on the back of the camera.

2. Using the touch screen, press the Picture Style icon on the left of the LCD monitor (**A**).

3. Use the touch screen to select the picture style you want to use (**B**).

4. If you would like to edit the style, press the Info button. From here you can make changes to settings such as sharpness, contrast, saturation, and color tone (**C**). Press the Menu button to return to the Picture Style screen.

5. When you are finished, press the Set button to lock in your changes.

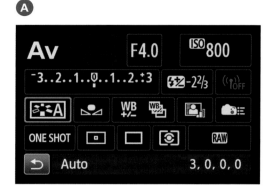

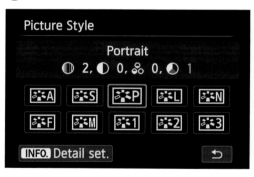

Setting the Picture Style with Live View

1. Press the Live View shooting button to get into the Live View shooting mode (**A**).

2. With Live View activated, press the Quick Control button on the back of the camera, and then press the Picture Styles icon on the right (**B**).

3. Use the touch screen to select from among the different base picture-style choices (**C**).

4. Press the Set button to lock in your changes.

Tip: If you have your quality set to RAW, using a picture style will not permanently embed the style into your camera, but it will give you a colorful preview of your image on the LCD monitor! I always set my picture style to Portrait so that when I preview my shots on the camera, the colors are bright and vibrant. It doesn't affect the final image (I still have to process them with software), but makes the photos look great when I'm previewing the photos or showing them to a friend.

Let's Get Creative

To finish off this chapter, I'm going to give you a few more shooting tips—fun ways you can play around with light to get some really neat results. Photography wouldn't have as much appeal to me if it weren't for all the exciting ways to use light, along with the different settings on my camera! These are just a few of the hundreds of ways you can experiment with your 70D.

The "Swirly Flash"

It's no secret that I don't like to use the 70D's built-in flash. The light is harsh and flat, and when you photograph people in a dark setting, such as indoors or at night, it's too easy to get a dark and underexposed background.

Figure 10.10
By using a slow shutter speed with the built-in flash, you can create fun and unique photos of your friends.
ISO 1600 · 1/8 sec. · f/11 · 50mm lens

So when I'm in a situation in which I have no choice but to use the flash on my camera, I like to change some of the settings to give my snapshots a different look. I drag the shutter, setting it much slower than normal, usually between 1/15 and 1/4 of a second, and spin the camera on axis with the subject while the shutter is open. I also play around with the ISO setting to pull in some of the ambient light coming in from behind my subject. This keeps the subject mostly frozen and well lit while creating an interesting blur of lights in the background (**Figure 10.10**).

I like to call this technique my "party trick" because when I'm in a room full of people, I'll use this method to take a quick portrait, and often it's something that they haven't seen done before. This technique is not limited to DSLR cameras, and I frequently show people how to set up their point-and-shoot cameras to do it. I find that it adds a unique look to an otherwise boring snapshot. One quick tip: This type of image usually works best when there are a lot of lights behind your subject, such as the lights from a Christmas tree.

Creating the "swirly flash" effect

1. Set your camera to Shutter Priority (Tv) mode and start with a shutter speed somewhere between 1/15 and 1/4 of a second.

2. Press the built-in flash button on the front of your camera.

3. Point the camera and center your subject in the frame. Start with the camera slightly tilted, and then press the shutter button while spinning the camera so that the subject stays centered in the image.

4. If your flash is too bright, press the Flash Exposure Compensation button on the top of the camera and use the Quick Control Dial to move the exposure value (EV) to the left. Take another photo and preview your results.

5. If the background is too dark or too bright, you'll want to adjust your ISO setting. The higher the ISO number is, the more ambient light you'll bring into the background.

6. If you have too much or too little blur in the background, adjust the shutter speed (a slower shutter speed for more blur, a faster shutter speed for less blur).

7. Keep adjusting the settings until you find that "sweet spot." It will be different for each environment, and there's no single right way to do it. Just have fun with it!

Light Painting

Another fun technique that's worth trying is light painting (**Figure 10.11**). For this, you'll need a dark environment (nighttime is best), your camera on a tripod, and some semi-powerful flashlights or other light source. Shine your flashlights on your subject to light it, and in effect you'll "paint" the light that will show up on your image.

But you don't have to paint the light on something for it to show up—if it's dark enough, you can stand in front of the camera and move the light source to make shapes or spell out something. A fun item to use for this effect is a sparkler (a type of handheld firework that emits sparkles). Just set up your camera on a tripod outdoors at night and have someone run around the frame holding a sparkler, and you'll create shapes and streaks that can look really cool. You could also use small flashlights or LED lights. In **Figure 10.12,** I used a small LED flashlight with a green gel over it to add a different color to the writing.

Figure 10.11
For this photograph, I used a long exposure while my friend scribbled the haystacks with a laser pointer and I "painted" the ground with a powerful LED flashlight. I added small blue and green gels on the flashlight to add color to the image.

ISO 800 • 10 sec. • f/4 • 24–105mm lens

Figure 10.12
I photographed this image with the help of my friend dav.d. That's me writing with a small LED flashlight. The original photo was backward, so I flipped the image horizontally using editing software.

ISO 800 • 30 sec. • f/18 • 24–105mm lens

Setting up your camera for light painting

1. Place your camera on a tripod in a dark environment, preferably at nighttime or in a darkened room.

2. If your environment is extremely dark, set your camera to the Bulb shooting mode with a large aperture. If you have some ambient light in your scene, set your camera to Aperture Priority (Av) mode and use an aperture that is large enough to capture the light from your light painting but small enough to give you a fairly slow shutter speed—several seconds is usually a good place to start.

3. Using a cable release or one of the self-timer drive modes, press the shutter button. If you are using Bulb mode, you'll need a cable release in order to hold the shutter open for the duration of your light painting.

4. With the shutter open, use a flashlight, a sparkler, or any other type of powerful light source to create your image. The creative possibilities are endless!

Playing with zoom lenses

One thing I love doing is experimenting with my gear and with the light I have in my scene. You never know what kind of fun results you'll get, just like with this shot of a bridge at night (**Figure 10.13**). I had my camera set up on a tripod and was using a long exposure (28 seconds) to get the trails of lights from the cars. I was also using a 70–200mm zoom lens zoomed out at 70mm to capture a wider shot of the bridge, and toward the end of the exposure I zoomed the lens closer to my scene, adding even more streaks of light to the image. (Bonus tip: Use a small aperture with long exposures to create "stars" on pinpoint lights in your scene.)

Figure 10.13 **I used a long exposure and a zoom lens to make additional light streaks in this photograph of a bridge at night.**

ISO 100 • 28 sec. • f/22 • 70–200mm lens

Conclusion

As you've gone through each chapter in this book, I hope you've found new ways to use your camera to get some really great shots! Photography is a mix of both technical skill and creativity, and the more you challenge yourself and step outside of your comfort zone, the more you'll improve as a photographer. You'll also find yourself thinking less about the shots you take and relying more on your instincts to create photographs.

As I close, I would like to leave you with a few last pieces of advice. You could read every photography book you can get your hands on, and while you would definitely soak up tons of information, you shouldn't forget to take the time to really look at photography. And I mean a *lot* of photography—lots and lots and lots. View images on the Internet, in the library, or in art galleries, and open up your mind to absorb as much visual information as you can. And, of course, get out and make your own photographs. Take what you've learned and put it to use. Try to see light *all* the time, not just when you're holding your camera. Break all the rules, don't limit yourself, and definitely don't let other people's opinions of you or your work define you or your photography. And last, don't be afraid to mess up, because you will! *Every* photographer takes bad photos—we just don't always see their mistakes.

But the most important thing to remember while taking pictures is to have fun! We're photographers because it's our passion, and we want to create memories and beautiful images that will be around for generations to come. The way I see it is that, good or bad, *everyone* is a photographer—some of us just take it to the next level. As for me… I'm a photo geek and proud of it.

Chapter 10 Assignments

Many of the techniques covered in this chapter are specific to certain shooting situations that may not come about very often. It's a good idea to practice them a few times so that when the situation does present itself, you'll be ready. Here are a few challenges to get you started.

Set a custom white balance

Set your camera to whatever white balance seems appropriate for your environment (if you are in the shade, select the Shade white balance setting). Take a quick photo of something in that setting. Then take a gray card or white piece of paper and follow the directions in this chapter for setting a custom white balance. Take another photo and compare its color with the first image.

Play with creative filters and RAW image processing

Photograph a few images with the quality set to RAW. Then play around with the different Creative filters, and even try "stacking" them (adding more than one filter to the same image) for some neat results. Next, select a few images to process in-camera using the RAW image-processing feature. Try using different settings to see what kinds of results you can get.

Try something new!

Take a shot at some of the last few creative tips included at the end of the chapter. Try photographing a person using the "swirly flash" method, or grab some flashlights and create a light-painting image. Use your imagination and come up with your own creative techniques using different light sources. There's no right or wrong way to do it—just experiment with your settings and different types of lights, and be sure to have a good time in the process.

Share your results with the book's Flickr group!
Join the group here: flickr.com/groups/canon70dfromsnapshotstogreatshots

Index

2nd Curtain option
getting creative with, 207
selecting, 203
2-sec self-timer, using, 166
10-sec self-timer, using, 166
19-Point Automatic Selection AF, 169
70D
avoiding overheating, 235
as DSLR (digital single-lens reflex) camera, 43–44
setting up, 31
100 ISO, 49

A

Access Lamp (Card Bus Indicator), 3
action, following, 179
action photography. *See also* motion
AF (autofocus), 165–169
anticipation using manual focus, 179
capturing frames, 168
continuous mode for expressions, 167
continuous shooting, 165–169
direction of travel, 158
drive modes, 166–168
focus modes, 168–169, 179
getting creative, 163
ISO adjustment on the fly, 162–163
isolating subjects, 165–166
manual focus, 170–171
Manual mode with Auto ISO, 165
reviewing in LCD monitor, 174
subject speed, 158
subject-to-camera distance, 160
wide vs. telephoto, 179
action photography tips
composition, 174
experimenting, 176
framing, 174
freezing movement, 177
getting in front, 174
repositioning cameras, 176
somewhere to go, 174
Adobe RGB color space, 15
AE Lock feature, shooting with, 105

AE Lock/FE Lock/Index/Reduce Button, 3
AEB (Auto Exposure Bracket) mode, using with HDR images, 150
AF (autofocus)
action photography, 165–169
assist beam, 193–194
AF Area Selection Mode Button, 4
AF areas
19-Point Automatic Selection AF, 19
setting, 20
Single Point AF, 19
Zone AF, 19
AF Mode Selection Button, 4
AF points
availability and settings, 169
selecting, 108–109
setting, 108–109
AF Point Selection/Magnify Button, 3
AF Start Button, 3
AF-ON button, using, 169, 201
AI Focus mode, explained, 168–169
AI SERVO mode
selecting, 168
shooting in, 168
Ambience setting, 63
angles, 214
apertures
examples, 49
explained, 48
and f-stops, 78
function of, 53
practicing with, 55
size of, 53
using to focus attention, 227
and zoom lenses, 78
Auto modes vs. Program AE, 68–69
autofocus modes, 18–20. *See also* focus modes
autofocus settings, 169
Av: Aperture Priority mode
benefit, 75
controlling depth of field, 91
environmental portraits, 99
explained, 74–76
isolating subjects, 165–166
setting up, 78
shooting in, 78
using, 76, 98–99

B

B: Bulb mode
explained, 83
setting up, 88
shooting in, 88

shutter speed, 84
using, 83–84
backgrounds
blurring, 47
considering in portraits, 118
in creative compositions, 214
Basic Zone
Ambience setting, 63
becoming familiar with, 91
best practices, 68
CA (Creative Auto) mode, 63
Close-up mode, 66
disabling Flash mode, 62
Full Auto mode, 62
Handheld Night Scene mode, 67
HDR Backlight Control, 67
Landscape mode, 65
menu items, 64
Moving Subjects mode, 66
Night Portrait mode, 66–67
Portrait mode, 65
setting up, 62
shooting in, 62
Special Scene mode, 64
Sports, 66
battery
charging, 5
registering, 5
black-and-white portraits, 115
blur, adding to images, 173
bracketing exposures, 150
bubble level, 136
built-in flash. *See also* flashes
effective range of, 196
E-TTL technology, 197
FE (Flash Exposure) Lock, 198
locating, 2, 4
metering modes, 197
shutter speeds, 197
using for mood lighting, 196–198

C

C: Custom User setting, 88–89
CA (Creative Auto) mode, 63
camera back
Access Lamp (Card Bus Indicator), 3
AE Lock/FE Lock/Index/Reduce Button, 3
AF Point Selection/Magnify Button, 3
AF Start Button, 3
Dioptric Adjustment Knob, 3
Erase Button, 3
Flash-Sync Contacts, 3
Hot Shoe, 3

Info Button, 3
LCD Monitor, 3
Live View & Movie Shooting Switch, 3
Menu Button, 3
Mode dial, 3
Multi-Controller, 3
Multi-Function Lock Switch, 3
Playback Button, 3
Power Switch, 3
Quick Control Button, 3
Quick Control dial, 3
SD Card Slot, 3
Setting (Set) Button, 3
Viewfinder, 3
camera front
 Built-in Flash, 2
 Depth-of-Field Preview Button, 2
 EF Lens Mount Index, 2
 Flash Button, 2
 Lens Mount, 2
 Lens Release Button, 2
 Mode dial, 2
 Red-Eye Reduction/Self-Timer Lamp, 2
 Shutter Button, 2
 Strap Mount, 2
 Terminal Cover, 2
camera modes and exposure, 132–133
camera settings
 examples, 90
 exposure compensation, 90
 Highlight Alert, 90
camera top
 AF Area Selection Mode Button, 4
 AF Mode Selection Button, 4
 Built-in Flash, 4
 Drive Mode Selection Button, 4
 Flash-Sync Contacts, 4
 Focal Plane Mark, 4
 Hot Shoe, 4
 ISO Speed Setting Button, 4
 LCD Panel, 4
 LCD Panel Illumination Button, 4
 Main dial, 4
 Metering Mode Selection Button, 4
 Microphone, 4
 Mode dial, 4
 Mode Dial Lock-Release Button, 4
 Shutter Button, 4
 Strap Mount, 4
Canon EOS 70D
 avoiding overheating, 235
 as DSLR (digital single-lens reflex) camera, 43–44
 setting up, 31

cards. *See* memory cards
catchlights, 109
Close-up mode, 66
close-up portraits, 45–46
CMYK (cyan, magenta, yellow, black), 15
color, considering, 221–222
color histogram, displaying, 27
color space, setting, 15–16
color temperatures
 warm vs. cool, 136
 and white balance, 15
composing. *See also* creative compositions
 black-and-white portraits, 115
 breaking rules, 114
 "Dutch angle," 113
 grid display for Live View, 112
 people, 111–114
 perspective, 113, 120
 portraits, 111–114
 rule of thirds, 111–112
 shooting at eye level, 113
continuous mode, using to capture expressions, 167
copyright information, setting, 17
creative compositions. *See also* composing
 angles, 214
 backgrounds, 214
 color, 221–222
 depth of field, 212–213
 frames within frames, 225
 leading lines, 223
 patterns, 219–220
 point of view, 218–219
 rule of thirds, 224
 shapes, 219–220
 specialty lenses, 216–217
 textures, 219–220
Creative filters
 applying to images, 260
 Art Bold, 258
 Fish-Eye, 258
 Grainy B/W, 258
 Miniature, 258
 playing with, 271
 Soft Focus, 258
 Toy Camera, 258
 Water Painting, 258
creative photography. *See also* images; photos
 light painting, 267–269
 "swirly flash," 266–267
 zoom lenses, 269

Creative Zone shooting modes
 Av: Aperture Priority mode, 74–78, 98
 B: Bulb mode, 83
 vs. Basic Zone, 19
 M: Manual mode, 80
 P: Program AE mode, 68–69
 Tv: Shutter Priority mode, 70–74
crop sensor vs. full frame, 43
curtain, first vs. second, 202

D
dark environments, shooting in, 130
Delicate Arch at Moab National Park, 44
depth of field
 controlling, 91
 in creative compositions, 212–213
 making shallow, 133
 and motion, 51–53
 in portraits, 123
Depth-of-Field Preview button, 2, 140
digital noise and long exposure, 87. *See also* noise
digital zoom, setting for videos, 242
dioptric adjustment knob, 3
display modes, scrolling through, 27
Drive Mode Selection button, 4
drive modes
 2-sec self-timer, 166
 10-sec self-timer, 166
 buffer, 166
 high-speed continuous shooting, 166, 168
 low-speed continuous shooting, 166
 silent continuous shooting, 166
 silent single shooting, 166
 single shooting, 166
DSLR (digital single-lens reflex) camera, 43–44. *See also* lenses

E
EF Lens Mount Index, 2
electronic level
 setting in LCD monitor, 137
 setting in viewfinder, 138
 using to balance images, 136
 using with videos, 241
environmental portraits, shooting, 99
EOS 70D Wi-Fi Instruction Manual, 25
EOS Remote app, downloading, 21
Erase Button, 3
E-TTL technology, 197
Evaluative metering mode, 104
exposure compensation
 changing, 90
 setting, 79

exposure time, increasing, 130
exposure triangle
aperture, 48
ISO, 48
shutter speed, 48
exposures. *See also* long exposures
bracketing, 150
calculating, 49–50
and camera modes, 132–133
checking with histogram, 29
explained, 48
lengths and digital noise, 87
perfecting, 48
reciprocal change, 49–50
expressions, capturing, 167. *See also*
face tracking
external flashes, using, 204
eye level, shooting subjects at, 113
eyes, focusing on, 106

F
f/4–f/22 apertures, 49
face tracking, setting up in Live View,
110. *See also* expressions
FE (Flash Exposure) Lock, 198
flash button, 2
Flash Exposure Compensation, using,
198–199
Flash mode, disabling, 62
flash synchronization, 202
flashes. *See also* built-in flash
disabling, 201
external, 204
using, 101–104
Flash-Sync Contacts, 3–4
focal lengths
normal, 45–46
telephoto lenses, 47
Focal Plane mark, 4
focus modes. *See also* autofocus modes
AF-ON button, 169
AI Focus, 168
AI SERVO, 168
Basic Zone, 19
Creative Zone shooting modes, 19
setting, 20
focus point, resetting for mood
lighting, 192
focus settings, experimenting with, 31
focusing
attention, 227
on eyes, 106
face tracking, 110
in low light, 191
on multiple subjects, 111
Quick Control screen, 108

setting AF point, 108
tip for portraits, 108
using AF-ON button for, 201
formats, RAW vs. JPEG, 40–43. *See also*
image formats
frame rates, 232
frames
capturing, 168
within frames, 225
freezing movement, 177
front of camera. *See* camera front
f-stops
and aperture, 78
explained, 50–51
Full Auto mode, 62
full frame vs. crop sensor, 43

G
golden hour, 138
gray card, using with white balance,
254–255
grid display
setting for video recording,
240–241
using with Live View, 112

H
Handheld Night Scene mode, 67
HDR (high dynamic range) images
AEB (Auto Exposure Bracket)
mode, 150
photographing, 148–151
HDR Backlight control, 67
HFD (hyperfocal distance)
adding to landscapes, 152
explained, 140
High ISO Speed NR, 187
Highlight Alert, enabling, 25–26, 31, 90
high-speed continuous shooting, 166
histograms, 28–29
horizon, 152–153
hot shoe, 3–4

I
image editing, in-camera, 258–262
image formats. *See also* formats
exploring, 55
frame capture, 168
image quality settings, chart of, 9
image resolution, 42
images. *See also* creative photography;
photos
balancing with electronic level,
136–138
maximum number viewed, 30

resizing, 262
reviewing, 31
sharpening via self-timers, 195
viewing up close, 30
in-camera image editing
Creative filters, 258–260
RAW processing, 261
index display, 30
IS (Image Stabilization) lenses
using, 74, 206
using for mood lighting, 190
warning about using with tripods,
131
ISO
explained, 48
external flashes, 204
maximum for mood lighting,
187–188
minimum for mood lighting,
187–188
numbers, 49
pushing to extreme, 206
raising for mood lighting, 186–189
selecting, 70
selecting for landscapes, 134–135
selecting for nature photos,
134–135
setting, 10–11
using Manual mode with, 165
ISO Speed Setting button, 4

J
JPEG and RAW formats, using
simultaneously, 43
JPEG
format, 40–43
image quality, setting, 7–9

K
Kelvin temperature properties, 15
kit lenses, 48

L
landscape images, composing, 143–145
Landscape mode, 65
Landscape picture style, 263
landscapes
balancing images, 136–138
camera modes and exposure,
132–133
color temperatures, 136
creating depth, 145
Depth-of-Field Preview button,
140
electronic level, 136–138

focusing tips, 140
golden hour, 138
HFD (hyperfocal distance), 140, 152
ISO, 134–136
shooting, 130
using tripods, 130–131
white balance, 134–136
LCD monitor
on camera back, 3
info displayed in, 5
reviewing shots in, 174
Vari-angle, 257
LCD Panel, 4
LCD Panel Illumination button, 4
LCD touch-screen features, 7
leading lines, 223, 227
Lens Mount, 2
Lens Release button, 2
Lensbaby, 217
lenses. *See also* DSLR (digital single-lens reflex) camera
choosing for portraits, 116
creative and specialty, 216–217
exploring, 55
function of, 44
IS (Image Stabilization), 74
kit, 48
lengths, 44
normal, 45–46
prime, 47
telephoto, 47
tilt-shift lens, 216
wide-angle, 44–45
zoom, 47
light meter ranges, 80
light painting, 267–269
lighting. *See also* mood lighting; natural light
catchlights, 109
focusing in low light, 191
metering mode for portraits, 104–105
outdoor, 100–101
using flashes, 101–104
lights, off-camera, 205
lines, seeing, 227
Live View
face tracking, 110
setting up grid display, 112
using with videos, 244
and white balance, 14
Live View & Movie Shooting Switch, 3
Long Exp. Noise Reduction, 196
long exposures. *See also* exposures
reducing noise in, 206
shooting, 194–196

taking in dark, 206
low light, focusing in, 191
low-speed continuous shooting, 166

M

M: Manual mode
explained, 80
light meter, 80
setting up, 83
shooting in, 80, 83
using, 80
using with Auto ISO, 165
main dial, 4
manual focus
for anticipated action, 170–171, 179
panning shots, 171
memory cards
choosing, 38
formatting, 38–39, 55
low-level formatting, 39
quality, 38
reformatting, 38
sizes, 38
verifying, 6–7
Menu button, 3
Metering Mode Selection button, 4
metering modes
AE Lock feature, 105
built-in flash, 197
Evaluative, 104
selecting, 104–105, 123
MF (manual focus), 20, 31
Microphone, 4
Mode dial
camera back, 3
camera front, 2
camera top, 4
Mode Dial Lock-Release Button, 4
mode settings. *See* camera settings; shooting modes
mood lighting. *See also* lighting
AF (autofocus) assist beam, 193–194
built-in flash, 196–198
flash exposure compensation, 198–199
flash synchronization modes, 202–203
focusing in low light, 191–193
high ISO, 188
High ISO Speed NR, 187
IS (Image Stabilization), 190–191
Long Exp. Noise Reduction, 196
maximum ISO, 187–188
minimum ISO, 187–188
raising ISO, 186–187

reducing red-eye, 199–201
resetting focus point, 192
second curtain sync, 202–203
shooting long exposures, 194–196
motion. *See also* action photography
creating sense of, 172–173
and depth of field, 51–53
panning, 172
practicing mechanics of, 179
stopping, 160–163
motion blur, using, 173
movement, freezing, 177
movie files, maximum length of, 234
movie-recording size, experimenting with, 249
movies. *See also* videos
disabling Wi-Fi option, 235
file settings, 234
Playback mode, 237
playing, 236–237
recording, 236
setting compression, 234
setting recording size, 234
Moving Subjects mode, 66
mRAW format, using, 41
Multi-Controller, 3
Multi-Function Lock Switch, 3
My Menu settings, 255–256

N

natural light, qualities of, 123. *See also* lighting
nature photography
balancing images, 136–138
camera modes and exposure, 132–133
color temperatures, 136
electronic level, 136–138
golden hour, 138
ISO, 134–136
using tripods, 130–131
white balance, 134–136
Night Portrait mode, 66–67
noise. *See also* digital noise and long exposure
explained, 10
getting rid of, 206
reducing in long exposures, 206
normal lenses, 45–46
NTSC and PAL, 233

O

off-camera lights, using, 205
overheating of camera, avoiding, 235

P

P: Program AE mode
 vs. Auto modes, 68–69
 setting up, 69
 shooting in, 69
 starting off with, 91
PAL and NTSC, 233
panning photography, 172
panning shots, using manual focus
 for, 171
panoramas, photographing, 146–148
patterns, 219–220, 227
people, composing, 111–114
perspective
 changing, 227
 considering, 113
 experimenting with, 120
photos, reviewing, 26–27. *See also*
 creative photography; images
picture styles, 263–265
Playback button, 3
playing movies, 236–237
point of view, 218–219
pop-up flash
 setting up, 102
 shooting with, 102
 testing limits of, 207
Portrait mode, 65
Portrait picture style, 263
portrait tips
 angles, 120
 avoiding center of frame, 116
 backgrounds, 118
 candid moments, 120
 children, 119
 choosing lenses, 116
 close-ups, 119
 human anatomy, 118
 perspectives, 120
 sunblock, 117
 using surroundings, 117
portraits
 black and white, 115
 close-up, 45–46
 composing, 111–114
 depth of field, 123
 focusing tips, 108
 metering mode for, 104–105
power switch, 3
prime lenses, 47

Q

Quick Control button, 3
Quick Control dial, 3
Quick Control screen, using with AF
 point, 108

R

RAW and JPEG formats, using
 simultaneously, 43
RAW formats
 benefits, 40–41
 image-quality settings, 42
 vs. JPEG, 40–43
 mRAW, 41
 processing software, 41
 selecting, 41–42
 smaller image sizes, 41
 sRAW, 41
RAW images
 playing with, 271
 processing, 261
RAW shooters, advice for, 41
RAW/JPEG image quality, setting, 7–9,
 235
reciprocal change, 49
recording movies, 236
red-eye, reducing, 199–201, 207
Red-Eye Reduction/Self-Timer Lamp, 2
Release Shutter Without Card setting,
 turning off, 6–7
resizing images, 262
Review Time setting, changing, 26–27
reviewing photos
 histogram information, 27
 Info button, 27
 in LCD monitor, 174
 Playback button, 27
rule of thirds
 applying to landscape images,
 143–144
 explained, 111–112
 sticking to, 224

S

SD (Secure Digital) cards, using, 38
SD card reader, using, 38
SD card slot, 3
second curtain sync, using, 202–203,
 207
self-timers
 2-sec, 166
 10-sec, 166
 using, 195
Setting (Set) button, 3
shapes, 219–220
shooting continuously, 165–169

Shooting Information Display, 27
shooting modes
 accessing, 57
 Basic Zone, 62
shots, steadying with IS lens, 206
shutter, mechanics of, 70–71
Shutter button
 camera front, 2
 camera top, 4
shutter curtain, 202
Shutter Priority mode. *See* Tv: Shutter
 Priority mode
shutter speeds
 Aperture Priority (Av), 197
 built-in flash, 197
 choosing, 50, 73
 controlling, 73
 explained, 48
 Program (P), 197
 Shutter Priority (Tv), 197
silent continuous shooting, 166
silent single shooting, 166
single shooting, 166
Single-Point AF, 169
smartphone
 Camera access point mode, 22
 Camera Connection, 23
 Connect Smartphone option, 22
 connecting to Canon 70D, 21–24,
 31
 Easy Connection, 23
 SSID, 23
Special Scene mode, 64
Speedlites. *See* external flashes
sports, shooting, 66
sports images, getting creative with,
 163
sRAW format, using, 41
sRGB space, 15
star photography, 192
stops
 and aperture, 78
 explained, 50–51
strap mount, 2, 4
"swirly flash" effect, creating, 266–267

T

telephoto lenses, 47
terminal cover, 2
textures, 219–220
themes, photographing, 227
tilt-shift lens, using, 216
tripod head, using, 131
tripods
 choosing, 131
 stability, 130
 using, 130–131

using with videos, 242
warning about IS lenses, 131
Tv: Shutter Priority mode. *See also*
 shutter speeds
 controlling time, 91
 setting up, 74
 shooting in, 74
 using, 70–71
 using to stop motion, 160–163

V

Vari-angle LCD monitor, 257
video camera back
 Info button, 230
 LCD monitor, 230
 Magnify button, 230
 microphone, 230
 mode dial, 230
 Movie Shooting Switch, 230
 Multi-Controller, 230
 Multi-Function Lock Switch, 230
 Playback button, 230
 power switch, 230
 Quick Control button, 230
 Quick Control dial, 230
 Setting button, 230
 terminal cover, 230
video camera LCD monitor
 aperture, 231
 attenuator, 231
 auto lighting optimizer, 231
 battery check, 231
 compression method, 231
 digital zoom, 231
 drive mode, 231
 exposure level indicator, 231
 exposure mode, 231
 focus method, 231
 ISO speed, 231
 Magnify/Digital/Zoom, 231
 maximum burst, 231
 movie shooting mode, 231
 Movie Shooting Remaining Time/
 Elapsed time, 231
 movie-recording size, 231
 picture style, 231
 possible shots, 231
 quick control, 231
 recording level, 231
 shutter speed, 231
 still image quality, 231
 video snapshot, 231
 white balance, 231
 Wi-Fi function, 231
 wind filter, 231

Video mode
 image quality, 235
 RAW/JPEG setting, 235
video quality
 280×720, 232
 640×480, 232
 1920×1080, 232
 ALL-I compression, 233
 compression settings, 233
 frame rates, 232
 IPB compression, 233
video recording, setting grid display
 for, 240
videos. *See also* movies
 adjusting picture styles, 249
 audio, 245–246
 Auto Exposure vs. Manual
 Exposure, 238–239
 composition, 240–242
 editing, 247
 electronic level, 241
 exposure compensation, 239
 exposure settings, 238–240
 focusing, 243–244
 limitations of microphone, 249
 NTSC and PAL, 233
 picture styles, 239–240
 playing back, 236
 playing back on computers, 238
 setting digital zoom, 242
 setting focus, 249
 setting Lock switch, 239
 shooting, 236
 slow motion, 233
 snapshots, 248
 tips for shooting, 246–247
 using Live View, 244
 using tripods, 242
 white balance, 239–240, 249
viewfinder, 3

W

water, silky appearance of, 140–143
white balance
 customizing, 254–255, 271
 explained, 11–15
 Kelvin temperatures, 15
 and Live View, 14
 previewing, 14
 selecting, 31
 selecting for landscapes, 134–135,
 152
 selecting for nature photos,
 134–135, 152
 setting, 13
 and temperature of color, 15

white balance settings
 Auto, 12
 Cloudy, twilight, sunset, 12
 Color temperature, 12
 Custom, 12
 Daylight, 12
 Flash, 12
 Shade, 12
 Tungsten light, 12
 White fluorescent light, 12
wide-angle lenses, 44–45
Wi-Fi
 drain on battery, 24
 enabling, 24–25
 setting up, 21–24

Z

Zone AF, 169
zoom lenses
 and maximum apertures, 78
 playing with, 269
 using, 47